PEGGY GUGGENHEIM

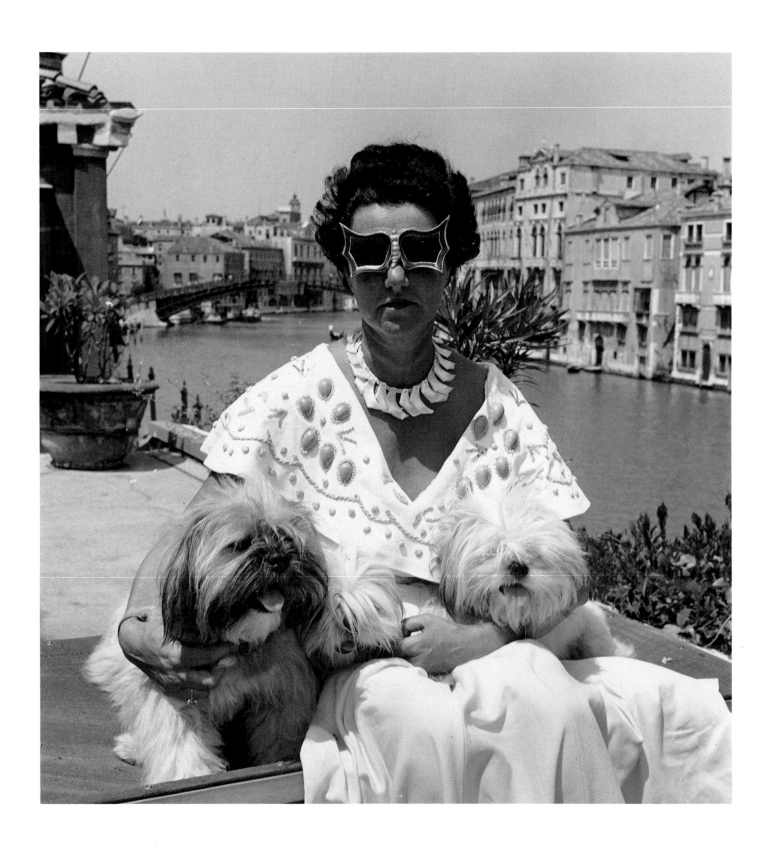

PEGGY GUGGENHEIM

A COLLECTOR'S ALBUM

LAURENCE TACOU-RUMNEY

𝓡 RIZZOLI INTERNATIONAL PUBLICATIONS, INC.

Photo research by Laurence Tacou-Rumney
Translated from the French by Ralph Rumney

Originally published in the United States of America in 1996
by Flammarion

Published in the United States of America in 2002
by Rizzoli International Publications, Inc.
300 Park Avenue South
New York, NY 10010

Copyright © 2002 Laurence Tacou-Rumney

2002 2003 2004 2005 / 10 9 8 7 6 5 4 3 2 1

ISBN (hardcover): 0-8478-2457-8
ISBN (paperback): 0-8478-2461-6
Library of Congress Control Number: 2002102944

Printed in Italy

Frontispiece: The "last Dogaressa" on the terrace of the Palazzo
Venier dei Leoni with her "beloved babies" in 1958.

"When I see
Mrs. Guggenheim
sunbathing on the roof,"
remarked Peggy's neighbor,
the prefect of Venice,
"I know the spring has come."

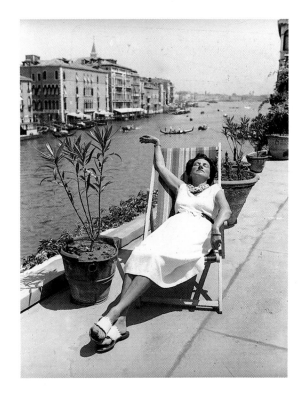

Contents

FOREWORD

It is hardly necessary to introduce Peggy Guggenheim to the public. She took the lead long ago by publishing several versions of her memoirs at different times under the revealing title, *Out of this Century, Confessions of an Art Addict*. It is a key document that her mentor, Herbert Read, found historical but amoral and he warned her that posterity would remember her as a tumultuous seductress. Between the mundane details of her daily life and the glittering window of her achievements, several voices are to be heard; all are impenetrable: Peggy boasting of her conquests with the bravado of a gunslinger carving notches on his smoking gun; the candid Galatea in quest of her Pygmalion; the exiled child seeking her vanished father; the capricious heiress to a squandered fortune; and finally, the innovator and searcher, who found herself at home in the leading art movements of her time. She was a rebel, continually at odds with her upbringing, with convention, with herself, at times a rock of intuitive certainties, at others submerged by her emotions, she recognized that despite poignant experiences, she had always skimmed the surface of life. Reflected in the multifaceted mirror of her detailed autobiography, Peggy remains as enigmatic as the sphinx. She assiduously compiled and jealously preserved photograph albums, which, here and there, reveal more than words. A smile, a glance, a gesture, a stolen instant of happiness or distress, suddenly emerge unblemished from the past. With great tenderness she offered herself with her children, or alone in hieratic poses, to the shutters of a youthful Berenice Abbott or Man Ray. Captivated by the lure of the snapshot, she posed naturally and sensually, for great photographers as well as for her intimates, in private moments and on historic occasions. With her lovers, husbands, and friends she attempted, and succeeded, in creating the necessary alchemy to capture the fleeting instant and preserve it forever.

This book is, first of all, for my dear husband, Sandro, who inspired it and helped me to get it under way; for our wonderful children, Olivia, Sindbad, Lancelot, and Santiago; for their grandmother Pegeen, Peggy's beloved daughter; for an entire family that the impetuous art addict swept along in the turbulent wake of her life's work, her collection, with never a backward glance. Her success was so complete that it has made her immortal, but like Faust, happiness was denied her. For this one key was missing; the smallest: $\alpha\gamma\alpha\pi\eta$, love.

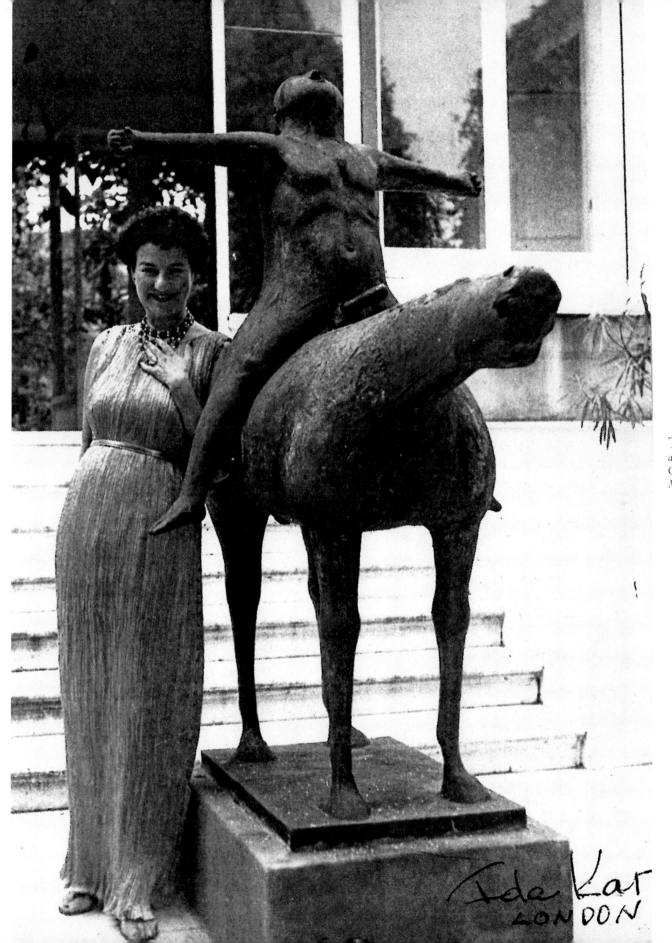

The vestal of the Arts
and her Angel of the
Citadel by Marino
Marini, Venice 1951

MILESTONES

Driven by an unerring instinct for bold artistic experimentation and a profound need to seduce, Peggy Guggenheim became one of the most influential collectors of modern art in the twentieth century. A possessive mother, abandoned lover, and restless nomad, she sought constantly to define herself through her collection. Arp, Brancusi, Calder, Carrington, Duchamp, Ernst, Fini, Giacometti, Hélion, Kandinsky, Léger, Masson, Motherwell, Pollock, Rothko, Tanguy, Laurence and Pegeen Vail, these were her friends, lovers, husbands, children, rivals, advisors, and protégés who were the guiding lights of her existence. Her entire life was crystallized in a moving mosaic of the history of art, reflecting both the indelible mark of a personality and the anthology of an era.

Born in New York and married in Paris, Peggy came into her own first in London and then New York before being consecrated in Venice. Throughout her life she wandered ceaselessly between these four cardinal points. Like her handsome father Benjamin, who went to a hero's death on the Titanic, she sought love in a series of romantic conquests and defeats. Constantly seeking environments conducive to new ideas and new sensations, at an early age she strayed from the conventional path and plunged into the effervescent world of Paris in the 1920s with her husband, the painter and writer Laurence Vail. A self-described emptier, thrower, and finally decorator of wine bottles, he was the father of Peggy's two children, Sindbad and Pegeen. Following her divorce from Laurence, whom she would refer to throughout her life as "my eternal husband," Peggy entered into a long, restless, "baroque" period in the English countryside with an eclectic, avant-garde literary entourage. There she played the surrealist Truth Game with her ardent and fierce friend Djuna Barnes, who dedicated her scandalous novel *Nightwood* to Peggy, and began an on-again-off-again love affair with a handsome, green-eyed Irishman named Samuel Beckett, who had yet to write *Waiting for Godot* and who signed the poems he wrote for her, "Oblomov."

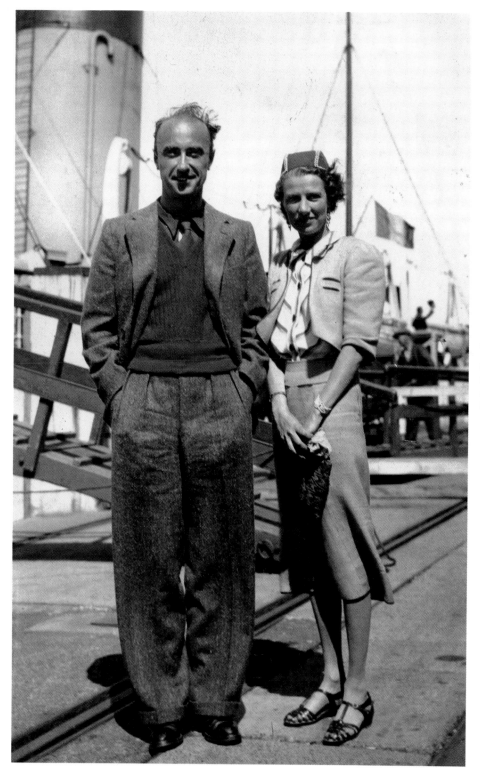

Yves Tanguy and Peggy
on their way to London for
the artist's exhibition
at Guggenheim Jeune
in July 1938

9

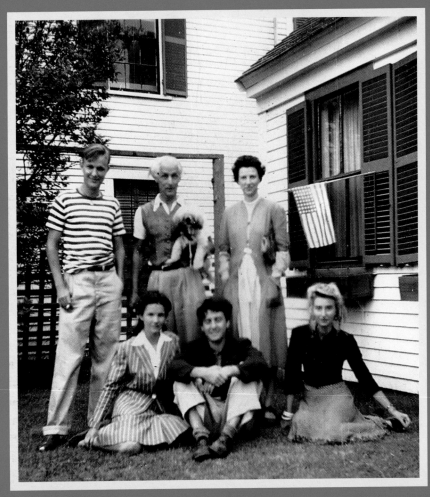

*F*rom left to right: Robert
Motherwell, Max Ernst, Peggy,
Anne Matta-Clark, Matta, and Pegeen

Simultaneously seeking liberation and stability in a world shaken by two world wars, a cataclysmic era that engendered intense artistic activity, Peggy discovered surrealism in an atmosphere of all-night parties, fights in cafés, gallery openings, and internecine quarrels, with the man who was to become her mentor, Marcel Duchamp.

Peggy's disappointments in love brought out the hidden resources of her character and in the late 1930s she opened the gallery Guggenheim Jeune on London's Cork Street. There she provided an eclectic showplace for all the avant-garde movements she supported, rejecting the artificial divisions dictated by conventional artistic theories of the time. She exhibited works by Kandinsky, Cocteau, Duchamp-Villon, Brancusi, Calder, Arp, Moore, and above all Yves Tanguy, whose paintings she introduced in England. Little did she suspect the role that art was to play in her life, even in its most intimate moments. The clouds of impending war put a temporary halt to her project to found a museum, which was to have been directed by her second *éminence grise,* Herbert Read.

Returning to Paris, the day "Hitler walked into Norway," Peggy recounted, "I walked into Léger's studio" and bought *Les Hommes et la Ville.*[1] In a few short months, using the precious list provided by Herbert Read and amended by Duchamp, she acquired over fifty paintings or sculptures of major importance by such artists as Giacometti, Picabia, Klee, Mondrian, Gleizes, Miró, De Chirico, Ernst, Dali, Tanguy, Magritte, and Brancusi. Now she was confronted with the problem of saving this remarkable collection before the Nazis could confiscate it. The Louvre judged the works too recent to be worthy of space in their shelters, so the precious collection was hidden in a barn near Vichy before being shipped to the United States in boxes labeled "household goods."

In Marseille in 1941, waiting to book passage back to the United States, Peggy helped numerous artists escape France; these included André Breton and his family as well as the surrealist painter Max Ernst, her future husband. Back in New York, Peggy resumed her project to open a museum–art gallery. She commissioned the Viennese architect, Frederick Kiesler, a member of the De Stijl group, to apply his revolutionary techniques to transform a former tailor's workshop on 57th Street into a radically new type of environmental space, which made Art of This Century one of the most influential artistic centers of the period. For the opening of the gallery on 20 October 1942, Peggy wore in her right ear a small-scale gold mobile forged by Calder and in her left, a miniature landscape by Tanguy, to demonstrate her "impartiality between Surrealism and Abstract Art."[2] This gesture was less frivolous than it may seem, as revealed by the ecumenical spirit of her first catalogue, published in 1942, which included prefaces by André Breton, Jean Arp, and Piet Mondrian. This synthesis of the major ideas of the modern tradition would prove to be one of the most important accomplishments of a period in which Peggy's role is still not fully appreciated today. In the exceptional space of her small gallery, she brought together the European avant-garde and young, unknown American artists. She instinctively foresaw, when few others did, the immense new frontier of American art, the emergence of new forces, new dimensions, and a new psychology. Despite her intimate relationship with the surrealists, she staged the first

exhibitions of Robert Motherwell, William Baziotes, Mark Rothko, and Clyfford Still, and above all played a key role in the early career of Jackson Pollock, who at the time was working as a carpenter in her Uncle Solomon's museum. When Peggy decided to close Art of This Century in 1947, the critic Clement Greenberg, writing in *The Nation*, evaluated her accomplishments: "During the three or four years as a New York gallery director she gave first showings to more new serious artists than anywhere else in the country."[3]

When Peggy published her memoirs in 1946, they were as frank and outspoken as confessions on a psychiatrist's couch. One critic remarked, "A supreme masochist, she is as relentlessly honest about herself as she is about her 'friends.'"[4] She was so honest that Max Ernst had to flee to Arizona to escape the storm surrounding his ex-wife's book and her Guggenheim uncles tried to buy up the entire print run. She disguised her friends and family in pseudonyms as transparent as some of her clothing, and published her "list" of romantic conquests, creating consternation and discord among numerous couples. She confessed to an obsessive but unusual complex, that of being a "poor" Guggenheim. Ambiguously, though she admitted that money cannot buy happiness, it remained an essential means of manipulation in all her personal relationships.

With the end of the war, Peggy returned to Europe in search of her dream home, which she found on the Grand Canal in Venice. The Palazzo Venier dei Leoni was the perfect showcase for one of the most important private collections of modern art and a living legend. Within its walls, some of them turquoise, cubist and surrealist paintings cohabited peacefully with African sculptures and pre-Columbian divinities, while Calder mobiles floated like bizarre chandeliers above Renaissance furniture. Peggy had become one of the most influential and flamboyant art patrons of the century and was courted, criticized, and feared by curators and artists throughout the world. Following the success of her pavilion in the 1948 Venice Biennale, the *palazzo* became an obligatory stop-over for an international cultural elite. Somerset Maugham, Truman Capote, Jean Arp, Tennessee Williams, Joseph Losey, Jean Cocteau, Igor Stravinsky, Yoko Ono, or Marlon Brando might encounter each other in the luxuriant garden, which was as much the domain of her Lhasa terriers as that of her sculptures by Giacometti, Richier, and Brancusi. Echoing in the glittering train of her lamé gowns by Poiret and Fortuny, were scandals, love affairs, failures, and provocations. Hiding behind her famous gilt butterfly glasses, Peggy dissimulated her grief and loneliness following the tragic death of her daughter Pegeen in 1967. Her lifelong friend Djuna Barnes echoed Peggy's sentiments when she wrote, "The whole thing is dreadful, it truly kills the heart. . . . Strange to think of the downthrust chin, the floating golden hair, the stubborn and lost wandering walk. . . . to know it is not there."[5]

As time healed her wounds and touched with white the hair that she had finally stopped dyeing jet black, Peggy discovered the joys of being a grandmother with Pegeen's four sons and Sindbad's children. An honorary citizen of La Serenissima, she felt herself linked to the city by a magical bond. Each day as the sunlight faded over the

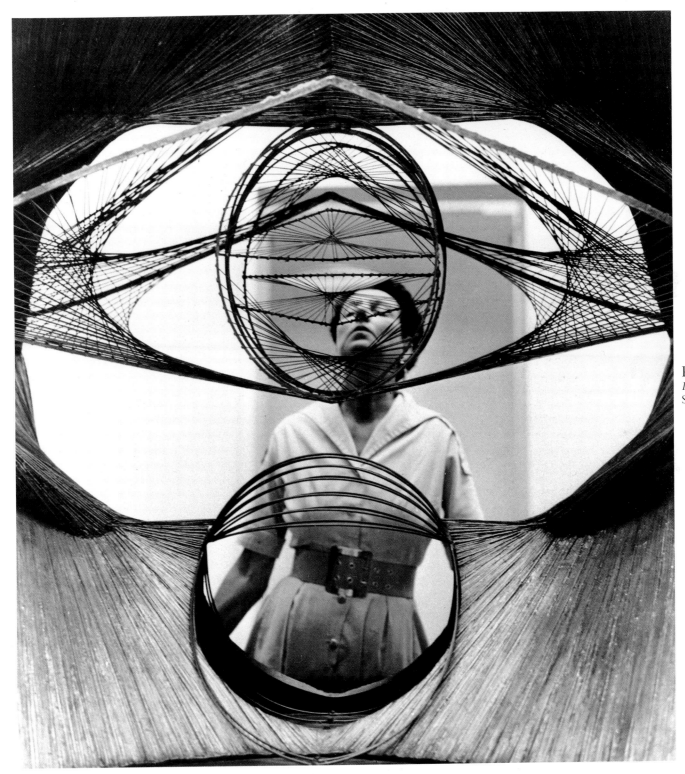

Peggy seen through
Pevsner's construction,
Surface développable

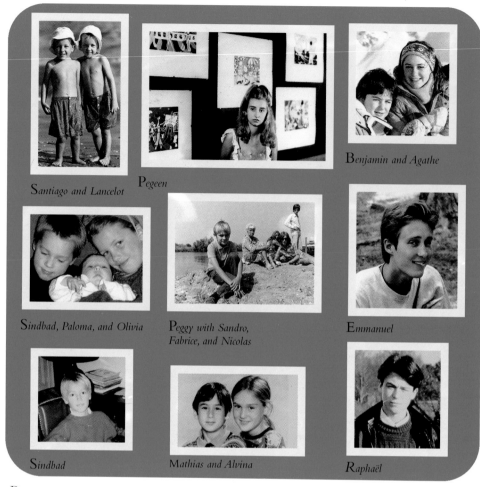

Santiago and Lancelot

Pegeen

Benjamin and Agathe

Sindbad, Paloma, and Olivia

Peggy with Sandro,
Fabrice, and Nicolas

Emmanuel

Sindbad

Mathias and Alvina

Raphaël

Peggy's descendants, third generation.
Her ten great-grandchildren through Pegeen
Right: Peggy's family tree drawn by Stanilas Bouvier

Grand Canal, her long gondola would glide silently through the shimmering reflections of the zebra-striped mooring poles in quest of "the true Venice, the Venice of the past alive with romance, elopements, abductions, revenged passions, intrigues, adulteries, denouncements, unaccountable deaths. . . ."[6]

Today, on the facade of the Palazzo Guggenheim, seventeen stone lions stand silent watch over the unique collection and the ashes of the last Dogaressa.

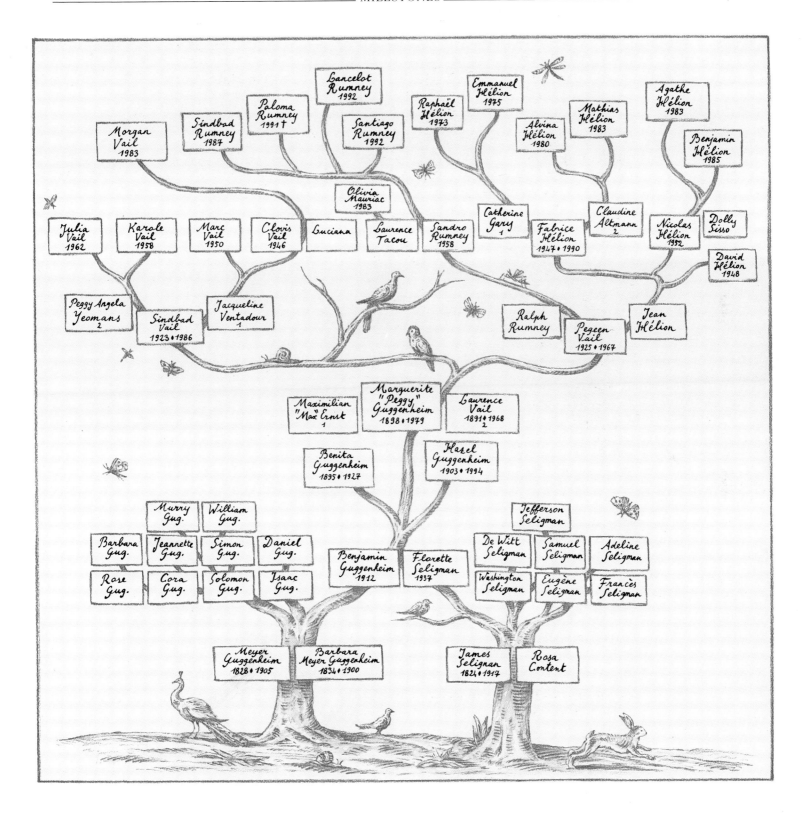

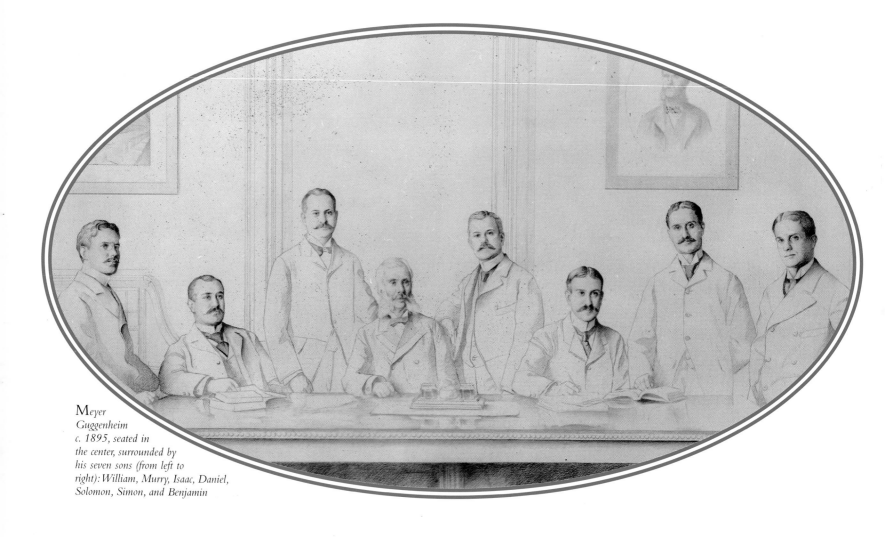

Meyer Guggenheim c. 1895, seated in the center, surrounded by his seven sons (from left to right): William, Murry, Isaac, Daniel, Solomon, Simon, and Benjamin

AN AMERICAN SAGA

The story of Peggy Guggenheim's family is in many ways the fulfillment of the American Dream. From humble beginnings the Guggenheims and the Seligmans developed, in a single generation, two of the most powerful industrial and financial empires of the century. Peggy wrote of their rise to the top with a touch of her characteristic irony: "I come from two of the best Jewish families. One of my grandfathers was born in a stable like Jesus Christ . . . and the other was a peddler."[1]

The Seligmans were the first to arrive in America. The family, whose name translates from German as "holy man," can be traced since the eighteenth century in the archives of the tiny Bavarian village of Baiersdorf, a hamlet near Nuremberg so insignificant that it appears on few maps. David, one of the many Seligmans still living there in the 1830s,

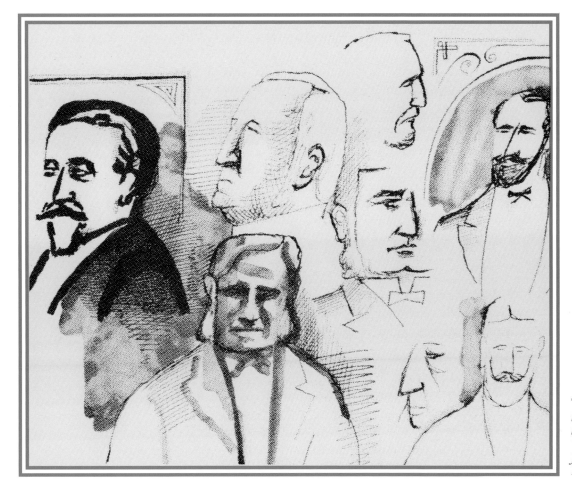

The eight Seligman brothers drawn by Steinberg: Joseph, William, Henry, James, Jesse, Leopold, Isaac, and Abraham

was a tailor, one of the rare trades open to Jews at the time. Though it was difficult to make ends meet and raise eleven children on his small income, David's wife Fanny insisted that they use her precious savings to send their eldest son, Joseph, to college, where he studied French, English, and Greek, in addition to his mother tongues of German, Yiddish, and Hebrew. He was the first Seligman known to have had a university education.

After his schooling, Joseph decided to seek better prospects in the New World. With the equivalent of one hundred dollars sewn into his clothes, he set out in 1837 to join a cousin in Maunch Chunk, Pennsylvania. Upon his arrival he was hired as a cashier by a prosperous local merchant, Asa Packer. Within a year Joseph had saved enough money to strike out on his own. He purchased two hundred dollars worth of pocket watches, rings, knives, and other goods likely to appeal to isolated farmers in the backwoods of

17

Pennsylvania. After three months on the dusty roads with a pack on his back, the young man had doubled his capital. This small fortune was instantly dispatched to Baiersdorf to reimburse his mother and bring over two of his brothers.

In the spring of 1839, Peggy's grandfather, James Seligman, then fifteen years old, and his brother William teamed up with Joseph as door-to-door salesmen. Soon they were able to open their first dry goods store in the town of Lancaster. James, who was a charmer and claimed that he could sell anything, kept the shop. He had grown tired of trudging the lonely roads of Pennsylvania and had tried to persuade Joseph to buy a horse and cart to seek trade in the south, but Joseph insisted on holding to their tried and true methods.

James persisted. One fine June day, he made a bet with his brother. When Mrs. Rankin, the wife of a local grocer came into the store, James whispered in Joseph's ear, "If I can sell her a pair of winter galoshes, will you let me go?"[2] No one could resist James's radiant smile, certainly not Mrs. Rankin, who had only come in to buy a few yards of cotton cloth. She was soon persuaded that she urgently needed a pair of winter boots. James headed south with his horse and cart, to return two months later with a tidy one thousand dollars in his pocket.

Following his mother's death in 1842, Joseph brought the rest of his family over from Germany. Extra income was needed to support nine more people, but James was up to the challenge. Four years later, the Seligmans set up their headquarters at 5 William Street in Manhattan, and brother Jesse was sent to open a branch in Watertown in upstate New York. One of Jesse's regular customers was a young army officer, First Lieutenant Ulysses S. Grant. Grant was stationed at a local military base and the two men became fast friends.

The house in Baiersdorf where all of the Seligman brothers were born

In 1850, Jesse and Leopold Seligman followed the California Gold Rush to San Francisco, with twenty thousand dollars worth of merchandise to be traded for the miners' gold. A nervous sister-in-law warned them not to cross Indian territory, so they took a roundabout route. They sailed to Panama and crossed the mosquito-infested swamps of the isthmus on mules, finally arriving in San Francisco more dead than alive.

Jesse wisely set up shop in a small brick building—most of the town consisted of log cabins. He also became a volunteer member of the fire brigade. A year later, one of San Francisco's legendary fires ravaged the city and the Seligman store was among the rare buildings to escape the conflagration. Prices shot up. The dollar ceased to be the general currency and it was replaced by gold dust, nuggets, and ingots. Back in New York, Joseph began to deal, very successfully, in the stock market with California gold. The Seligmans survived the Panic of 1857 and finished the decade richer than ever. They even expanded their activities in 1860 by opening a new clothing factory which was run by brother William.

When the Civil War broke out in the following year, William encouraged his brothers to support the Union cause with personal contributions. He then contacted his friend, a fellow German immigrant named Henry Gitterman, who was the provisions

officer for the Union army. Gitterman ordered four hundred uniforms with a promise for more orders to come. The brothers sent Isaac to Washington as Gitterman's "assistant," though his real job was to try to contact President Lincoln. At a White House reception he was shocked to see most of the guests, including military men, in shirtsleeves. Summoning up his courage, he approached the president and respectfully informed him that the Seligmans made very fine uniforms. Lincoln smiled and promised to take note of the matter.

In 1861, very few companies wanted to do business with the nearly bankrupt United States Treasury. The Seligmans felt that the potential gains outweighed the risks and developed a virtual monopoly on the sale of uniforms. The government ran up a debt of 1.5 million dollars with the Seligmans, who reluctantly agreed to be reimbursed with three-year Treasury Bonds yielding 7.3 percent interest, payable every six months. Because of the government's precarious financial position these bonds were not easy to exchange, but Joseph thought something might be made of them in the markets of Paris, London, Munich, or Amsterdam, so he set out for Europe. His trip was a great success. The sale of the bonds helped significantly to stabilize the fragile United States economy and increased the Union's chances for victory. Joseph's experience in Europe inspired him to realize his dream of establishing an international Seligman bank on the Rothschild model. Meanwhile, the United States government continued to rely on the family. When Jesse's old friend, Ulysses S. Grant, was named commander of the Union forces in February 1864, it was whispered that Lincoln's decision had been made with Joseph's advice. The government turned to the Seligmans again to underwrite a sixty-million-dollar bond issue.

Soon after the war ended in April 1865, J & W Seligman & Company, World Bankers, with a capital of six million dollars, opened its doors in the heart of Wall Street. This was the beginning of the "Rothschild" operation, and soon branches of the Seligman bank were founded in the major European financial centers. William, who was something of a playboy, chose to run the Paris branch; Henry, the last to have emigrated, selected Frankfurt, and Isaac, fresh from his White House experience, opted for London. Leopold and Abraham, with their lesser business talents, were dispatched to San Francisco, while Joseph, James, and Jesse stayed in New York. Apart from the women and children, the whole family, which now numbered at least 104 members, worked in varying capacities for the Seligman consortium.

To celebrate the end of hostilities, Joseph hosted a historic dinner for the commanders of the Union and Confederate armies, General Ulysses S. Grant and Brigadier General Pierre Gustave Beauregard. Peace brought renewed prosperity and bank profits soared as the Industrial Revolution gathered momentum. Joseph scored a major coup when in 1867 he and Cornelius Vanderbilt began to buy up the stock of the New York Mutual Light and Gas Company, which most investors considered practically worthless. Within a few month, when the company began laying gas mains throughout New York City, prices soared to $100 per share. Joseph and Vanderbilt made a million dollars each.

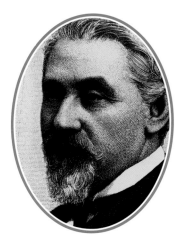

Joseph Seligman

James Seligman

When Ulysses S. Grant was elected president in 1869, he offered Joseph the post of Secretary of the Treasury. Joseph refused for "family reasons," which was indeed the case, but not in the usual sense of the term. Though he was fully qualified for the post, the American millionaire could not help feeling that because of his humble beginnings as an immigrant peddler, he was somehow unworthy of such a high office. He nonetheless remained close to Grant, who enjoyed his pithy comments and deadpan humor.

By the late 1860s, Joseph, like many American investors, began to take an interest in railroads. However, railroads proved to be one business for which the Seligmans had absolutely no talent. Encouraged by James, Joseph underwrote hundreds of railroads, even though many of their routes were clearly impracticable. In an attempt to save one of these lines and prevent his employees from being put out of work, he even bought a locomotive, which was christened the "Seligman." Despite this generous gesture the line failed and the Seligman was sold at auction for two dollars.

Mary Todd Lincoln

Joseph was an active philanthropist and devoted himself to many causes. He was perhaps most proud of the assistance he was able to provide to the widowed Mary Todd Lincoln. Following her husband's assassination, she was so destitute that she was unable to pay for her son's education. Joseph undertook an energetic letter-writing campaign to Washington and himself paid her an allowance for several years until 1870, when he was able to persuade Congress to approve a pension bill for presidential widows. The Seligmans were now deeply attached to their adopted country and Joseph and James engaged Horatio Alger as tutor for their sons. Presumably they expected him to imbue the boys with the ideals of young American heroes such as Tattered Tom or Ragged Dick. Whether or not Alger succeeded is unsure, but his book royalties were very profitably invested.

When Joseph died in 1879 he did not leave the fabulous fifty-million-dollar fortune conjectured in newspapers at the time. However, testimony to his generosity was widespread; a village on one of his famous railroads in Missouri even changed its name to Seligman. Joseph had never been deeply religious and was a founding member of Felix Adler's secular Ethical Culture Society. In accordance with his last wishes, he was accompanied to his final abode by a representative of that institution. Nonetheless, his brother James also insisted upon the presence of a rabbi from the Reformed synagogue Temple Emanu-El, where James was a member of the board of directors.

Upon Joseph's death, Jesse became the head of the Seligman family. By the turn of the century, the Seligmans had invested heavily in the Panama Canal. Unfortunately, the French company that was supposed to be digging the canal went bankrupt and the undertaking had become a serious headache. Another major obstacle was that the isthmus still belonged to Colombia, which was being capricious about granting the operating concession. The Seligmans contacted the Frenchman, Philippe Buneau-Varilla, who became known as "the man who invented Panama," with a view to organizing the secession of Panama from Colombia. In 1901 Buneau-Varilla returned from Panama with a group of leading insurgents and invited James and Jesse to a meeting in his suite

A *Union soldier wearing a "Seligman" uniform*

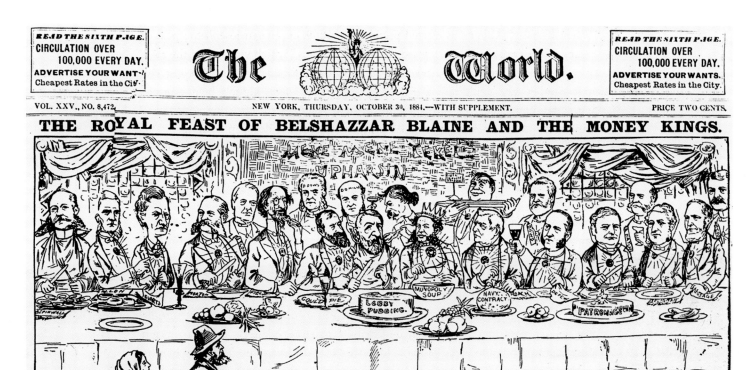

Caricature published in The World, *New York, 1884. Jesse Seligman is pictured third from the right*

at the Waldorf. In return for financing their revolution, the rebels promised to grant the concession for the Canal. When James asked how much a revolution would cost, the Panamanian reply was six million dollars, though the Seligmans' more reasonable counter-offer of one million was accepted with good grace. Buneau-Varilla drafted Panama's Declaration of Independence in James's office and hurried out to Macy's department store to buy a few yards of silk for the new flag, which was soon flying above James's mansion in Westchester. Panama's independence was guaranteed by American warships and in 1903 Buneau-Varilla's flag was raised over the presidential palace. The Seligmans' man was the first ambassador sent by the new republic to Washington. For the Seligmans "Operation Panama" was an unqualified success.

James's marriage to Rosa Content was far less peaceful than the Panamanian revolution. A strikingly beautiful brunette, she had a volcanic temperament and was accustomed to living in style. Rosa had been born into one of America's oldest Jewish families and her aristocratic parents saw her marriage to James as a misalliance that could only be tolerated because of his great wealth. Their eight children, De Witt, Samuel, Washington, Eugene, Jefferson, Adeline, Frances, and Florette (Peggy's mother) were raised in an unhealthy climate of germ-phobia. Their mother denied their school friends

The Seligman locomotive bought by Joseph in order to save one of his railroad lines

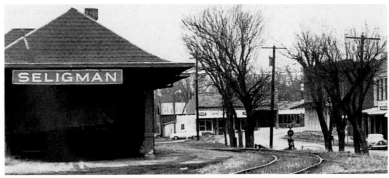

The St. Louis–San Francisco line still passes through the Seligman train station in Missouri

access to the house for fear they bore infection. As adults, all of them developed eccentricities. Frances never left home without a feather boa on her shoulders and a rose in her hair. She was "an incurable soprano," recalled her adoring niece, Peggy. "If you happened to meet her on the corner of Fifth Avenue while waiting for a bus, she would open her mouth and sing scales trying to make you do as much."[3] Jefferson lived in two small hotel rooms in the East Sixties where he stocked fur coats to give to his lady friends. One day his little sister, Florette, demanded a coat, finding it unfair that everyone received one but her. Jefferson once published an engaging article in which he theorized that germs were transmitted by shaking hands and recommended that the practice be replaced by the more hygienic kiss.

Following the marriage of his daughter Florette, James Seligman moved out of the house to escape his wife's unpredictable temper. He lived first in a hotel before moving in with Florette and her family. As an old man (he lived to be ninety-three) he, too, cultivated unusual beliefs. He eschewed the telephone which he regarded as a diabolical invention serving only to transmit gossip. He also kept birds that were allowed to fly freely around his apartments, to the delight of his many grandchildren.

By the end of the nineteenth century, most of the Seligman clan had died out and their vast enterprises were almost all extinct. Only the New York office, run by Joseph's second son, Isaac Newton Seligman, was still operating. Most of the Seligman progeny had become gentlemen and ladies of leisure, living on inheritances from their more energetic forbears.

The Guggenheims were fond of saying that they had made their fortune on foot. They had indeed come a long way from the Surb River Valley in Switzerland where their story begins. Like David, founder of the Seligman dynasty, Simon Guggenheim was a tailor. A poor widower and the father of five children, he nevertheless had no hesitation in redoubling his family by marrying Rachel, a charming widow with seven children of her own. Though Simon's grandfather Isaac had been the richest man in the

"It took Panama when Bunau-Varilla handed it to me on a silver platter," said Theodore Roosevelt

Meyer Guggenheim
1828–1905

village, his wealth, made up of gold and silver coins and notes of tender, had been frittered away by his many offspring. Simon had nothing but a loving wife to support and twelve children to raise. In 1848 the whole family sailed for Philadelphia in the hope of building a better life in the land of opportunity. During the two month passage, Simon's son Meyer and Rachel's daughter Barbara fell in love.

Like the first Seligmans, Simon and Meyer Guggenheim trudged the roads of Pennsylvania selling their wares. Meyer, whose business sense was acute, quickly realized that he could make more money if he manufactured his own merchandise. The most popular article he sold was a scouring agent for ovens and stoves. However, his customers complained that it stung their hands when they used it. Meyer asked a chemist in Bethlehem, Pennsylvania to analyse the composition of the powder for him. Meyer then improved on the original by developing a gentler formula. His new product was an instant success, selling as fast as he could make it. While Simon oversaw production, Meyer was responsible for selling the merchandise and he continued to seek new ways to innovate.

Meyer sold his small business after he married Barbara in 1852 and decided to branch out into more up-market goods such as coffee, spices, and Swiss embroidery. Then the young couple left for New York, where the family grew and the business prospered. By 1879 Meyer and his seven sons were running a group of small companies which imported and distributed Swiss products. The Guggenheims were certainly well-off, but they were far from achieving the vast wealth that would make their name a legend. Then, fortune arrived at their doorstep in the person of Charles H. G. Graham, one of Meyer's business associates. Graham owed money to Meyer and offered to reimburse his debt with holdings in lead and silver mines in Colorado.

Meyer accepted and promptly set off to inspect his new mines, the "A.Y." and the "Minnie." He was unpleasantly surprised to discover that both were flooded by the nearby Arkansas river and, to all intents and purposes, nonproductive. At great expense he spent several months having them pumped dry. Just when he was beginning to think he had made a bad investment, Meyer received a telegram from Leadville announcing that a large vein of silver had been struck in the A.Y. Several months later, the Minnie began to turn out large quantities of high-quality copper.

Meyer immediately summoned all of his sons to Colorado to learn about mining and metallurgy. Copper was not a rare commodity, and American mines were producing enough to satisfy growing industrial demand. Moreover, profits were almost nonexistent because of the exorbitant cost of refining. Recalling the success of his early days with the scouring agent, Meyer made enquiries to find an efficient and cheap method of refining copper. He discovered the Gatling Procces, developed by R.J. Gatling, the inventor of the machine gun, and immediately bought the patent. Now Meyer had his feet on the ladder that would take him from mere wealth to a fabulous fortune.

Meyer's youngest son, Benjamin had just graduated from Columbia University and became the accountant for both mines. A revolver at his belt, he handed out the payroll

INTERIOR VIEW OF THE CELEBRATED
PALACE CHAIR CARS
ATTACHED TO ALL EXPRESS TRAINS ON THE
Missouri Pacific Railway.

No extra Charge is made for seats in these Cars. NO OTHER LINE runs these Cars between St. Louis and Kansas City.
Go West via the "MISSOURI PACIFIC."
F E. FOWLER.
General Passenger Agent.

Advertising poster vaunting the extreme comfort offered by the Missouri Pacific Railway of which Joseph Seligman was the director

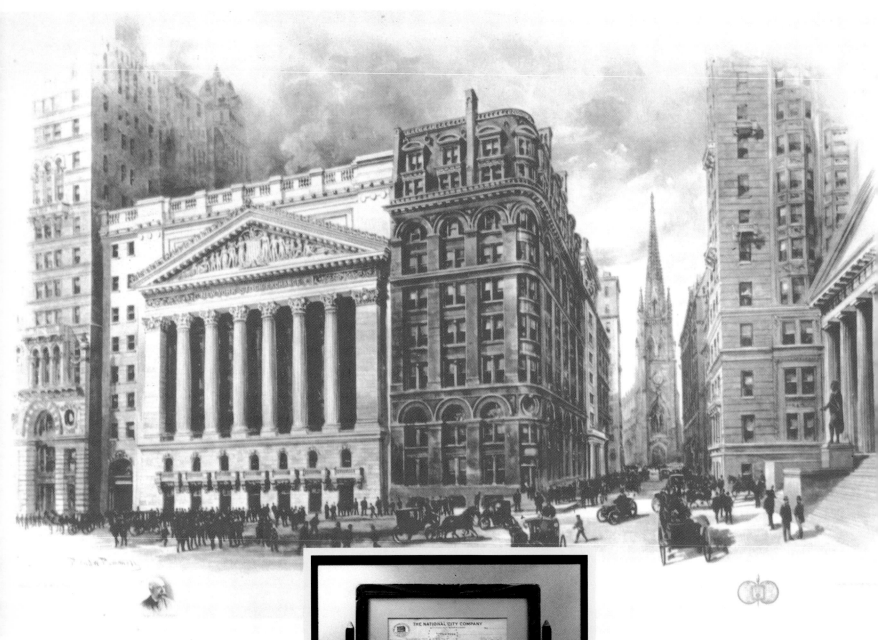

The New York Stock Exchange
at the beginning of the century

A check for 70 million dollars made to the
order of the Guggenheim brothers for the
sale of their copper mines in Chili

24

to the over one hundred workers. With his younger brother William, Benjamin discovered a world far removed from his refined New York upbringing. Meanwhile their older brothers were running the family businesses. The investment in the Gatling process had proved to be well-founded and the Minnie's output was increasing daily.

M. Guggenheim's Sons was founded in 1882 and Meyer wanted all seven of his sons to be associated with the company. To make his point, he assembled the brothers in his office and gave each of them a stick of wood, saying, "Singly, the sticks are easily broken, together, they cannot be broken. So it is with you. Singly, each of you may be easily broken. Stay together, my sons, and the world will be yours."[4] Six years later, the Guggenheims acquired their first foundry, the Philadelphia Smelter C°. Shortly afterwards, the over fourteen million dollars in profits being generated by the Minnie were used to establish a trust that combined a dozen refineries into the Colorado Smelting & Refining Company.

The apogee of the Guggenheim empire was the creation of the Guggenex consortium in 1904. Guggenex set out to buy mines all over the world: tin in Bolivia; copper and silver in Nevada, Utah, Mexico, and New Mexico; gold in Alaska; diamonds in Africa; they even diversified into rubber plantations in the Belgian Congo. When Guggenheim's Sons took over the American Smelting & Refining Company, the family fortune was estimated at more than forty million dollars.

While Meyer was active in the stock market, his older sons ran the mining operations. However, Benjamin and William, the two youngest, left the family business just as it was taking off for new heights. William published, at his own expense, an autohagiography entitled: *William Guggenheim, the Story of an Adventurous Life*. As for Benjamin, who was his mother's favorite, he quickly abandoned business ventures for love affairs. He was handsome and eligible, and became a favorite subject of speculation for New York matchmakers up and down Fifth Avenue.

Given the close circles of their society, it was inevitable that Benjamin Guggenheim would meet Florette Seligman. But when Benjamin asked James Seligman for the hand

In 1907, for a trifling million dollars, the Seligmans built their new bank headquarters, known today as the Flat Iron Building

Guggenheim—"He and his brothers are commercial kings by grace of some able, some daring, and some lawless achievements; he is a senator of the United States by grace of his millions . . . and for no other reason in the world."

Hempstead House, one of the residences of Daniel Guggenheim in Sands Point, Long Island

"How Absurd! He Wants His Own Country."

of his daughter, his suit was accepted without enthusiasm. The Guggenheim fortune may well have been enormous, but because of their Swiss origins, they were not considered part of the upper echelons of New York Jewish society, which was dominated by families of German extraction. However, the truth was that in one generation, Meyer Guggenheim had overshadowed the Seligmans by building the most colossal financial empire in the United States. Those who envied him could not forgive him for the fortune they attributed to outrageous good luck. Meyer did nothing to help matters, he was fond of saying: "I didn't use my head to make my fortune. I did it by buying quality goods and sitting on them. So you see my prosperity is not due to my head but rather to my other end."

The eccentric Jefferson Seligman, Peggy's favorite uncle

The wedding ring that Benjamin placed on Florette's finger in 1895 might well have been alloyed with traces of copper from the Guggenheim mines, gold from the Seligman banks, and a dash of Meyer's remarkable "Midas touch." The marriage was celebrated with pomp and circumstance under a canopy composed of thousands of roses, and Benjamin's brother Solomon signed the register as a witness. During the wedding reception at fashionable Delmonico's restaurant, dowagers sifted through the bridegroom's racy past and the extravagant eccentricity of the bride's family, though no one could have predicted the extraordinary destiny that awaited Benjamin and Florette's daughter, Peggy.

The Castlegould stables at Sands Point; at the time, the Guggenheim Long Island estates employed a staff of nearly two hundred

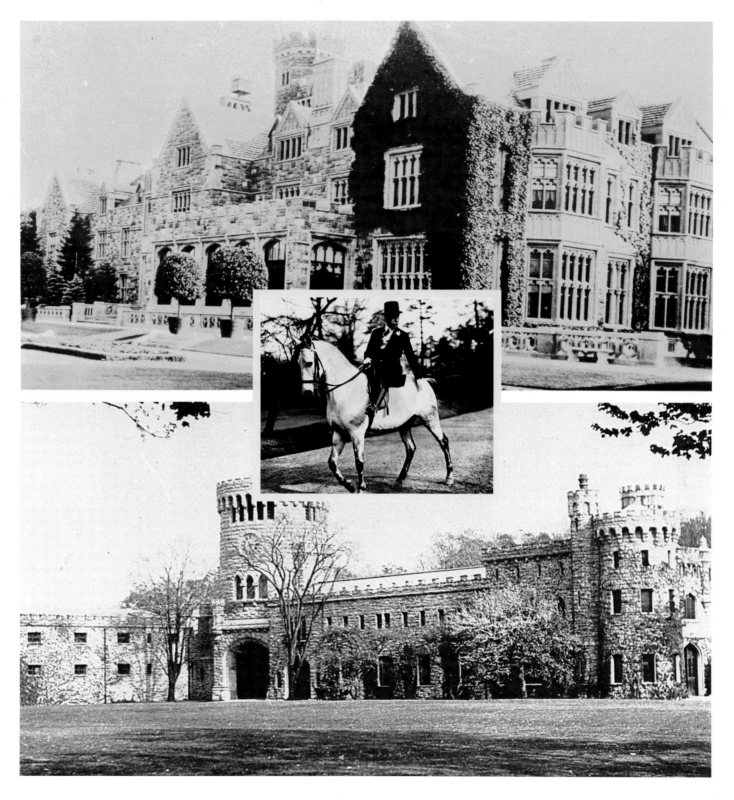

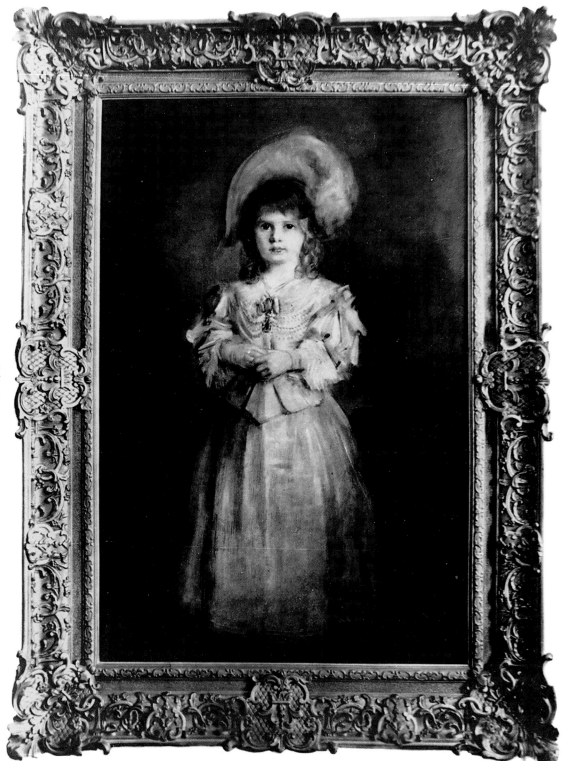

*Portrait of Peggy
at four years old
by Franz von Lenbach*

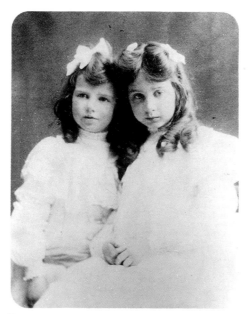

Peggy and Benita in 1904

A Gilded Cage

A bracelet of diamond daisies was the first present Benjamin gave to his second daughter. Baby Marguerite, her turquoise eyes sparkling, came into the world mewing like a cat on 26 August 1898 at her parents' home on West Sixty-ninth Street in Manhattan. From her earliest childhood Peggy avowed a deep veneration for her beautiful older sister, Benita. Within a year of Peggy's birth the family had settled into a Victorian house on East Seventy-second Street, just off Central Park where their closest neighbors were the Rockefellers and President Grant's widow. Benjamin's hunting trophies were a prominent feature of the decor. In the marble and glass entry hall a stuffed Adirondack eagle, its talons chained, spread its wings over a small fountain.

Florette's domain consisted of the immense reception rooms and conservatory of the first floor. Every week she received visitors in a paneled room decorated with a monumental tapestry of Alexander the Great entering Rome, which covered half of one wall. The two children, who were painfully bored by the socializing, had ample leisure to study it in detail. On the third floor, in the red library, portraits of the Seligman and Guggenheim grandparents watched from their sumptuous gilded frames as a recalcitrant

B_enjamin and Florette, c. 1910_

little girl toyed with her meals. Florette was no beauty but she had great charm and the magnificent, deep blue "Seligman" eyes. In the evening, Peggy liked to visit the pink, silk-covered room where her mother's special hairbrusher attended to Florette's tresses in front of a full-length mirror. The last floor, topped by a glass dome, was the refuge of the children and their grandfather. There Peggy played with a rocking horse, a doll's house decorated with tiny bearskin rugs, and a curio cabinet filled with miniature ivory and silver furniture, which she kept under lock and key.

When Peggy and Benita played outdoors, they usually went to Central Park. They pedaled little cars, or went skating in winter, though Peggy hated the cold and was unenthusiastic about taking to the ice. Later, the sisters rode their horses around groups of rowdy kids on roller-skates. Sometimes they went to theater matinées and Peggy once fell head over heels in love with an actor in a play called _Secret Service._ She insisted on going to every performance so that her piercing shrieks could warn him when he was about to be gunned down by the enemy.

Despite its privileges, life at home was less than ideal as Benjamin took up his bachelor philandering again. Alleging acute migraines, he installed a red-headed nurse in the house to massage his headaches away. From then on his mistresses succeeded one another with regularity. Peggy suffered from constant exposure to her father's deception and her mother's tears. She later wrote, "I was perpetually being dragged into my parents' troubles and it made me precocious."[1] Still, she adored her father and would lurk on the staircase listening for his whistle when he came home in the evening. Then she would run down the stairs and leap into his arms.

On one of their regular visits to Europe, Benjamin, who encouraged his daughters to take an interest in the arts, traveled with seven-year-old Benita and four-year-old Peggy to Munich where their portraits were painted by the celebrated artist, Franz von Lenbach. Surprisingly he portrayed Peggy in a "Vandyck" costume, with red rather than

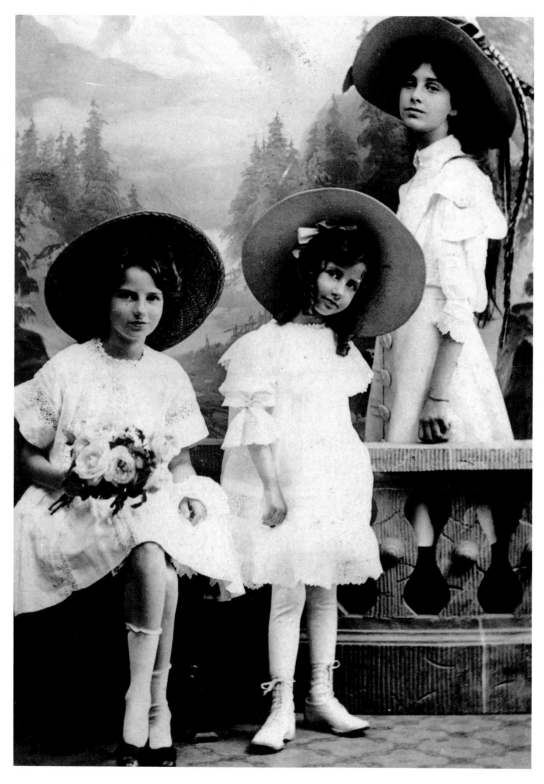

Peggy, Hazel, and Benita at Lucerne, 1908

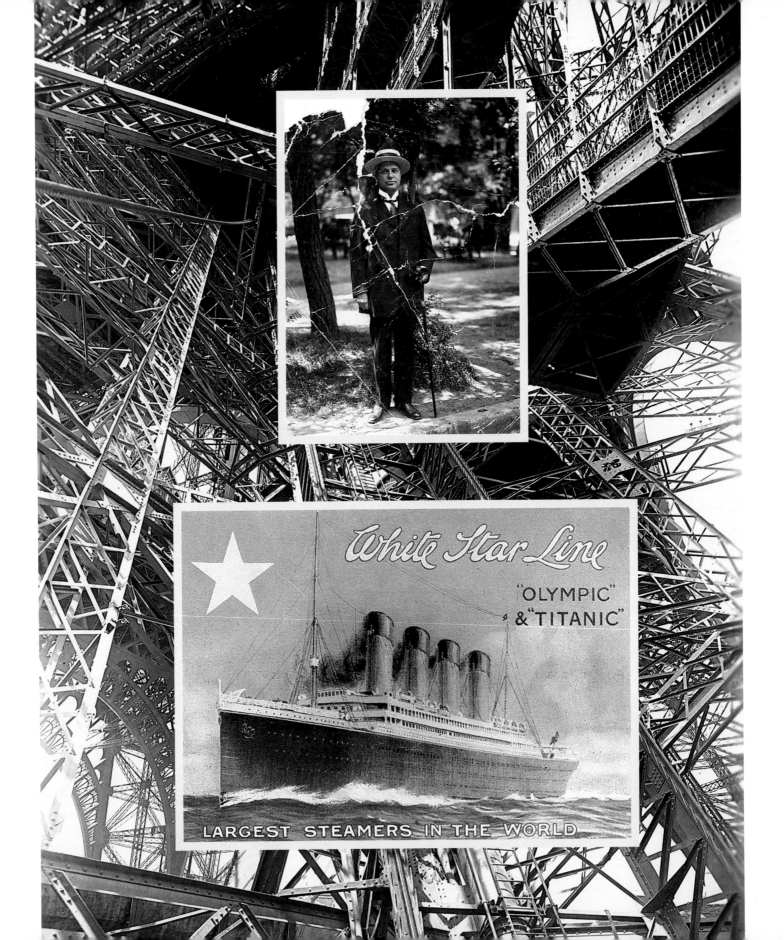

White Star Line

"OLYMPIC" & "TITANIC"

LARGEST STEAMERS IN THE WORLD

Benjamin the dandy, during the days of the International Steampump Company

chestnut hair and brown eyes; hers were green. Peggy, who would always be sensitive about her looks, later noted that "with Benita he was less fanciful. Perhaps because she was so beautiful, he portrayed her as she really was."[2] In that same year their sister Hazel was born, arousing an intense jealousy in Peggy.

Later the three young girls were introduced to art during trips to France, first touring the châteaux of the Loire Valley with their parents, then trailing behind their governess through the Louvre and the Carnavalet Museum in Paris. Peggy admitted a penchant for more material pleasures. She was fascinated by the elegance of the ladies she saw parading along the jetty at the fashionable resort town of Trouville in Normandy, and started making sophisticated dresses for her wax dolls. She always felt at home in Europe, because everywhere she went she would run into "hundreds" of British and French Seligman cousins.

One afternoon, while they were having hot chocolate with their governess at Rumpelmeyer's in Paris, Benita and Peggy noticed a fascinating woman sitting at the next table and staring at them. The children were intrigued and pestered their governess with questions until she admitted that this was their father's aristocratic mistress. There are differing versions as to her identity; she was either the Marchioness Cerruti or the Countess Taverny. Whoever she was, they kept running into her: in the Bois de

The Eiffel Tower before the elevators were constructed

Boulogne, at the theater, at restaurants, and even at Lanvin where Florette, Peggy, and Benita had to beat a hasty retreat when they encountered Benjamin's mistress in one of the dressmaker's salons.

In 1911, Benjamin Guggenheim founded the International Steampump Company. Among other activities, it underwrote the construction of elevators for the Eiffel Tower. The company also provided Benjamin with a perfect excuse for more frequent trips to Paris, where the brunette countess had recently been supplanted by a blonde singer. By the spring of 1912, Peggy's father had been away for eight months and, unbeknownst to his family, was on the brink of ruin. He decided to return to New York, but a dockers' strike at Le Havre forced him to change his travel plans at the last minute. The maiden voyage of the latest transatlantic liner, the Titanic, was attended by huge publicity, and he reserved tickets. Among the names on the passenger list for the 10 April crossing were those of Mr. and "Mrs." Guggenheim and Victor Giglio, Ben's Egyptian secretary.

Four days later, Benjamin and Victor were awakened at midnight by a steward who handed them life jackets and told the men to make their way to the bridge as quickly as possible. They put on evening dress so that they might meet their fate like gentlemen. The bridge was a scene of total panic. The White Star Line had been convinced that the Titanic was unsinkable and had equipped it with only a third of the necessary lifeboats. A ship that passed nearby saw the distress flares, but, knowing they came from the Titanic, assumed it was simply a fireworks display and sailed on. Ben and Victor helped the women and children into the lifeboats, declining the places to which they were entitled as first-class passengers. Having said farewell to his mistress, Benjamin asked another passenger to tell Florette that he had done his duty to the best of his ability.

White Star Line advertisement for the Titanic

Shortly afterwards an ominous crash signaled the fifteen hundred passengers still on board that their last moment had come. After a reckless life Benjamin Guggenheim sank to his last resting place a hero.

In New York, James Seligman had just celebrated his eighty-ninth birthday with his entire family, including Florette and her daughters. The next day, the city was in an uproar and the newsboys were shouting themselves hoarse: "Special edition! Titanic sinks! Hundreds dead!" Her father's death was a terrible shock for Peggy. It took her years to come to grips with the loss, and, she later admitted, "I have never really recovered, as I suppose I have been searching for a father ever since."[3]

Peggy's uncles were disagreeably surprised to discover Benjamin's blonde companion among the six hundred and fifty survivors. A return ticket and a sum of money were promptly provided. They could do nothing about the disaster but scandal was averted. A far more serious problem was that the International Steampump Company and his other distractions had swallowed up almost all of Benjamin's fortune. His brothers Daniel, Murry, Solomon, and Simon tried to conceal the gravity of the situation from his widow by advancing her money from their own pockets. When Ben's creditors had been paid off, all that remained of the eight million dollars with which he had left the family business were eight hundred thousand dollars for Florette and four hundred and fifty thousand for each of the girls. Benjamin's heirs faced a great drop in their resources at a time when his brothers were wealthier than ever and getting richer every day. At the time, Guggenex controlled eighty percent of the world's mining industry.

Florette's standard of living was lowered considerably and she and the girls had to leave their residential suite at the St. Regis for a small apartment, dismiss most of the servants, and sell paintings, tapestries, and jewelry. Peggy took these changes all the harder as her uncles were millionaires and she suddenly felt like a "poor relative." She was humiliated by the thought that she was inferior to the rest of the family and no longer a "real Guggenheim."

Benita, 1919 Hazel, 1919 Peggy, 1913

Despite the decline in their wealth, Peggy, her mother, and her sisters maintained certain elements of their former lifestyle. They spent the summer of 1914 at Ascot with the English Seligman cousins, playing tennis, and going to parties. While war broke out in Europe, Peggy and Benita flirted with the Singer brothers, nephews of the sewing

A *geisha girl named Peggy, c. 1908*

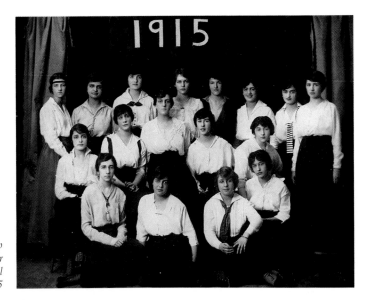

Place de la Concorde
c. 1910. In the
background to the left,
the Crillon Hotel where
Florette always stayed
with her daughters.
Center: Peggy at ten
years old

Peggy, at the far left of the top
row with a ribbon on her
forehead, and the Jacoby School
graduating class of 1915

machine magnate. In the course of that year, Florette finally decided to send Peggy to school. She selected the Jacoby School on Manhattan's West Side, an institution dedicated to the education of well-bred Jewish young ladies. After a few weeks Peggy caught whooping cough and devoured Turgenev, Tolstoy, Chekhov, and Dostoevsky during her convalescence. Then she contracted the measles and worked her way through Ibsen, Strindberg, Oscar Wilde, and George Bernard Shaw. With the same enthusiasm she enrolled in a typing course and then took up knitting. As her contribution to the war effort she knitted socks for soldiers. Indeed Peggy became so keen on this activity that she was constantly knitting—at meals, at the theater, and even in bed.

Travel to Europe was impossible for the duration of the war, so for their holidays Florette took her children to her birthplace, her father's mansion on the New Jersey shore. For Peggy the Allenhurst mansion was "so ugly in its Victorian perfection that it was fascinating. . . . The porches were covered with rocking chairs where the entire family rocked all day."[4] Childhood portraits of Florette and her seven brothers and sisters, wearing black velvet outfits with white lace collars, looked down from the dark paneled walls. The Guggenheims, on the other hand, affected a more extravagant lifestyle. One of them had built himself an exact replica of the Petit Trianon at Versailles. Another inhabited a superb Italianate villa with marble interior courtyards, fantastic grottoes, and terraced gardens. The Seligmans, however, could boast that ex-presidents and European nobility graced their table.

In 1916 an afternoon Leap Year party was given in the Ritz Tent Room for Peggy's formal debut into society. Countless soirees followed but, although she adored dancing,

Trouville c. 1910.
For her wax dolls
Peggy meticulously
copied the
sophisticated dresses of
the elegant ladies
strolling on the jetty

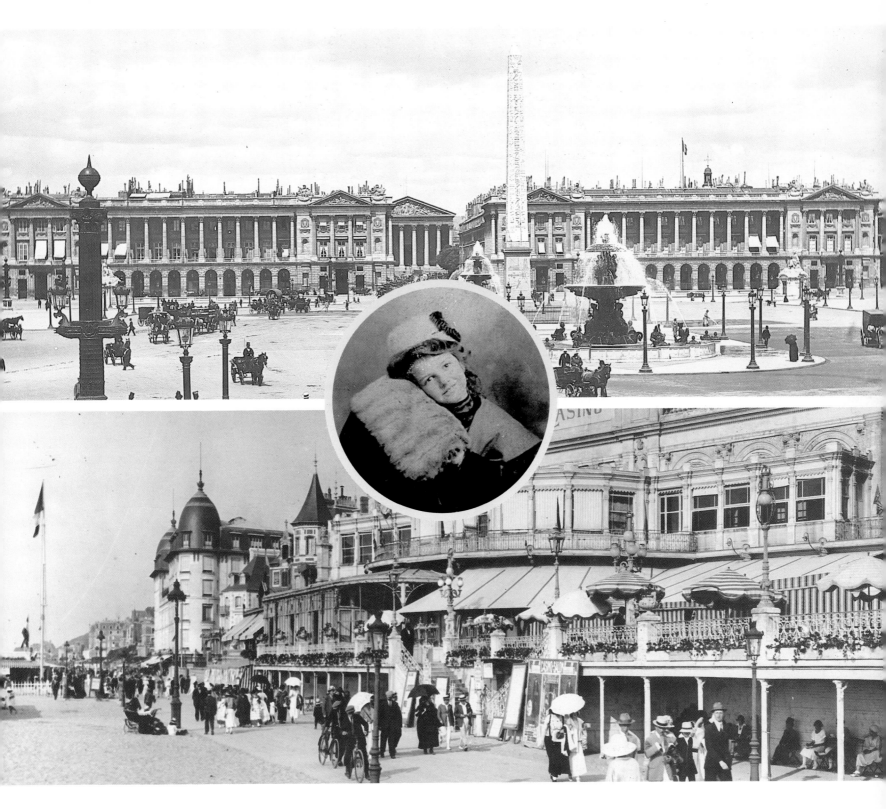

Benita with an attentive escort

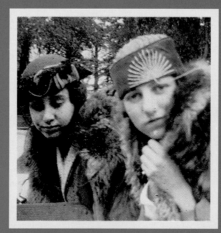

Peggy and Benita in 1919

A boating party

Picnic on the lake shore

Diving suitors

Tennis match

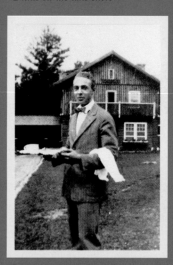

Country outing

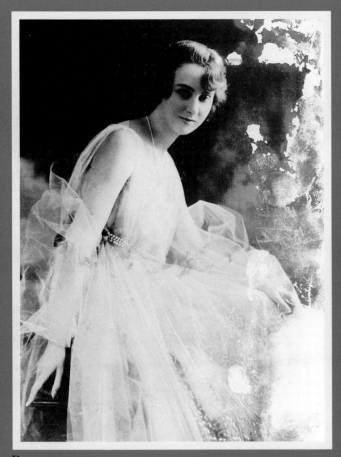

Benita, 1920

Peggy with a group of friends, c. 1920

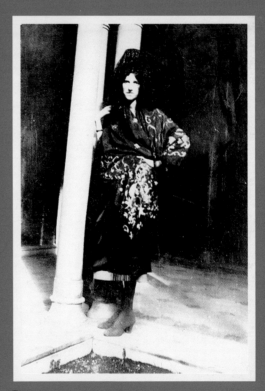

Benita, 1918

Peggy dressing up in an Andalusian costume, c. 1920

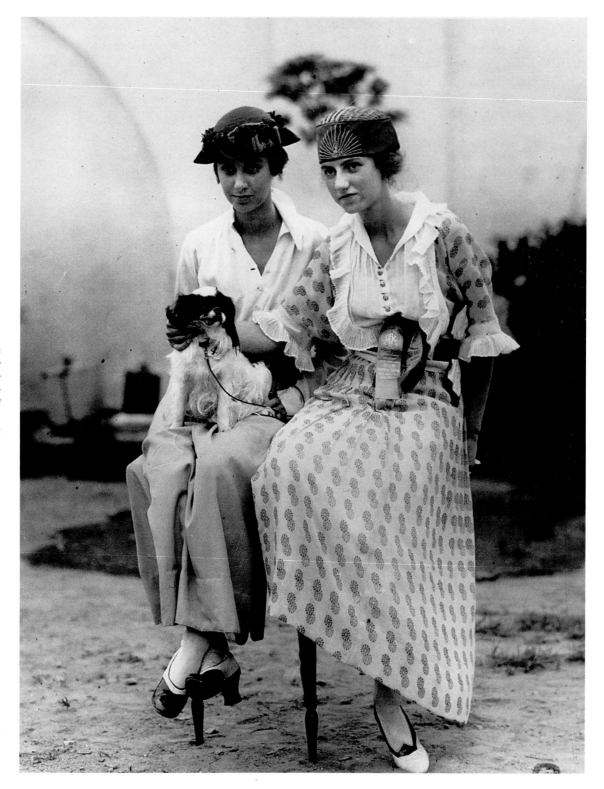

Peggy and Benita with Twinkle, their pekinese that won first prize at the 1919 dog show of the Westchester Kennel Club in Gedneys Farm, New York

she found the parties "artificial" and the young men who squired her too dull to hold her interest. In 1918 she gave up the New York social whirl to work in an office of the Defense Department, helping young officers to acquire cut-price uniforms and equipment. She soon collapsed from overwork, then passed through an existential crisis, over-identifying with Raskolnikov, the hero of _Crime and Punishment._

Upon reaching her majority in 1919, Peggy came into her inheritance. Despite Florette's misgivings, Peggy's first reaction to her new-found independence was to set out with a cousin to explore the United States from coast to coast. They went from "Niagara Falls to Chicago and from there to Yellowstone Park, all through California, down to Mexico, up the coast to the Canadian Rockies." In the nascent Hollywood, she met a number of film people who "all seemed quite mad."[5]

The next winter, Peggy soon found herself at loose ends again and set out for Cincinnati to have her nose reshaped. The surgeon offered her a choice of plaster samples, but he was unable to achieve the desired effect and abandoned the operation half way through. The result was a disaster—hardly the nose "tip-tilted like a flower" that she had discovered in Tennyson's poetry. According to Peggy, it may have been "ugly" before the operation, but afterwards it was "undoubtedly worse."[6] She cloistered herself in the Midwest and waited for the swelling to go down.

The most important change in Peggy's life was neither the money nor the nose but her independence—an independence that engendered uncertainty about what she would do with her life. Desperate to escape her bourgeois environment, she went to see her cousin, Harold Loeb, to beg him to give her a job in his "radical" bookshop near Grand Central Station.

The Sunwise Turn bookstore was a haven for young writers and artists like Djuna Barnes, e.e. cummings, and Malcolm Cowley. They all lived in Greenwich Village, which might have been light years away from fashionable Fifth Avenue instead of fifty blocks. Peggy was fascinated by their vibrant artistic lives, which seemed so different from her own experience. A rebel with a pearl necklace, she was ready each morning to become a new person; perhaps someone like Harold Loeb's partner, Mary Clark, whom she spent hours studying. Loeb described Peggy as a "young magpie" ready and willing to do the most boring of clerical jobs. Her only salary was a ten-percent discount on the books she might buy. One of her tasks was to measure the length of books necessary to fill the library shelves of her rich aunts.

At the store, Helen and Leon Fleischman, who worked for the publishers Boni and Liveright, befriended young Peggy. One day they took her to meet Alfred Stieglitz. Someone handed her an abstract painting by Georgia O'Keeffe, and to the group's great amusement, she began turning it around trying to figure out which way to look at it. This was her first contact with abstract art.

What Do You Want? was the name of an avant-garde play put on by the Provincetown Players. The author was a young American who had been born in Paris and he made a deep impression on Peggy. Laurence Vail was about twenty-eight at the time and he

Peggy Waldman, Peggy's faithful friend and wise advisor

never wore a hat—something exceptional in those days—leaving his dashing blond hair blowing in the wind. "He appeared like someone from another world," Peggy remarked, "I was shocked by his freedom but fascinated at the same time. He had lived all his life in France and he had a French accent and rolled his r's. He was like a wild creature. He never seemed to care what people thought. I felt when I walked down the street with him that he might suddenly fly away—he had so little connection with ordinary behavior."[7] For Peggy it was love at first sight, but Laurence was already leaving New York for Paris.

Eager for a change, Peggy made a short trip to Europe. There she fulfilled her desire for "seeing everything" by spending hours trying to get to masterpieces hidden away in the provinces. She had no formal training in art appreciation, so a friend encouraged her to read the great art critic Bernard Berenson's volumes on connoisseurship. Peggy avidly sought the "seven points" that underpinned Berenson's system of identifying master-works. When she would find a painting with "tactile value" she was delighted.

Back in New York, Peggy met the Fleischmans again at her sister Hazel's wedding, and immediately suggested that they all go to Paris together. Peggy's mother was delighted and booked their usual suite at the Crillon.

Peggy and her
escort, the steadfast Boris Dembo, at the Crillon

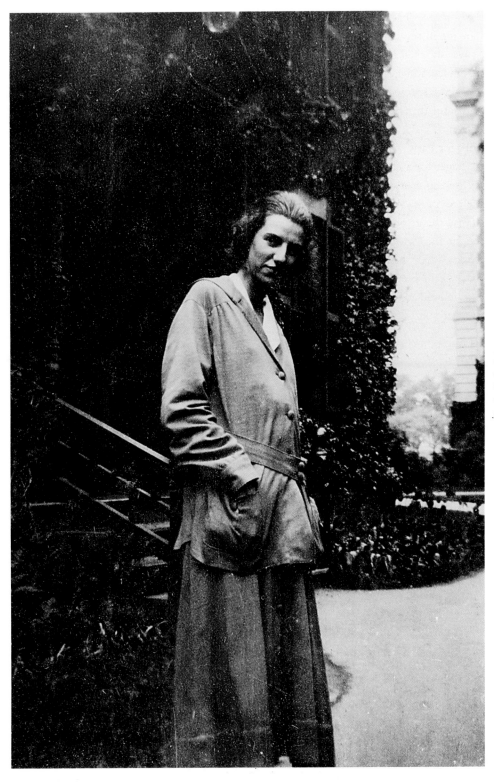

Peggy in 1921,
a young,
independent
woman searching
for a new life

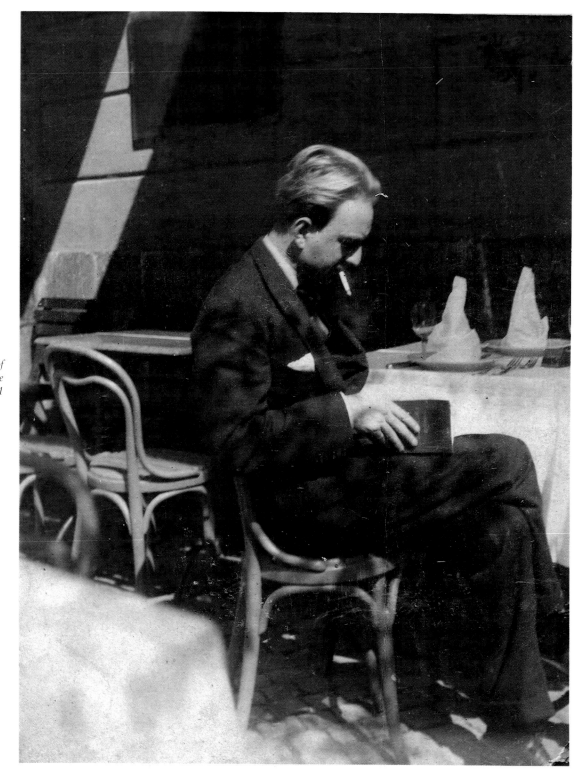

Laurence Vail, the "King of Bohemia," on a Montparnasse café terrace, 1921

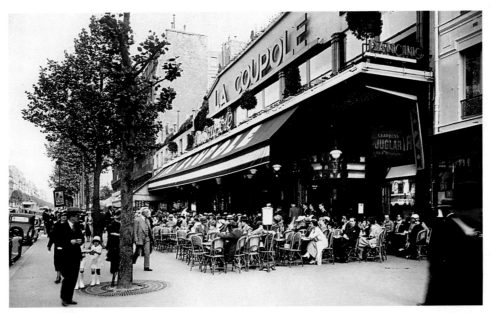

The terrace of La Coupole, the headquarters of the artistic and intellectual circles of the 1920s

VIE DE BOHÈME

By 1921, Europe was beginning to recover from the horrors of war and Paris was becoming once again the center of a vibrant intellectual and social universe. Attracted by a freedom of mores unthinkable in Prohibition-era America, a wave of young writers and artists flowed into Paris to mingle with the French avant-garde. Around the time of Peggy's arrival, Ernest Hemingway, e.e. cummings, John Dos Passos, and Man Ray already had their tables at the Dôme, the Rotonde, or the Parnasse, where they would encounter James Joyce, Ezra Pound, or F. Scott Fitzgerald. Through the occasional sale of an article or poem, these young people were able to live well in Paris on very little money. Life was vibrant and exciting. Jean Cocteau and the British poetess and painter Mina Loy would run into Marcel Duchamp at the Jockey nightclub in Montmartre. Duchamp had stopped painting in 1911 after completing his groundbreaking *Nude Descending a Staircase*; he now devoted himself to chess and had once played for the French chess team. To make a living, he bought and sold the sculptures of his Romanian friend, Constantin Brancusi. Another Romanian, Tristan Tzara, wearing a monocle, was an impassive observer of Nancy Cunard's eccentricities and Kiki's scenes with Man Ray. Rumors of the festivities reached Peggy and her mother on the other side of the Seine in the gilded salons of the

45

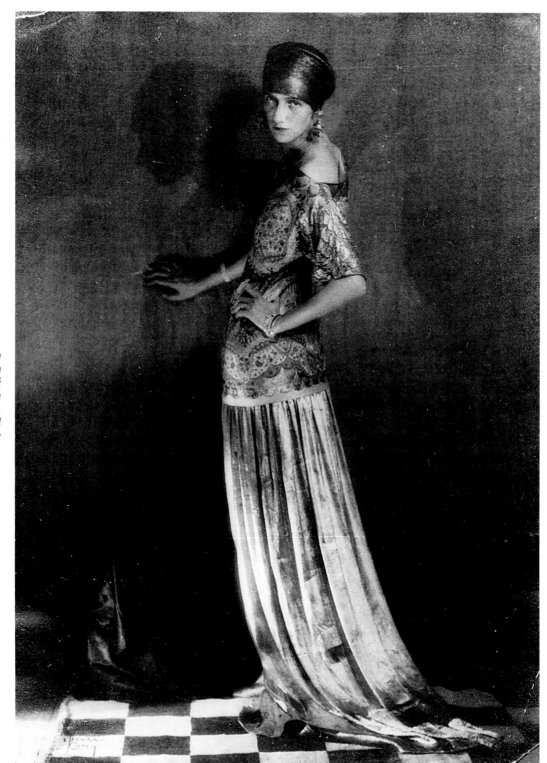

Peggy, *photographed by Man Ray in 1924, wearing a Paul Poiret gold lamé evening gown covered with multicolored glass beads, and a turban designed by Vera Stravinsky*

Pensive Peggy, 1921

Crillon Hotel. With her Russian friend, Fira Benenson, Peggy was then passing her time collecting marriage proposals from appropriate young men. Each new conquest required a new outfit and was punctuated by a visit to Lanvin, Poiret, or Molyneux.

At one of the first dinners the Fleischmans gave in Paris, Peggy again met Laurence Vail. She soon realized that he was less easily swept off his feet than her usual beaux. The first time he asked her to stroll along the banks of the Seine she wore a mink-trimmed outfit that she had designed herself and she baffled the waiter in a small Left Bank bistro by ordering a porto flip, her usual cocktail at the Crillon, rather than the expected glass of red wine.

At that time, Laurence was experimenting with literature and painting. As neither of these activities brought in any money he was forced to live with his parents in an elegant residential neighborhood near the Bois de Boulogne. His mother provided him with an allowance of one hundred dollars a month, which he immediately squandered on parties with his friends in Montparnasse. Brilliant and capricious, he found it difficult to devote himself to just one project or make firm decisions. As Peggy recalled, he "was always bursting with ideas. He had so many he never achieved them because he was forever rushing on to others."[1] The next time Peggy saw Laurence he had moved to a small Left Bank hotel on the Rue de Verneuil and she had moved to the Plaza Athénée on the

elegant Avenue Montaigne, where Vail finally made his first move when Peggy was at home alone. Peggy was delighted. At age twenty-three she had become preoccupied with losing her virginity, but she put up a token resistance, saying that her mother was due back any minute. Then she remembered the postcards of the erotic frescoes in Pompeii she had brought back with her from Naples. It occurred to her than Laurence might be the man of the moment, so she grabbed her hat and they were off. Peggy remarked, "I think Laurence had a pretty tough time because I demanded everything I had seen depicted in the Pompeian frescoes."[2]

With similar enthusiasm Peggy plunged into Laurence's hectic life in the artists' studios, bars, and cafés of Montparnasse, where he was known as the "King of Bohemia." "It was almost too exciting," Peggy admitted; she had calculated that the hours "whiled away" in the Coupole, the Select, and the Deux Magots added up to years of her life. Laurence's writing had not brought him fame but, as their friend, the critic Malcolm Cowley noted, "Laurence was in the center of things. . . . If you knew anyone you knew Laurence."[3] Invitations to the impromptu, often wild parties he gave in his mother's house were highly prized. At the first one she attended, Peggy recalled, "I received a proposal (I can hardly say of marriage) from Thelma Wood . . . she got down on her knees in front of me."[4] Thelma introduced Peggy to her lover, the writer Djuna Barnes, a stunning redhead who had once had an affair with Laurence, as had another one of Peggy's new aquaintances, the beautiful Mary Reynolds, a wealthy widow who was generous with the artists of Montparnasse. She would later become Marcel Duchamp's longtime companion. Djuna Barnes had been the recipient of one of Peggy's earliest acts of artistic patronage. Leon Fleischman had borrowed a hundred dollars from her to pay Djuna's passage to Paris sometime in 1919 or 1920. This was the beginning of Peggy and Djuna's lifelong relationship. In an excess of generosity, and in an attempt to out-do Helen, Peggy gave Barnes a favorite fur cape and a hat decorated with long feathers in which she thought the statuesque Djuna resembled a dashing Italian soldier.

Laurence's father, Eugene Laurence Vail, was half Breton and half American. From him, Laurence inherited a love for art and a sense of humor. Eugene Laurence—whose father, Laurence Eugene, had been a watercolorist—was a talented painter particularly well known for his views of Venice and Brittany. He was awarded a gold medal at the Universal Exposition of 1889 and King Victor Emmanuel III bought one of his paintings for the Venice Museum of Modern Art. A few years earlier he had accompanied the captain of his regiment to Venice, where he had been delegated to receive Queen Margerita at the opening of a geographical conference. When the Queen asked him if he were not a bit young to represent America he replied, without a smile, "it's a very young country Your Majesty."[5]

Early in life, Laurence acquired a love for mountains. His mother, Gertrude Mauran Vail, was both sophisticated and adventurous. Though a staunch Daughter of the American Revolution, she was an expert mountain climber and one of the first women to reach the summit of Mont Blanc. Even as a small boy, Laurence accompanied his mother on climbing expeditions. Perhaps memories of those days prompted Laurence to take Peggy

to the top of the Eiffel Tower—which they ascended in one of Benjamin's elevators—to propose marriage. Petrified by her immediate and enthusiastic response he fled to Normandy. Their engagement caused an uproar—everyone seemed to be against the marriage. Peggy's mother rushed back from Rome to try to put a stop to it. Meanwhile Laurence's mother sent the beautiful Mary Reynolds to Normandy in the hope of rekindling an old flame. Her plan backfired as Mary and Laurence argued continuously. At first, this opposition only made Laurence more determined. Then he changed his mind again after consulting his sister Clotilde, who was jealous of any woman who might threaten her almost incestuous love for her brother. She tried to convince Laurence to accompany her to Capri. Miraculously, the marriage date was finally set for 10 March 1922. On the wedding morning Laurence's mother telephoned Peggy and said "He's off." Peggy nearly fainted, "I thought she meant that Laurence had run away. He hadn't. She merely meant that he was on his way to fetch me."[6]

Two days after the ceremony the newlyweds set off for Rome. On the station platform her mother secretly slipped Peggy a personal passport in case she needed to escape Laurence, whose travel documents served for them both. The couple ran into Peggy's cousin, Harold Loeb, in the Eternal City and he asked Laurence to submit a poem to his avant-garde literary magazine, _Broom,_ in which he had already published Vail's "Funeral March." His ode "Little Birds and Old Men" upset the Guggenheim uncles who thought they recognized themselves in it.

Laurence had rented a charming villa not far from Tiberius's palace on Capri, where they spent an idyllic three-week honeymoon until Clotilde arrived. The three of them then drove across Italy and Peggy discovered Piero della Francesca's frescoes at Arezzo in which she tried to identify Berenson's "seven points," much to her husband's annoyance. That autumn, Laurence and Clotilde set off on a motor bike for the Basque coast, while Peggy sailed for New York to see Benita. Upon her arrival she discovered that she was pregnant, wired the news to Laurence, and booked her return passage.

Laurence, deeply moved, was waiting for her on the quay when she arrived in Southampton. They immediately began making plans for the child. The couple decided that the baby would be born in London to avoid French military service, and they set up house there. The arrival of Michael Cedric Sindbad Vail on 15 May 1923 set off a general panic among guests at a dinner party given in the Kensington home where the Vails were living. Peggy was moved up to the bedroom amidst a crowd of friends, doctors, nurses, and midwives. Confined to her bed for three weeks, Peggy invited a childhood friend, Peggy Waldman, to visit her from New York to keep her company. Peggy admired Waldman's intelligence and cherished her friendship. She remarked that her old friend "never failed to appear at the crucial moments in my life. I felt all I had to do was to bring out my Aladdin's lamp and Peggy would pop out and help me."[7]

After a quick trip to Paris for the Bastille Day festivities, the Vails, including Clotilde, took a house for the summer at Villerville in Normandy. Although Peggy found it "a hideous old house, with a bathtub in the cellar,"[8] there was a lovely garden and an artist's

L_aurence, 1923_

studio. Peggy Waldman and Mina Loy were permanent guests and could be seen on the water's edge with their skirts tucked up, trying their hand at catching shrimp. The surrealist poet Louis Aragon, Clotilde's current lover, took up residence. Man Ray and his muse and model, the "remarkable hand-painted Kiki,"[9] were also invited. Even Nora and James Joyce, whose *Ulysses* had been published in Paris the previous year, turned up while visiting their daughter Lucia in a nearby boarding-school.

Following an autumn trip to Capri with Peggy Waldman, Mary Reynolds, and the ever-present Clotilde, Peggy and Laurence were left alone at last. They decided to spend the winter in Egypt, where they plundered the souks. Laurence bought exotic materials

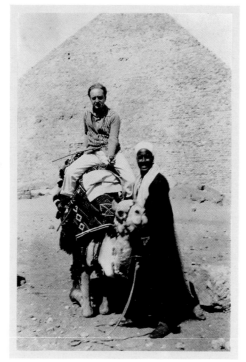

Laurence in Egypt

to have made into suits, while Peggy scoured the bazaars for extravagant earrings. They descended the Nile, explored the Valley of the Kings, and then pushed on to Jerusalem. Coming home, Laurence smuggled four hundred Turkish cigarettes through customs in a disemboweled rag doll.

Upon their return to Paris, they rented a Proustian apartment on the Boulevard Saint-Germain, and to the owner's dismay cleared out the Louis XVI furniture and redecorated in rustic French style. There they gave lavish bohemian parties and became one of Paris's most stylish couples. Laurence loved extravagant clothes and he urged Peggy to buy a gold lamé evening gown by the fashionable designer Paul Poiret. Its top was entirely covered

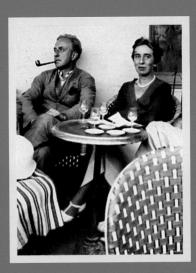

Clotilde during her short career as
an actress in Milan

Laurence and his adored sister
on a café terrace in Capri, 1923

The cover of Peggy and Laurence's
guest book, illustrated by Laurence

The Lutétia Hotel where Peggy and Laurence lived in the early years of their marriage

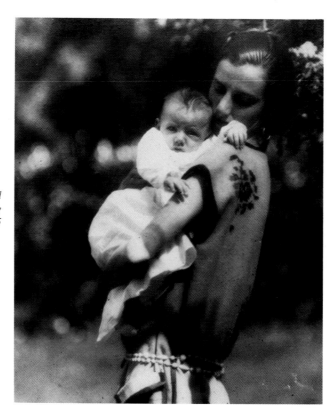

*P*eggy and her son Sindbad
photographed by Man Ray
in Paris, 1925

with glass beads and she wore it with a Ballet Russe-style turban made by Stravinsky's fiancée, Vera Sudeikin. For himself, Laurence preferred sandals rather than shoes and had his shirts made from exotic curtain material from Liberty's in London. His blue velvet trousers came from the Toulon market and his collection of ties was astonishing. Laurence was at his best at parties. He would stroll about with a glass of champagne in one hand, gesticulating theatrically with the other before a mesmerized audience. Peggy, who did not drink at the time, was often bored and wandered from room to room keeping an eye on the silver, as most of the guests were casual acquaintances whom Laurence had picked up in bars or cafés. In spite of her initial hesitations about Laurence, Peggy's mother was delighted with these bohemian evenings at the Vails. Her daughters were finally all married and she no longer had to worry about her husband's infidelities, so she was free to enjoy life. However, this did not prevent her from referring to any woman who took a lover as N.G. (no good).

The frenetic activities of an entire generation in search of new sensations gave Peggy the feeling of belonging to a circle of lost souls in search of truth. The eccentric behavior of her thrill-seeking contemporaries gave Peggy the courage to rebel against the rigid precepts of her upbringing and she entirely shared Laurence's contempt for convention. Their friend Mary Reynolds had embarked on a dissolute lifestyle. One evening, after

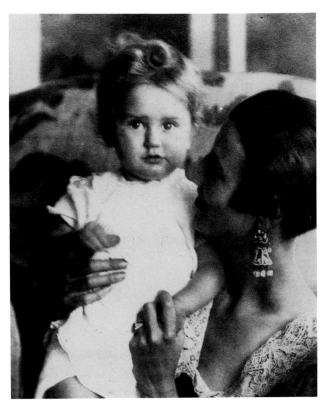

*One-year-old Pegeen
photographed with her mother
by Berenice Abbott*

losing her key, she went home with Marcel Duchamp. The next morning, she came over to borrow cab fare from Peggy because she did not dare ask Duchamp to loan her ten francs, since he disapproved of her wild evenings at the Bœuf sur le Toit. Peggy was fascinated by their relationship, which seemed to come straight out of a Flaubert novel. She described Duchamp as, "a handsome Norman who looked like a crusader. . . . Mary was really much too beautiful for him, but in the end she managed to get him anyhow. It took years, but that probably made it more exciting."[10]

Soon after their wedding, Peggy discovered that Laurence's good looks and eloquence were accompanied by a volcanic temper. Constant disputes clouded their marriage. Like a Shakespearian actor, Laurence liked big scenes played out in public. When Peggy bobbed her hair in keeping with the style of the times, Laurence threw furniture and objets d'art out of the window, clutching his wife's hair to his heart. On another occasion, after Laurence hurled wine bottles over the heads of four French Army officers in a café, he was immediately hauled off to jail. While Peggy wandered around Paris with Marcel Duchamp wondering if this were the right moment to begin an affair, Clotilde was able to have the charges against Laurence dropped. Conveniently, one of the officers had fallen in love with Clotilde and they were soon married.

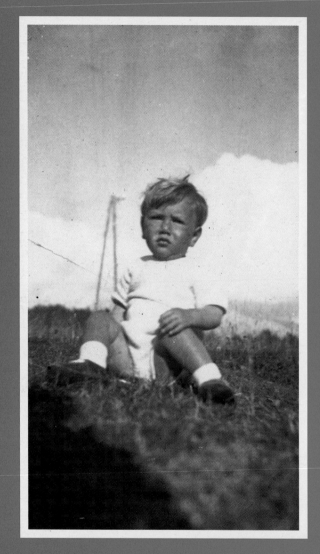

Sindbad and Pegeen at Pramousquier in 1928

Laurence and Sindbad

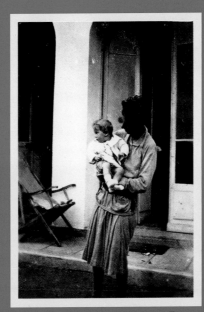

Peggy and Pegeen

Sindbad and Peggy

Peggy, Sindbad, and the family dog

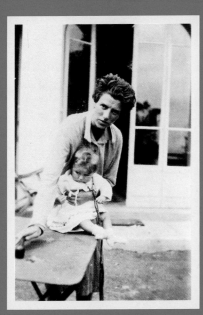

Peggy and Pegeen

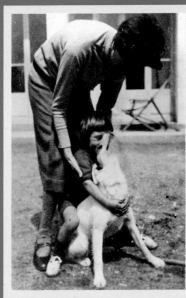

Returning from Venice in the spring of 1924, Peggy found Paris in a state of great excitement. Count Étienne de Beaumont was organizing Les Soirées de Paris. He rented the celebrated Montmartre music hall La Cigale and hired the most gifted artists in the capital to write ballets and design the sets. Stravinsky and the Group of Six were to compose the music, Toumanova and Massine were to dance. Picasso, Ernst, Picabia, De Chirico, and Miró were in charge of sets and costumes. With their friends, the Vails attended most of the performances.

At the beginning of the summer, Peggy and Laurence, accompanied by Laurence's mother, Clotilde, Sindbad, and his nurse, went to the Austrian Tyrol before going on to St. Moritz, where they met Benita and her husband. As summer gave way to autumn they dropped Clotilde off in Milan, where she was to sing with an Italian opera company. Peggy and Laurence continued on to Venice, where they were joined by Mary Reynolds. The couple spent three months in Venice. One of Laurence's friends, a forger of Italian masterpieces, helped them to buy splendid period furniture for their future home. Driven out of Venice by the December rains, they went to Rapallo where Ezra Pound was living. They discovered that he was a fine tennis player but "crowed like a rooster whenever he made a good stroke."[11]

In January 1925, while driving through the Côte d'Azur on their way back to Paris, the couple fell in love with a town called Le Canadel between St. Raphael and Toulon. They immediately began house hunting. In nearby Pramousquier they heard that La Croix Fleurie, an inn where Cocteau had spent winters with his lover and protégé Raymond Radiguet, was up for sale and they bought it on the spot. It was in an isolated

Peggy and Sindbad

Laurence and Sindbad

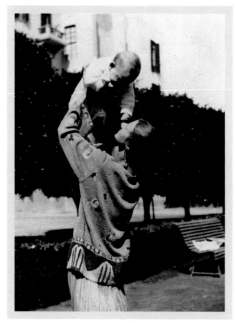
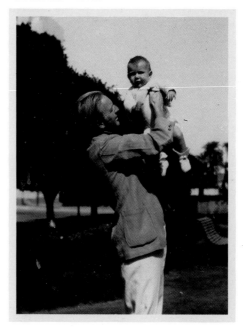

location without telephone or electricity, but the abundant sun, the pine trees, and the secluded beach more than made up for the lack of modern comforts.

In the spring, now expecting her second child, Peggy sailed for New York with Laurence and Sindbad, who, dressed in a sailor suit, was a great success with the other passengers. Peggy, anxious to help her struggling friends who were trying to make it as artists, had taken with her some of Mina Loy's collages of flower cut-outs in Louis Philippe frames—bought in the Paris flea markets—which Laurence had dubbed Jaded Blossoms. She made the rounds of the New York shops with the pictures perched on her bulging belly until she managed to persuade several Madison Avenue galleries to sell them for a one-third commission.

The family returned to Europe, and on 18 August 1926 a daughter was born at Ouchy in Switzerland. They called her Pegeen Jezebel, the first name for everyday use and the second for fertility. A modern father, Laurence was present at the birth. The Vails soon settled into their new home at Pramousquier, where they relaxed and received visits from neighbors like André Masson and their many friends from Paris. Mina Loy came with her two daughters and painted a fresco depicting lobsters with umbrellas attached to their tails. Isadora Duncan, a vision in purple and rose, arrived in a little Bugatti, the car in which she would lose her life. She nicknamed Peggy "Guggie Peggleheim" and advised her to "never use the word wife."[12]

Under the attentive eyes of Chuto, the pet pig, Laurence played bowls with Joseph the gardener. Between dips in the sea and the perusal of her favorite authors, Peggy did her accounts. Much to Laurence's annoyance, she spent hours adding and subtracting every cent, less out of parsimony than from an intense fascination with the symbolic value of

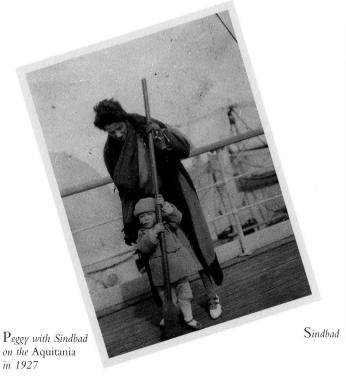

Peggy with Sindbad on the Aquitania *in 1927*

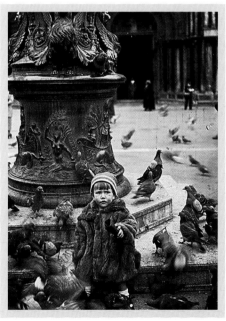

Sindbad

numbers. Between Peggy's American trust fund and Laurence's allowance from his mother money was not a problem; compared to their artist friends, the Vails were clearly rich.

They wintered at the Lutétia Hotel in Paris and returned to Pramousquier at the first signs of spring. Laurence would drive them down south at breakneck speed in the Hispano. During the winter, Laurence finished his novel *Murder! Murder!*, which Robert McAlmon judged "barmy but wittily amusing."[13] Though she found it extremely funny, Peggy was offended by some of the references to her. Laurence was so angry at her criticism that he burned the manuscript in his studio stove, a spectacular but empty gesture, since he had kept a copy. The final version was published in 1932.

Around this time Peggy struck up a friendship with Man Ray's assistant Berenice Abbott. Peggy gave Abbott five thousand francs to buy her first camera and Abbott thanked her by making a series of extraordinary portraits of Peggy and her children at Pramousquier. Peggy also undertook a new activity. In 1926 Mina Loy suggested that they open a gallery–shop on the Rue de Colisée, just off the Champs-Elysées. They planned to sell Mina's creations and exhibit the works of young artists. Peggy kept the shop while Mina and her daughter, Joella, created intricately decorated lamp shades and glass novelties, and Clotilde painted velvet slippers by hand. Laurence hung realistic canvases such as *Women and Children,* which showed female factory workers breast-feeding their babies under the eyes of cigar-smoking bosses. The lamp shade gallery foundered after a falling out between the two women.

In the summer of 1927, Peggy mistakenly opened a telegram addressed to Laurence, which bluntly informed her that her beloved sister Benita had died in childbirth. The news sent Peggy into a state of shock and, to make matters worse, Laurence, instead of helping her, was jealous of her sorrow. In fact, she noted, her grief, "so much deranged him that he made dreadful scenes. After that I never felt the same toward him again and I blamed him for having separated me from Benita for all those years. The following year as a result of all this was an unusually stormy one and finally broke up my marriage."[14] Later in Paris broken-hearted Peggy was unable to restrain her laughter when a fortune-teller predicted that she would soon meet the man of her life.

The following winter, Peggy's good friend Eleanor (Fitzi) Fitzgerald introduced her to the celebrated anarchist Emma Goldman. Peggy got on so well with Emma that she offered her a small cottage, the "Bon Esprit," in St. Tropez. During the summer of 1928, encouraged by Peggy, who had organized a fund to support her, Goldman began to write *Living my Life.* However, the two women eventually fell out, and in revenge, Emma made no reference to Peggy in her memoirs.

A more lasting friendship was formed between Peggy and Emma's secretary, Emily Coleman, an eccentric and turbulent young American. She was extremely attractive in a boyish way and was fond of flaunting her romantic conquests. Emily's latest love interest was an Englishman named John Holms, who was staying in St. Tropez with his long-time companion Dorothy. He was very tall and well built, with a fine head of auburn hair. Like all Englishmen, he was proud of his forebears and adored his Irish mother, though he detested his father, who had been Governor General of India. He was extremely strong

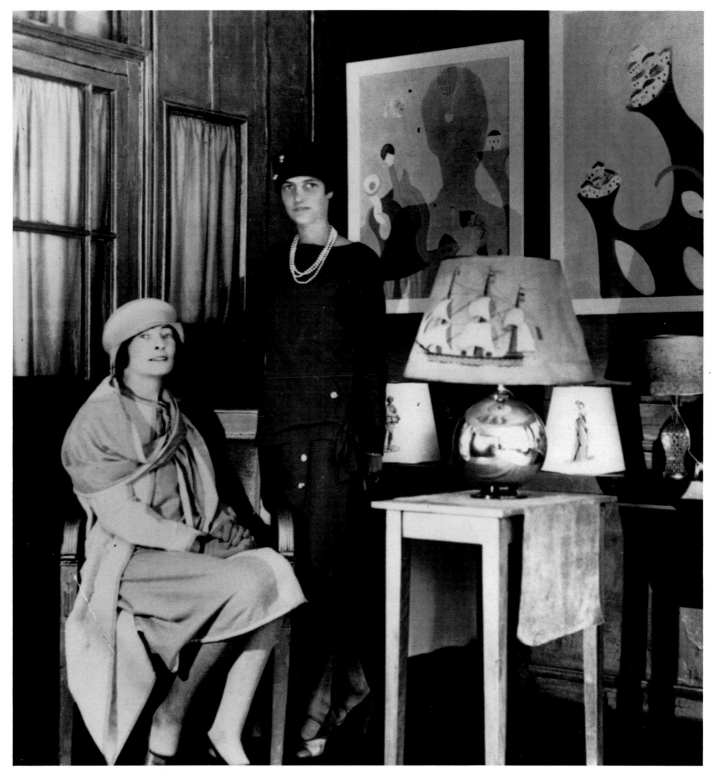

Peggy with her friend Mina Loy in their boutique–gallery, Rue du Colisée, 1926

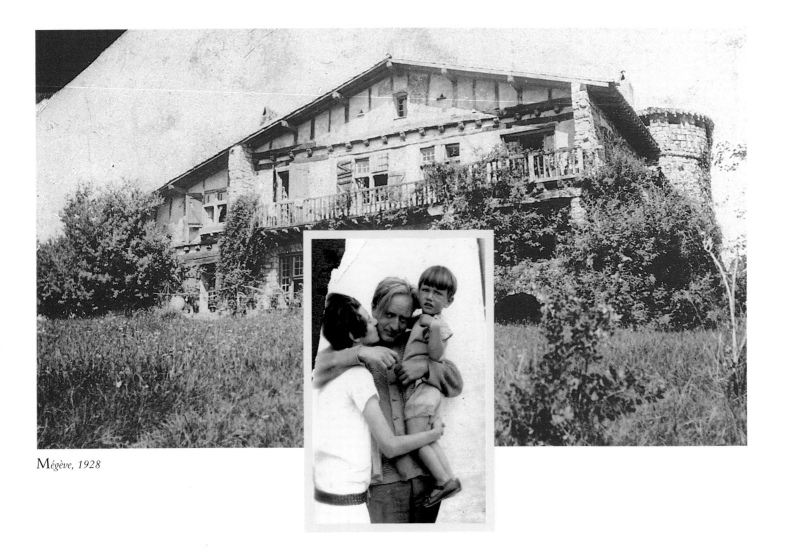

Mégève, 1928

and during the First World War had surprised four Germans having breakfast under a tree and beaten them to death. To his great shame he was awarded the military cross for this exploit.

Peggy met John on the first anniversary of Benita's death. Drowning her grief with wine during a dinner at St. Tropez, Peggy's sorrow turned to madness and she jumped up on the table and began to dance. Holms escorted her outside and kissed her. Soon afterwards she invited John and Dorothy to stay in the guest cottage at Pramousquier. The violent scenes between her and Laurence were becoming more and more frequent and in her heart of hearts she had already decided to leave him. Holms's kiss was to trigger her departure.

The situation was both tragic and comic. As soon as Laurence went to his studio to work, Peggy hastened to John. He saw Peggy as someone exceptionally promising and

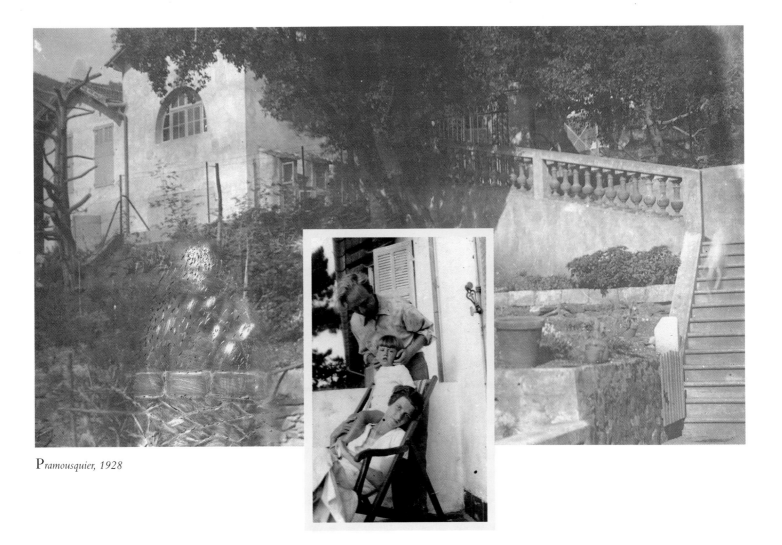

Pramousquier, 1928

himself as her Pygmalion. Peggy was ready to leave her husband and the waiting period became intolerable until she forced the issue. Knowing that Laurence was following her, she went one evening to rejoin Holms. A Homeric fight ensued, which was finally broken up, *in extremis*, by the gardener. John and Dorothy fled, scrambling over the fence in the dark, and sought refuge in Madame Octabon's bistro. The next day they left for Avignon.

Peggy soon found an excuse to join them. In tears, she kissed Laurence good-bye. Realizing that he suspected nothing, her sobs redoubled. After a long night of discussion in Fréjus with Peggy, Emma Goldman sent a letter to Laurence to explain the whole situation and incite him to magnanimity, but her efforts produced the opposite effect. Laurence, between fury and despair, even threatened to do away with his rival. But for Peggy, despite her regret at throwing away her pretty diamond wedding ring, a new life was about to begin.

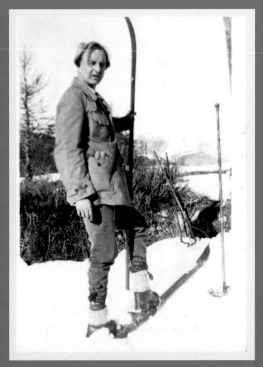

Laurence at Mégève, 1928

Peggy, Clotilde, and Pegeen

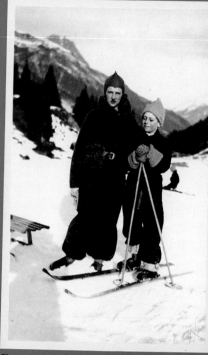

Peggy and Sindbad

The Hispano that Laurence drove "as if the furies were in pursuit of him."

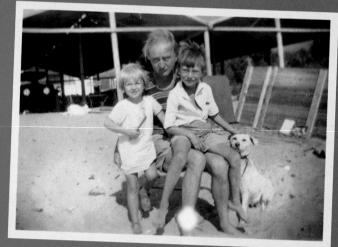

Laurence, Pegeen, and Sindbad

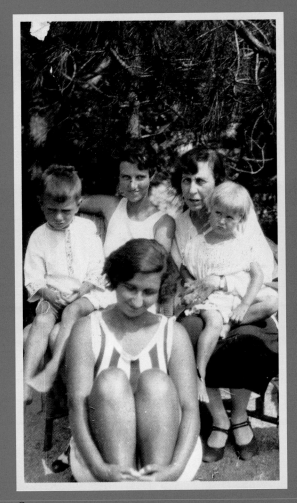

Sindbad, Peggy, Florette, Pegeen, and Doris, the kindly nurse

Peggy and Sindbad

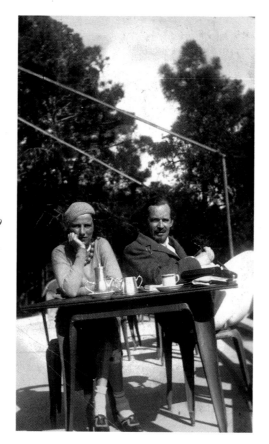

John Holms and Peggy in 1929

A Comedy of Manors

A fine and persistent drizzle streaked the windows beneath an overcast sky. The only source of light in the dark and sodden countryside filtered from the windows of an isolated manor house. Through these windows, an outsider might have observed in the great hall a giant of a man with auburn hair stoking the huge fireplace. He was the only male present. His eyes on the flames he quoted John Donne in a bass voice: "And while our souls negotiate there, we like sepulchral statues lay." He had an audience of three women—a blonde, a brunette, and a redhead, who lent half an ear as they lolled on crimson sofas. Peggy, the brunette was proposing the Truth Game. Red-haired Djuna was declaiming that, for her, Emily Brontë was like "God, Shakespeare, and the Bible,"[1] while Emily, the blonde, was splitting her sides at John's latest wisecrack. It was a typical evening at Hayford Hall.

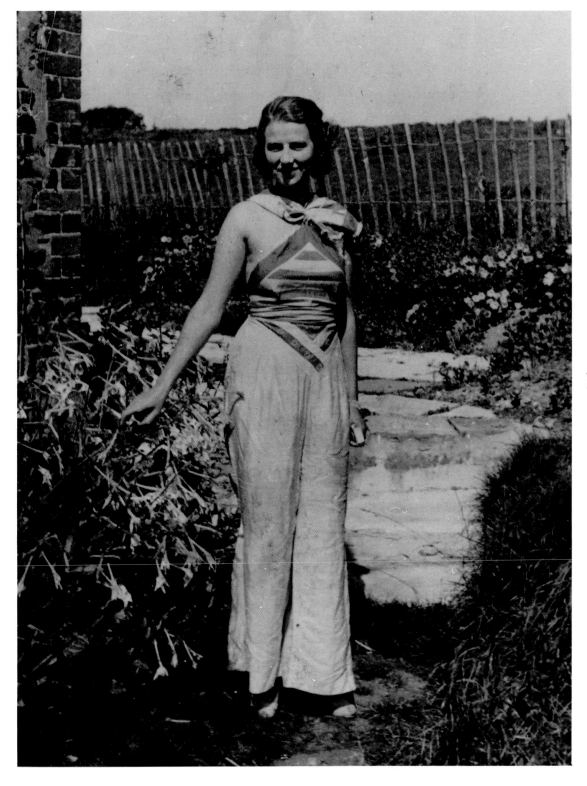

"I never knew that anyone like John existed," Peggy wrote

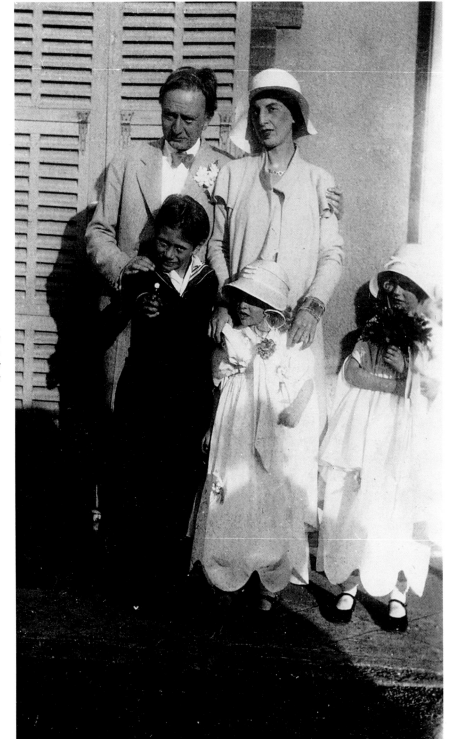

*Laurence and Kay's
wedding with Sindbad,
Pegeen, and Bobby
at Saint-Tropez*

*Laurence, Sindbad, Pegeen,
Bobby, and Apple*

*Peggy and her children
on the beach at Saint-Tropez*

Upon her arrival in Avignon, Peggy immediately consulted her lawyer to draw up a divorce settlement. Peggy was made guardian of Pegeen, while Sindbad was to live with his father. Peggy and John spent most of the next two years exploring Europe by car, eventually traveling through more than twenty countries. Peggy disliked the Nordic countries, which she found beautiful, but too cold and menacing. However, her greatest disappointment in their travels would come later when they visited her beloved city of Venice. John was so unhappy there that they cut their stay short. At first, their relationship was essentially physical, "He loved me because to him I was a real woman." Peggy noted, "I refused to listen to him talk, and he was delighted that I loved him as a man."[2] Despite his phenomenal erudition and great intelligence, John was unable to realize his dearest wish: to write, though his sole ambition was to be a writer. However, when he was not reading, he spent his time in brilliant conversation, and Peggy remarked, "Drink made him talk, and he talked like Socrates."[3] Gradually, he began to exercise a profound influence on all of Peggy's thoughts and actions.

Peggy, Pegeen, and Sindbad at Hayford Hall

The repercussions of the 1929 stock market crash had forced a large part of the American expatriate community to return home and the golden days of Montparnasse were coming to an end. Peggy and John, however, remained, settling during the autumn of 1930 in the outskirts of Paris on Avenue Reille near the Porte d'Orléans. Their house was a sort of "mini-skyscraper" with only a room or two on each of its five floors, which had been built by Georges Braque. Amédée Ozenfant's painting school was next door and they were soon renewing their ties with old friends, including Helen Fleischman, who was about to marry Giorgio Joyce. The Joyce clan would often visit Peggy and John. Giorgio, who had a good bass voice, would sing duets with his father, a tenor. His sister Lucia, who was studying dance at the time, was usually with them. James and John held long conversations but never about literature, which Joyce hated to discuss. A favorite subject was Trieste, where they both had lived, and they exchanged stories about the dreaded Bora. When this ferocious wind is blowing at full force, rope handrails have to be set up in the main streets to prevent people from being blown off their feet.

"John was a wonderful athlete." Here caught rock climbing between Sindbad and Pegeen

In the meantime, Dorothy finally decided to return to England, but insisted that John marry her first to save her reputation. John, who was weak-willed, but a true gentleman, agreed. When Peggy's mother arrived for a visit from America and discovered Peggy's liaison, she disapproved. Peggy tried to defend John by reciting his family tree, but the only note Florette made in her little book was "Governor of India."

Meanwhile, Laurence had met his new love, Kay Boyle, in December 1928 at the Coupole. Soon after their meeting, Kay and Laurence were inseparable and by the spring of 1929 they were living together. A talented writer and journalist, Kay Boyle supported important causes and encouraged Laurence to work. He translated Charles-Louis Philippe's celebrated _Bubu de Montparnasse,_ while Kay translated Radiguet's _Le Diable au Corps (Devil in the Flesh)_ and began selling short stories to American magazines. Despite the income from these activities, the monthly checks that arrived from Peggy were very welcome, though they created tension between the two women. In addition to Kay's

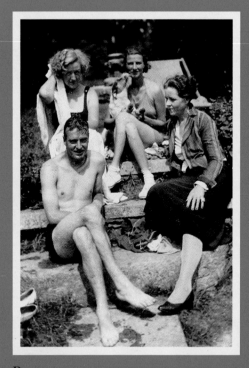

Emily Coleman was a skilled rider

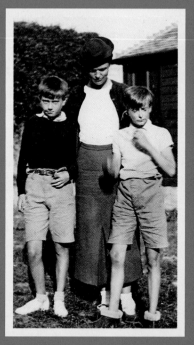

Peggy with, to her left, the novelist Antonia White and Tom Hopkinson, and to her right, Djuna Barnes, Hayford Hall, 1933

Emily Coleman between Sindbad and her son Johnny

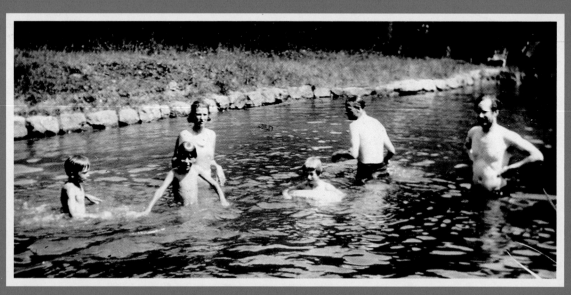

Sindbad, Johnny, Peggy, John, and Tom Hopkinson: "Our life at Hayford Hall was completely cut off from the world."

daughter Bobby, Kay and Laurence would have three daughters, Apple, Kathe, and Clover. Though Kay was an excellent stepmother, Peggy was unhappy to see so little of Sindbad. The situation between the two couples gradually improved, however, and soon Peggy was able to see her son every Thursday. When Laurence and Kay were married at St. Tropez in April of 1932, Peggy and John were among the guests.

Life at Avenue Reille was fairly calm. John would get up late and read all day. In the evening the couple made the rounds of the Montmartre nightclubs and Montparnasse cafés, often meeting up with Peggy's cousin, Harold Loeb and Jean Gorman, whose husband was writing Joyce's authorized biography. Peggy and John visited the Gormans regularly. Jean must have complained to Joyce about all these late nights because one day she came with a poem he had written:

> _To Mrs. Herbert Gorman who complains that her visitors kept late hours:_
> _Go ca'canny with the cognac and of the wine flight shy_
> _Keep a watch upon the hourglass but leave the beaker dry_
> _Guest friendliness to callers is your surest thief of time_
> _They're so much at Holms when with you, they can't dream of Guggenheim._[4]

Three years were spent in the house on Avenue Reille. In fine weather John got out the Delage and took Peggy, Sindbad, Pegeen, and often Emily Coleman, to the South of France or Italy. The children adored John. He was attentive to them and as a first-class athlete, he was able to join in their games. John's close friend Edwin Muir, a poet and translator of Kafka, described John's physical and mental prowess: "Holms gave me a greater feeling of genius than any other man I have met. . . . There was a strange contrast between his instinctive certainty and grace as a physical being, and the painful creaking of his will. In his movements he was like a powerful cat: he loved to climb trees or anything that could be climbed . . . His body seemed fit for every enjoyment, and his will for every suffering.[5]

John's French was less than fluent and in Paris he was often obliged to forgo the pleasures of conversation on which he thrived. One day he announced that he wanted to spend the summer in England since he had not been back for years. To please him, Peggy rented a manor house in Devonshire, where they passed the summers of 1932 and 1933.

Hayford Hall was a large Victorian structure in the dramatic landscape bordering Dartmoor. There were eleven bedrooms, but the nexus of the house was a huge hall where everyone gathered by the fireplace after dinner. John held his audience in thrall and often talked until dawn. "I am sure so much conversation was never made in this hall before or since," affirmed Peggy.[6] Here time stood still. Friends visited frequently, including Chekhov's disciple William Gerhardie, who had recently published _The Polyglots;_ Wyn Henderson, who was to play an important role in Peggy's life; the novelist Antonia White, author of the best seller _Frost in May;_ and Edwin and Willa Muir. Djuna Barnes, who was in the midst of writing _Nightwood,_ and Emily Coleman with her son Johnny, who was Sindbad's age, were permanent residents.

Djuna spent the whole day indoors, only slipping out briefly to the rose garden to bring Peggy a flower. She was very distressed by her recent break up with Thelma Wood and her nerves were further strained by Emily Coleman, who threatened to burn her manuscript if she betrayed a certain confidence. Because of her extravagant manner of dress and bright-red lips, she had been assigned a rococo-style bedroom. Fully made up and wearing a beautiful French negligee, she wrote propped up in bed while guarding her manuscript, claiming that she had no clothes suitable for country wear.

Peggy and Djuna's relationship at this point was highly ambivalent. Djuna was jealous of Peggy's wealth and never stopped telling her that, in her place, she would make better use of the money. They both agreed, however, that one's wealth should be shared with artists. They were also united in persecuting poor Emily whose favorite pastime was the Truth Game. This was a merciless sport, dear to the surrealists, to which the denizens of Hangover Hall (as Antonia White's daughter, Susan Chitty, had renamed the manor), frequently dedicated the small hours of the night. Each player would fill out an anonymous questionnaire regarding a specific participant. Then the sheets were read out loud, usually by Djuna. It was often Emily who was the most abused. One night, when everyone else was in bed, Djuna found her piecing together the torn scraps of paper she had rescued from the waste paper basket, muttering "Garter see who gave me a zero for sex appeal."[7]

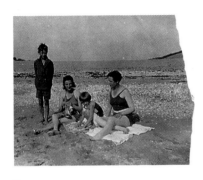

Sindbad, Peggy, Pegeen, and Djuna at the beach

This intimate cohabitation created an atmosphere that was lively, stimulating, explosive, and envenomed. Djuna was critical of everyone all the time. Of Emily, because she spent her time interviewing John like an investigative journalist; of John, because his indulgence and flawless erudition irritated her. The sources of friction were multiple and reciprocal. John prescribed the Truth Game as a treatment for Djuna's intellectual dishonesty. When Emily complained that Peggy had lost her soul, Djuna told Peggy, "Dear you are so saving you will find it again."[8] Peggy complained of Barnes's ego and Emily's superficiality, while Emily and Djuna criticized each other ferociously. Each tried to provoke the other with cruelty. Djuna claimed that debates concerning literature were above all interesting to those who were unable to write. Peggy would then join in to apply this statement to her dear John, who suffered more and more from his terrible handicap.[9] Yet, while she enjoyed the breath of fresh air that blew in with the "outside" visitors, she found that they "really had a better time when we were alone with our foursome, even if we fought and it all got intense. We somehow spurred each other on."[10]

The great hall, "the holy of holies" was forbidden to the children, but Sindbad, Pegeen and Johnny had plenty of daytime pastimes in which John was a frequent participant. There were lily ponds to swim in, tennis courts for hotly contested tournaments, and horses and ponies for riding. Sindbad had fallen in love with Marlene Dietrich and wrote her a long letter, asking for a photograph and telling her that he liked "beer and skiing." He concluded with "I hate Greta Garbo. Don't you?"[11]

John and Peggy made a trip to London in March 1933. John wanted to help Djuna get her novel *Ryder* published in England. He had arranged a meeting at a pub, the Chandos, with an old friend, Douglas Garman, who was working with an avant-garde

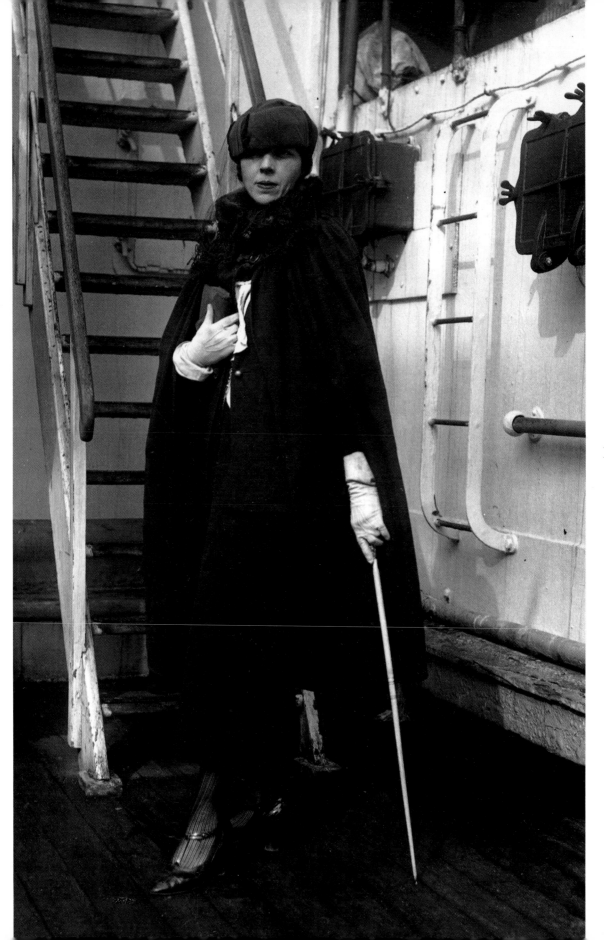

Djuna Barnes

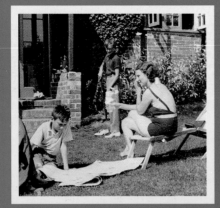

Peggy, Sindbad, and Johnny

Pegeen and Debbie Garman

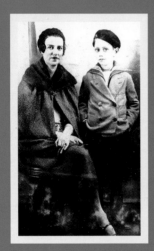

Peggy and Sindbad

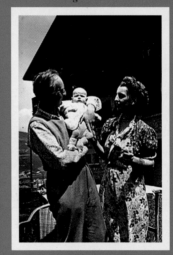

Laurence and Kay at Mégève

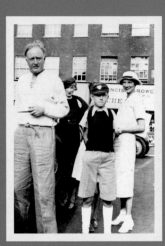

Laurence, Sindbad, Peggy, and Kay in 1936

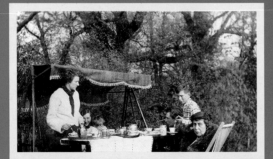

Peggy, Douglas, Florette, and Sindbad

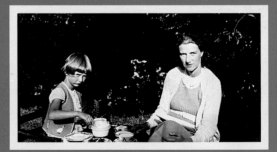

Pegeen and Peggy

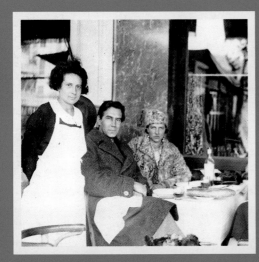

Douglas and Peggy in 1935

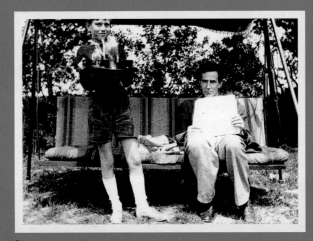

Johnny and Douglas reading Worker

Johnny, Pegeen, and Douglas

Emily Coleman

The handsome Douglas Garman

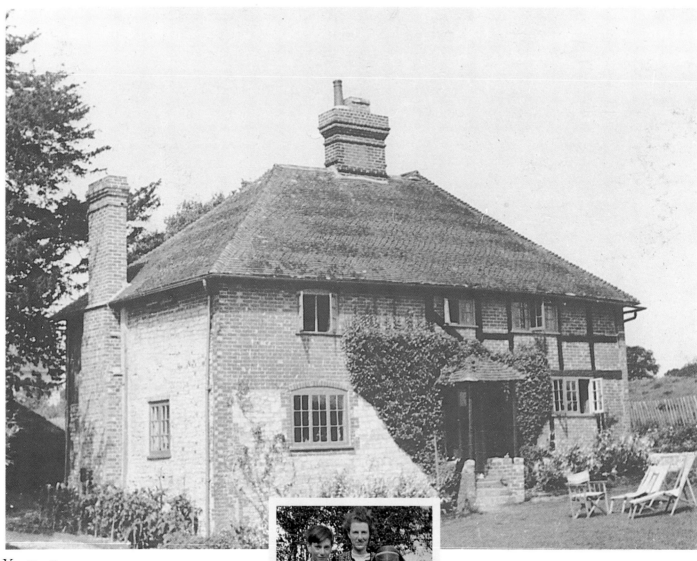

Yew Tree Cottage

Peggy between
Sindbad and Pegeen

74

publishing house owned by his brother-in-law, Ernest Wishart. Douglas and Peggy were instantly attracted to each other. Garman never published *Ryder* but he invited himself to their Paris home for the Easter holidays and Emily warned her that she risked losing John for a whim.

On a rainy August day at Hayford Hall, when all the riding paths had turned to mud, John was thrown from his horse and broke his wrist. The wrist was badly set and caused him terrible pain. Surgery was scheduled for January 1934. To bolster his courage he drank more than usual the day before and awoke with a severe hangover. John's heart stopped during the operation; he never came out of the anesthesia. An inquest determined that his organs were deteriorated from alcohol abuse, but Peggy was crippled with guilt for not having postponed the operation. Djuna, who adored John, and had recently lost Thelma, was doubly supportive during this period of despair.

Peggy and Djuna had forged secret and ambiguous bonds, and despite frequent quarrels, these ties never weakened. As Peggy wrote to Emily Coleman, "Djuna has written one beautiful book, for which I personally am . . . under eternal obligation to support her no matter how much destruction my $150 brings to her. . . ."[12] *Nightwood*, written and revised at Hayford Hall, was dedicated to John and Peggy. T.S. Eliot wrote the preface, and Emily Coleman would be one of its most ardent defenders. When it appeared in 1936, the book was a success, but caused a scandal due to its theme of Sapphic love, based on Djuna's affair with Thelma Wood. Critics lost no time in identifying one of the novel's protagonists, Jenny Petherbridge, a rich American widow, with Peggy, despite denials by Peggy and Djuna. Djuna later wrote to Peggy recommending that she never evoke this period of their lives in front of journalists.

The fervent friendship of Peggy Waldman helped Peggy to surmount the first days of grief. When Waldman had to return to her children, Emily was sent for. All animosity between them disappeared as they mourned John together. Peggy told Emily, "Now that John is dead, we are running into eternal danger."[13] Alone, every morning, Peggy scrutinized her mirror searching for her soul, which she feared she had lost. John's many close friends visited or wrote letters of condolence. When Peggy deciphered the name of Douglas Garman among them, her feelings were mixed. She had completely forgotten him and at the moment all her thoughts were for John. Still, as the days went by, "I began to think about him again, and by degrees I realized that I would use him to save me from my misery."[14]

Less than two months later she was involved in a passionate, guilt-ridden relationship with Garman. The first time he took her in his arms she burst into tears. This prompted him to write her a poem which began: "Doubting I lay, but you too brought / Tears from a world I had not shared."[15] After several months of hiding their affair, the couple moved to the English countryside. Perhaps in an attempt to recreate her life with John, Peggy rented Warblington Castle. Garman, who was finishing a book, visited with his daughter, Debbie (who was the same age as Pegeen). The Colemans, and Emily's friend, Phyllis Jones settled in for the summer.

Far from being consoled, Peggy wept frequently in public and thought that Garman deserved something better. His first marriage had been less than happy. Although he came from a bourgeois family—his father was a doctor in Birmingham and his mother was said to be an illegitimate daughter of the British Prime Minister Earl Grey—he was a revolutionary at heart. He had taken his wife to Russia after the revolution and had become enamored of a Bolshevik woman. Upon his return, his wife left him and he fell ill. He went to recuperate on his brother's ranch in Brazil, before returning to England to work in publishing.

Yew Tree Cottage, where Peggy moved with Garman in the autumn, was named for the five-hundred-year-old tree whose branches brushed the roof. Garman had a green thumb and spent hours trying to introduce new species to the garden, before joining Peggy for long walks in the downs. The surrounding countryside was unspoiled; pheasants and rabbits were abundant and frequent victims of their neighbors' guns.

In September it became cold and rainy. While Peggy shivered in bed, turning the pages of Proust with fur-gloved hands, Garman read *Das Kapital* and edited a new avant-garde review. They had few guests and Peggy grew increasingly depressed. Peggy

A *moment of repose in the sun*

confessed to Emily that she was living like a recluse and that she was on the edge of a nervous breakdown.

Like so many writers of the 1930s, Garman began to devote more and more time to Karl Marx. He finally became a Communist party member and told Peggy that she should contribute her capitalist fortune to "the cause." From then on he only invited Communists to their home. Other than party members, only Djuna and Emily visited them. When Douglas and Peggy quarreled, he would employ the worst insult in his vocabulary and accuse Peggy of being a Trotskyite. In the spring of 1936 there was a major surrealist exhibition at Burlington House in London and Garman wanted to attend. Peggy and Djuna laughed at him, saying that they had had their fill of surrealism in the 1920s.

The house was so cold that Pegeen and Debbie were always coming down with colds or the flu and Peggy spent much of her time nursing them. She ordered countless sheepskin rugs to insulate the damp cottage. Another winter went by in the mud and the rain while Peggy reread *Anna Karenina* and *Wuthering Heights*. Time passed and dissension widened. When Garman's interest in Communism extended to affairs with young and attractive party members, Peggy began to realize that their life together was drawing to a close.

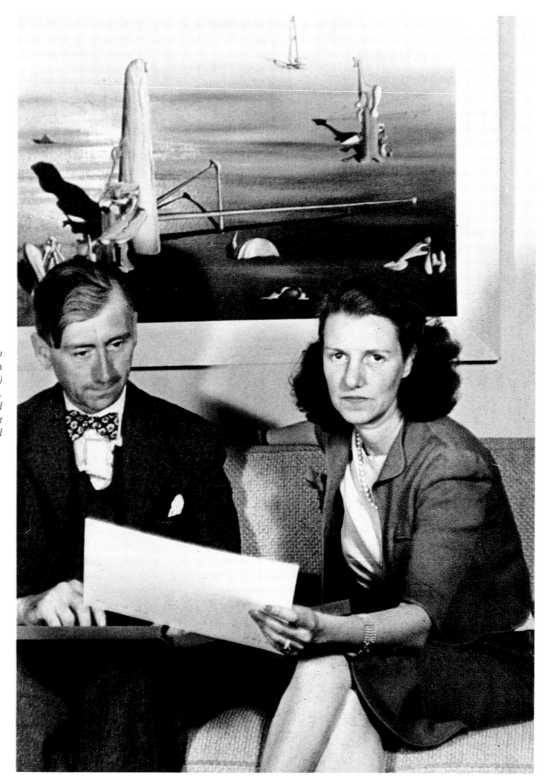

*Herbert Read and Peggy with
Le Soleil dans son écrin
(The sun in its jewel case)
by Yves Tanguy, in 1939.
Peggy asked Gisèle Freund
to include her legs and Herbert
Read's head*

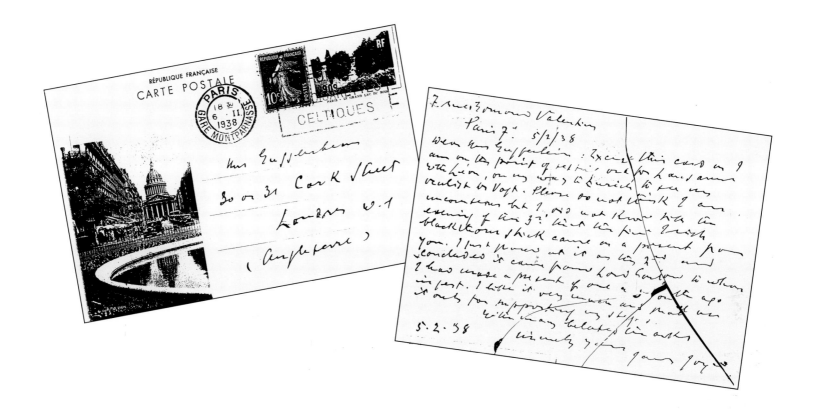

GUGGENHEIM JEUNE

In the spring of 1937, as Peggy was drifting like a lost soul in an emotional wasteland, she received a letter dated 11 May from the "genie of the lamp," Peggy Waldman. Her faithful friend advised her "to do some serious work—the art gallery, book agency—" that would allow her to help artists and writers. She added, "I think you'd be so much better off . . . if you had another active interest . . . particularly one that brought you in contact with stimulating people."

Peggy opted for the art gallery and threw all her energy into the project. To assist her, Emily Coleman brought to Yew Tree Cottage her latest conquest, Humphrey Jennings, a young surrealist painter, photographer, and poet who would achieve a lasting reputation as a film maker. The following month, Peggy, Jennings, and Garman's daughter, Debbie joined Florette at the Crillon in Paris. Peggy was devastated to learn that Florette had

Peggy Waldman, Peggy's good genie, had a smile like the Cheshire Cat in Alice's Adventures in Wonderland

six mouths to live. Peggy spent hours with her mother wandering through the International Exposition. Although she had long been acquainted with many of the artists, whom she had met in the social whirl of her years in Paris, this was her first opportunity to get an overview of modern art in an international context. Pegeen and Sindbad arrived from their home in Mégève, where they had been spending the summer with Laurence and Kay. They moved into the Crillon with Peggy and Florette, who cherished these last days with her daughter and grandchildren. She would die in New York in November, before Peggy was able to arrive at her bedside.

Peggy introduced Jennings to Marcel Duchamp who, in turn, took her to meet André Breton in his tiny gallery named Gradiva. A week later the couple went to visit the surrealist painter Yves Tanguy to invite him to exhibit in England. Back in London Peggy broke off her association with Jennings and found a magnificent location for the gallery on the second floor of 30 Cork Street in the West End. She hired Wyn Henderson, a companion from the Hayford Hall days, to act as her secretary. A talented typographer (she would design all of the gallery's publications) redheaded Wyn was dynamic and efficient; while Peggy returned to Paris to propose a show to Brancusi, Wyn had the interior of the gallery completely redesigned. She also came up with the name Guggenheim Jeune, which was a nod to the groundbreaking Parisian gallery Bernheim Jeune that had shown Matisse and the futurists, as well as a subtle dig at Peggy's Uncle Solomon, whose own impressive collection of modern art was already well established.

Brancusi was not in Paris, but Peggy looked up her old friends Marcel Duchamp and Mary Reynolds. Although busy organizing the International Surrealist Exhibition, due to start in January 1938 (just before the opening of Guggenheim Jeune) Duchamp took time out to help Peggy. He advised her to specialize in the two main tendencies of modern art—surrealism and abstraction—and helped her build a list of what he considered to be the most important artists within these movements. Peggy confessed that her knowledge of art began with the Italian Renaissance and ended with the Impressionists. Duchamp took this in stride; he was always willing to initiate chosen neophytes into his secrets provided they had the means to apply his knowledge (He had already counseled Walter Arensberg and Katherine Dreier). Peggy described her education with Duchamp: "To begin with, he taught me the difference between Abstract and Surrealist art. Then he introduced me to all the artists. They all adored him, and I was well received wherever I went. He planned shows for me and gave me lots of advice. I have him to thank for my introduction to the modern art world."[1]

One such introduction was to Jean Cocteau, who belonged to neither of Duchamp's favored movements, but agreed to exhibit at the new gallery. To plan the show, Peggy went to see Cocteau in his hotel room on the Rue de Cambon. She found him lying in bed smoking opium. On another occasion, she took him out to dinner, and he spent the entire meal looking at himself in the mirror behind her chair, but Peggy found him "so beautiful, with his long oriental face and his exquisite hands and tapering fingers, that . . . [she did] not blame him for the delight he took in his image."[2] The exhibition was

Marcel Duchamp.
In 1937 he became
Peggy's mentor

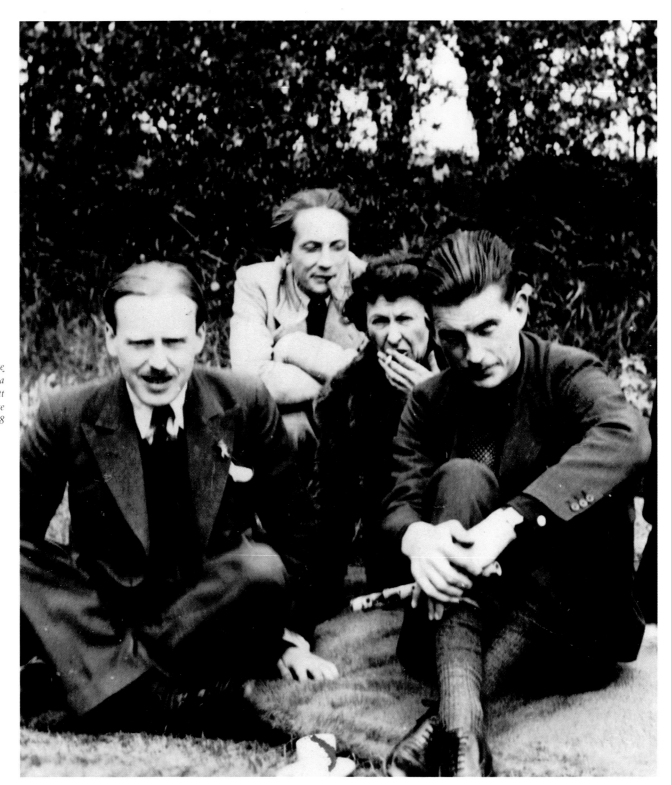

From left to right: George Reavey, Geer van Velde, a friend and Samuel Beckett at Yew Tree Cottage in 1938

to be of drawings and furniture designed by Cocteau for his play *Les Chevaliers de la Table Ronde*. He also entrusted her with some thirty drawings and a series of dinner plates expressing the same theme, as well as two linen bed sheets on which he had made ink drawings. Although Cocteau was not well enough to make the journey to London, his catalogue preface paid homage to the man who many artists regarded as their mentor: "Marcel Duchamp has prescribed the diet. We must eat, we must eat, stones, so long as they come from the finest shop in London. The time has come to give him thanks and to undo what I have done. . . . I open an exhibition. I open it like a pomegranate, for it to be eaten and for it to eat me and for the visitors to the exhibition to eat the succulent stones of vest pocket death. Ladies and Gentlemen, it is a mad thing to exhibit oneself in vain."[3]

Duchamp also took Peggy to meet Jean Arp and Sophie Taeuber-Arp at their resolutely modern house in Meudon. Arp was an Alsatian artist–poet, who had changed his name from Hans to Jean as a protest during the First World War. Peggy found Arp amusing and she adored his sculpture and appreciated his poetic sensibility. Peggy was less enthusiastic about Sophie's work, qualifying it as "dull," although she found that *Plastiques* magazine, edited by Sophie, was a worthwhile endeavor. Arp took Peggy to the foundry to see the works he had cast in bronze. *Tête et coquillage* was a case of love at first sight for Peggy, and the piece became the first purchase for her collection.

In December 1937, Peggy, aided by Duchamp, was busying herself in Paris with plans for exhibitions. She ran into Helen (Fleischman) Joyce who invited her to dinner at Fouquet's, a fashionable restaurant on the Champs-Elysées, on the day after Christmas. She was delighted to see James Joyce, who was in the midst of writing *Finnegan's Wake*. While Joyce was questioning her about the artists she was planning to show, her attention was attracted by a young man who had already been a guest at her parties on Avenue Reille. Samuel Beckett, a tall, lanky Irishman was fidgeting in his too-tight suit. Peggy could not take her eyes off this taciturn figure whose large green eyes gazed abstractedly into some void. Despite his shy appearance, his occasional barbs betrayed a lively humor and black wit. After dinner, the evening continued at Helen's home. When the time came to leave, Beckett offered to accompany Peggy back to her borrowed apartment on Rue de Lille. "He did not make his intentions clear but in an awkward way asked me to lie down on the sofa next to him," Peggy recalled. As he was leaving the following evening, she was stunned by his apparently disenchanted and nonchalant comment: "Thank you. It was nice while it lasted."[4]

The relationship would surely have ended there if she had not met him quite by accident on a traffic island on the Boulevard Montparnasse. Peggy called him Oblomov after the indolent hero of Goncharov's novel. For the first time in her life Peggy felt that she could truly express herself. While she favored old master paintings, Beckett stressed the importance of "living" modern art. He pushed her to organize shows for his two friends: Jack Yeats (the poet's brother) and Geer van Velde (brother of Bram). Peggy did later exhibit van Velde and bought several of his paintings.

James Joyce was Beckett's idol

Beckett's veneration of Joyce knew no bounds. He sought his company on every occasion, but the celebrated author of *Ulysses* was distant, his affections being reserved for his family. According to Richard Ellman, Joyce's biographer, "they engaged in conversations which consisted of silences directed towards each other, both suffused with sadness, Beckett mostly for the world, Joyce mostly for himself. Joyce sat in his habitual posture, legs crossed, toe of the upper leg under the instep of the lower; Beckett, also tall and slender, fell into the same gesture."[5] However, their calm relationship was clouded by Joyce's daughter, Lucia; she was in love with Beckett, but the feeling was not reciprocated. Beckett later confessed to Peggy that "he was dead and had no feelings that were human and that was why he had not been able to fall in love with Joyce's daughter."[6] Throughout their turbulent relationship, which lasted slightly over a year, Peggy was never to know the day or the hour of their rendezvous. Oblomov's comings and goings were totally unpredictable and she confessed to finding the suspense very exciting. Although the critics rejected it, Peggy was enchanted with the Proustian overtones of Beckett's new work, *Murphy.* Before leaving for London, Peggy asked Beckett to translate Cocteau's preface for the opening show of her gallery.

Three weeks before the opening of Guggenheim Jeune, Peggy, Duchamp, and Mary Reynolds were in London in the midst of a crisis. The British customs authorities refused to release a work by Cocteau that they were holding at Croydon. This was an embroidered sheet entitled *La Peur donnant des ailes au Courage,* depicting the French actor Jean Marais and two other figures. Despite the fig leaves that Cocteau had placed at strategic points, the British authorities were shocked by the depiction of pubic hair. Peggy, accompanied by Marcel Duchamp, rushed down to Croydon. After she swore not to show it in public, the sheet was released. The work could be viewed only in her private office and Peggy grew so fond of it that she finally bought it. She had no thoughts at this period of becoming a collector, but in order to encourage the artists she showed, she was soon buying at least one piece from each exhibition.

Guggenheim Jeune opened on 24 January 1938 and Peggy was delighted to receive a congratulatory telegram signed "Oblomov." She soon returned to Paris with Duchamp to find Beckett again and to plan future exhibitions. When Peggy saw Beckett, she asked him bluntly what his intentions were with regard to herself. He simply replied: "none."

For Joyce's fifty-sixth birthday in February 1938, Beckett scoured Paris to find the writer's favorite Swiss wine, while Peggy bought him a blackthorn walking stick. During the celebratory dinner Joyce offered a prize of a hundred francs to anyone who could guess the name of his next book. Beckett won with *Finnegan's Wake.* In the center of the table was a plaster model of Dublin, with a green ribbon representing Joyce's beloved river the Liffey. Joyce topped off the evening by dancing a jig.

The pioneering abstract painter Wassily Kandinsky was the next artist Duchamp urged Peggy to exhibit. Kandinsky was over seventy at the time but still very active and in good spirits. He was delighted by the prospect of a show in London where his paintings were little known, and he assembled a retrospective of his works from 1910 to 1937.

Poster for the International Surrealist Exhibition in 1938

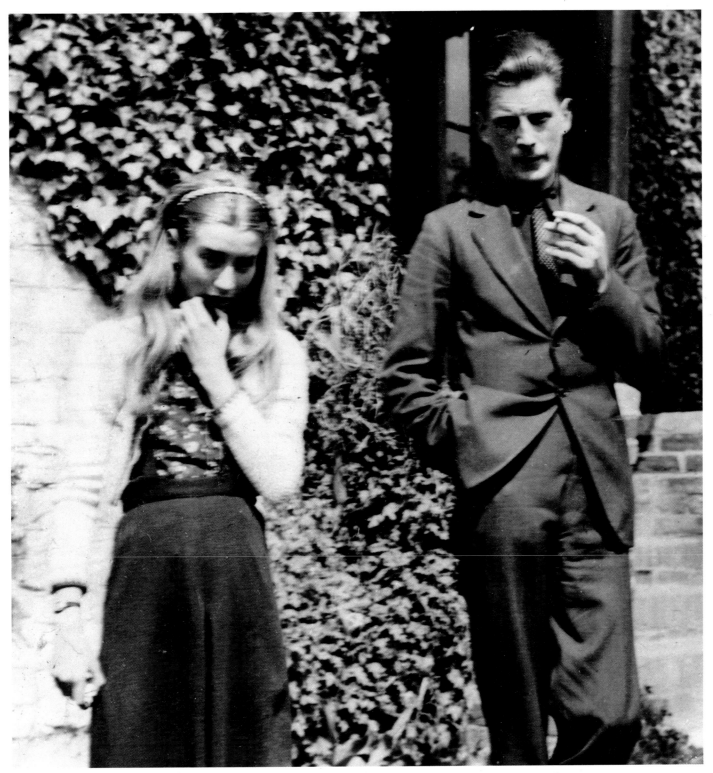

Pegeen and Beckett

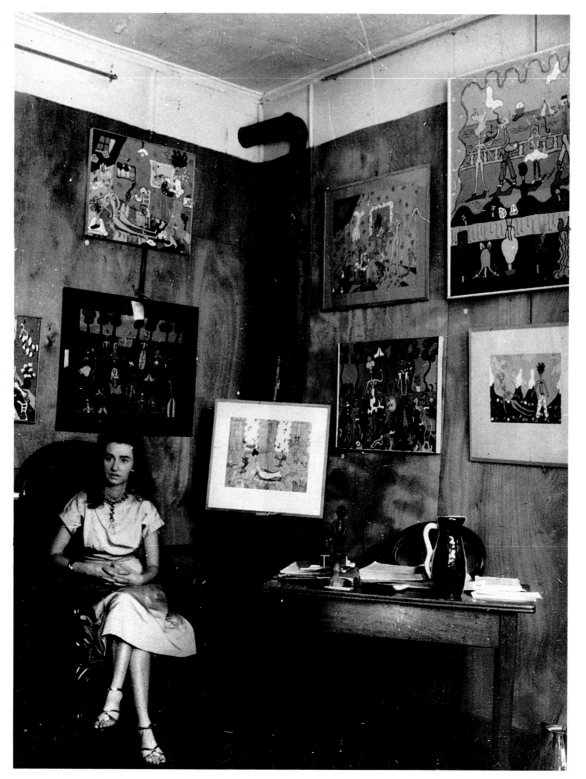

*Pegeen
in her studio*

Despite good reviews in the press, nothing was sold. Peggy bought a 1936 work, *Dominant Curb* that—to her eternal regret—she would sell during the Second World War because a friend said it was fascist. At Kandinsky's request, Peggy wrote to her Uncle Solomon in New York to suggest that he buy an early work by the artist. Peggy's uncle— who already owned over twenty paintings by Kandinsky—now preferred the work of a second-rate Kandinsky imitator, Rudolph Bauer. He nonetheless sent a friendly reply, saying that he had passed her letter on to Baroness Hilla Rebay, the curator of his collection (and his very possessive mistress). The theosophic Baroness's insulting response was to rankle Peggy for the rest of her life. She reprinted it word for word (including typos and grammatical errors) in her memoirs:

Solomon Guggenheim, Baroness Rebay, and Frank Lloyd Wright, the architect of the Solomon R. Guggenheim Museum

> *Dear Mrs. Guggenheim "jeune"*
>
> *Your request to sell us a Kandinsky picture was given to me, to answer.*
>
> *First of all we do not ever buy from any dealer, as long as great artists offer their work for sale themselves & secondly will be your gallery the last one for our foundation to use, . . . It is extremely distasteful at this moment, when the name of Guggenheim stands for an ideal in art, to see it used for commerce so as to give the wrong impression, as if this great philanthropic work was intended to be a useful boost to some small shop. . . . You will soon find you are propagating mediocrity; if not thrash. . . .*
>
> *Due to the foresight of an important man since many years collecting and protecting real art, through my work and experience, the name of Guggenheim became known for great art and it is very poor taste indeed to make use of it, of our work and fame, to cheapen it to a profit. Yours very truly, H.R.[7]*

The opening group sculpture show organized by Duchamp was resolutely international: France, Rumania, Russia, Britain, Switzerland, and the United States were all represented. Arp, who was a participant and assisted Duchamp in arranging the show, stayed with Peggy in London. She found him to be a perfect house guest, making her breakfast and washing dishes. Peggy had a delightful time until the crates that Duchamp had sent from Paris arrived at customs. British red tape once again intervened; this time in the person of James B. Manson, director of the Tate Gallery and art "expert" for the customs authorities. He quite simply refused to accord the status of "works of art" to sculptures by Constantin Brancusi, Raymond Duchamp-Villon, Antoine Pevsner, Jean and Sophie Arp, Henri Laurens, and Alexander Calder. They were thus subject to high import duties as "manufactured goods." Only Henry Moore's *Reclining Figure* escaped this fate as it was already in England. Wyn Henderson quickly alerted the most important art critics and started a petition protesting Manson's decree. The press took up the matter and the small gallery enjoyed enormous publicity. The matter was raised in the House of Commons and it was judged that Manson had gone too far. It was not long before he lost his position, causing Peggy to boast that she had thus "rendered a great service to foreign artists and to England."[8] The following exhibition, presented in May 1938, was of works by

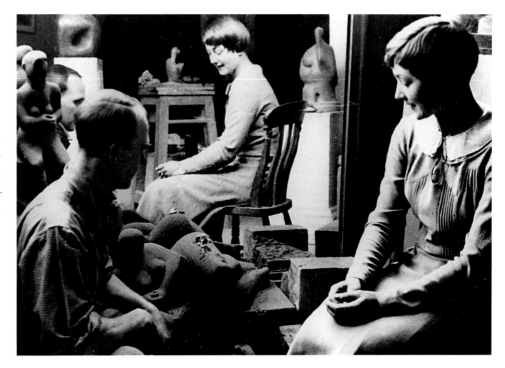

*Henry Moore with his wife
Irina at his Parkhill Row
studio in London, during
the Guggenheim Jeune
Exhibition of
Contemporary Sculpture*

Beckett's friend Geer van Velde. It had little success, but to spare Beckett's feelings, Peggy, using a variety of pseudonyms, bought nearly everything in the show.

Within a few months, Roland Penrose, a poet and patron of the surrealist movement, opened the London Gallery in the same building as Guggenheim Jeune. The Belgian surrealist poet, E.L.T. Mesens, administered it with panache and commercial flair. Peggy enjoyed a good relationship with Mesens; they shared a window on the street and took care to coordinate their shows. The London Gallery soon became the meeting place for surrealists in London and the *London Bulletin*, edited by Penrose and Mesens, was their voice. Poems and essays by André Breton, Paul Eluard, Herbert Read, Samuel Beckett, and Djuna Barnes were published regularly alongside reproductions of surrealist paintings and advertisements for the Cork Street galleries which presented a united front for progressive art. Peggy bought Paul Delvaux's *The Break of Day* from her neighbor. Visitors to the London Gallery dropped in on Peggy and attended her openings, which were said to be the most amusing in London. Peggy was already on her way to becoming a celebrity and the members of the press were regular visitors. They came to the gallery not only to see the works of art, but also to meet the flamboyant gallery owner. "Peggy's influence in London was considerable," recalled Roland Penrose, "Cork Street was where the important things were happening. Everyone came there and Peggy brought an international flavor to it all."[9]

Peggy with Yves and Jeannette Tanguy in front of the Delage, June 1938

When Peggy returned to Paris to pick up the Tanguys—a retrospective of Yves Tanguy's work was scheduled to open at Guggenheim Jeune on 5 July 1938 and she had offered to drive the couple to London—she saw Beckett again. They drove the van Veldes to Marseille in her Delage and on the return trip to Paris, she and Beckett stopped in Dijon. Peggy appreciated their new relationship as friends and was delighted to visit the museums in his company. After dropping Beckett in Paris, Peggy sped to Boulogne with Yves Tanguy and his wife in order to meet the Channel ferry. She found the Tanguy's joyful simplicity a refreshing change from Beckett's intellectual sullenness. In London, the Tanguys stayed with Peter Dawson, an English surrealist painter who helped to install the show, while Peggy joined her sister Hazel and Pegeen at Yew Tree Cottage.

At that time, Tanguy's evocative landscapes were virtually unknown in England. His exhibition proved to be a major event not only for the surrealists, but for the entire British art world. Peggy bought the colorful *Toilette de l'Air*. She later purchased *Le Soleil dans son Écrin*, a striking work that she described as fascinating but disturbing. Roland Penrose acquired a picture, and the *London Bulletin* devoted half an issue to the show. The event was such a success that most of the works were sold and Tanguy suddenly found himself quite well-off. Peggy usually took a group from the opening to dinner at the Café Royal, but on this occasion the outing was replaced by a wild party at Penrose's home. In the small hours

Yves Tanguy, Untitled,
20 July 1938

Peggy took Tanguy back to her apartment. Now that things were finally over with Beckett, she felt free to start a new affair. Tanguy, and his unsuspecting wife Jeannette soon moved into Peggy's London flat and they all drove down to Yew Tree Cottage. Every four days, he would send a pound note to Paris. Ostensibly this was intended to provide food for the Siamese cat that he had confided to his friend, the painter Victor Brauner, but in fact it was destined for the needs of the cat-sitter. Tanguy was a Breton of humble origin and had spent several years in the merchant marine before joining André Breton and the surrealists in 1926. He was the least pretentious artist Peggy had ever met, "He had a lovely personality, modest and shy and as adorable as a child. . . . He adored Breton the way Beckett adored Joyce, and seemed to think his whole life depended on his being a Surrealist."[10]

After several weeks, the Tanguys went back to France, but before the end of August Tanguy managed to return alone to Yew Tree Cottage. Over the course of his stay, Yves painted and traded pictures with Pegeen and he also made a series of drawings in green ink. Peggy, claiming that one of them resembled her, insisted on keeping it. The figure had a "little feather in place of a tail, and eyes that looked like the china eyes of a doll when its head is broken and you can see inside."[11] Later, Tanguy would give Peggy two tiny pink landscapes mounted as earrings. Peggy liked them so much that she ruined one by touching it too soon. He replaced it with a similar painting in blue. Tanguy soon rushed back to Paris to greet André Breton on his return from Mexico, where he had visited the painter Diego Rivera and met his idol, the exiled Leon Trotsky. Shortly after Tanguy's departure, Beckett arrived at Yew Tree Cottage on his way to Ireland. He was intrigued when he saw a photo of her standing by Tanguy's side and asked her a million questions about him.

Terrified by the Munich Crisis, Peggy had the Guggenheim Jeune paintings moved from London to Yew Tree Cottage and was considering going with her children to Ireland. Djuna, whom she invited to come along, made light of the situation. She sat on Peggy's bed swathed in a marabou cover and said, "We'll be bombed in feathers."[12] Breton could be seen around Paris in his medical officer's uniform; he had been a psychiatrist during the First World War and was classified on the conscription list as a doctor. Everywhere he went he was accompanied by his daughter, Aube and his wife, Jacqueline, whom Peggy described as "Surrealist-looking." As Peggy wanted to be alone with her lover, she was put off by the trio, but Tanguy delighted in their company.

On 29 September 1938, the Munich Pact was signed and, for a short time, the rumors of war were forgotten. Peggy went back to London for her gallery's second season. In October she presented an exhibition of children's art, including works by Pegeen, Laurence and Kay's daughters, and Sigmund Freud's fourteen-year-old grandson, Lucian, who was to become one of Britain's most powerful modern figurative painters. One of Lucian's drawings depicted three nude men on a staircase, which Peggy interpreted as being portraits of Freud. The show was a virtual sell-out. During this same period, Roland Penrose brought Picasso's *Guernica* to London. The painting, with its masterful treatment of the horrors of the Spanish Civil War, attracted a great deal of attention. In November, in collaboration with Peggy and Arp, Penrose organized an exhibition of

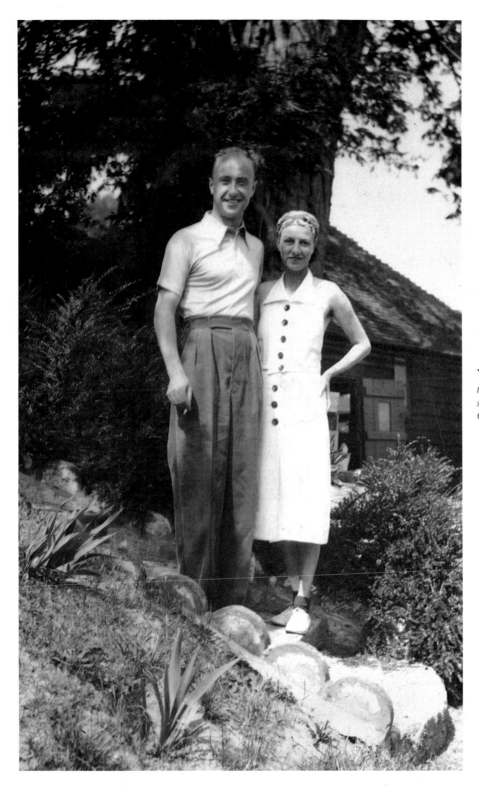

Yves and Peggy in the heat of an English summer, Yew Tree Cottage, July 1938

collages, *papiers collés*, and photomontages, which included works by Breton, Ernst, Picasso, Braque, Arp, Masson, Gris, and himself.

One day, a lively septuagenarian opened Guggenheim Jeune's door and asked Peggy where he could find the best nightclub in town. She was startled to recognize one of the great masters of abstract art, Piet Mondrian, whose paintings were included in an exhibition called *Living Art in England* next door at the London Gallery. Mondrian was not the only unexpected visitor. Several months earlier, Henry Moore had lent Peggy an enormous wooden figure that reclined in the middle of the gallery. One day he walked in unexpectedly and opened a small bag, inviting her to choose between two lovely *Reclining Figures,* one in bronze the other in lead. Peggy picked the bronze.

Peggy began the new year with a display of paintings resulting from the scientific research conducted by the psychiatrist Grace W. Pailthorpe and the painter Reuben Mednikoff. Pailthorpe was fascinated by the surrealist method of automatic painting in which the artist suppresses conscious control over the movements of the hand to reveal images stemming directly from the subconscious mind. The paintings, executed by Mednikoff, were accompanied by texts by Pailthorpe. The *London Bulletin* published a long article by her and commented that most visitors had found the works to be in the most surrealistic of spirits. Although there was extensive press attention, nothing was sold.

Despite its fine reputation, Guggenheim Jeune had been losing money since it opened and Peggy began to look for an artistic activity with less commercial risk. Roland Penrose and Mesens were holding discussions with Helena Rubinstein about the possibilities of establishing an art center in London along the lines of the New York Museum of Modern Art. Alfred H. Barr, MoMA's director, had succeeded in familiarizing the public with the main movements in modern art: cubism, surrealism, and abstraction. This was exactly what Peggy hoped to do in England.

In March of 1939, while planning a major exhibition of abstract and concrete (geometric) art to be held in May, Peggy contacted Herbert Read regarding her museum project. Read was an eminent art historian and the editor of *Burlington Magazine* since 1933. Peggy knew that founding a modern art museum was one of his dreams, and invited him to collaborate with her as the future museum's director. Wyn Henderson was to be in charge of administrative duties. Read agreed to resign from the magazine and signed a five-year contract with Peggy, but because she could give him no guarantees, he discussed his anxiety about his future with a close friend, T.S. Eliot, who reassured him regarding Peggy's positive reputation in the art world.

To get the museum off the ground, Peggy determined to cut back on expenses. She traded her roomy Delage for a small Talbot and stopped buying clothes. Djuna, who was jealous of this new project, was particularly upset, being afraid that Peggy would decrease her subventions to artists and writers, which by that time amounted to some ten thousand dollars a year.

After a lengthy search, Peggy and Herbert Read thought they had found the ideal location for the museum. Although it was Regency rather than modern, Sir Kenneth

Clark's mansion in Portland Place promised to be a splendid museum. Lady Clark explained that they were abandoning their London home because her children wanted to move to the country, though Peggy later realized that the Clarks' true motivation was their fear that London would be a target in the impending war. Fortunately for Peggy, their lawyers were on vacation and the lease was never signed.

Peggy and Read decided that her tiny collection, which was embryonic at this stage, would be expanded and a rotating loan collection assembled to put the different movements in perspective. Peggy wanted the museum to serve as a cultural stimulus and she proposed that artists be invited to meet with the public. Read drew up an exhaustive inventory of all the movements and significant artists to be shown, beginning his chronology in 1910 with Picasso and the cubists. Peggy immediately crossed out Matisse and Cézanne as not timely enough, and planned to show the list to Duchamp in Paris. Peggy's first objective was to locate the proposed works. To assist her in this task she counted greatly on the good offices of Nellie Van Doesburg, who, as the widow of the De Stijl painter Theo Van Doesburg, knew everyone in the art world. Peggy had many reasons to be fond of Nellie; she was chic, lively, had a good sense of humor, and above all, she loved art. Armed with her precious list, Peggy set off with Nellie for the south of France in her little blue Talbot for a well-deserved vacation before the museum opening.

G
U
G
G
E
N
H
E
I
M JEUNE & Jean Cocteau
30 CORK STREET W.1

A Picture a Day

France's general mobilization order was issued when Peggy and Nellie were visiting with the Kandinskys in southern France in late August 1939. Despite the rumors of war, which became more alarming every day, Peggy continued her car trip with Nellie as if nothing were happening. However, urgent decisions had to be made; Peggy had her museum to think of and cabled Laurence Vail to ask his advice. Laurence, whom Peggy referred to as her "eternal husband," was living in the ski station of Mégève with Kay and the six children: Sindbad, Pegeen, Bobby, Apple, Clover, and Kathe; he insisted on keeping the family in France. Travel visas were becoming more and more difficult to obtain, so if Peggy wanted to be with her children, going back to England was out of the question.

On 1 September 1939 Hitler invaded Poland and France soon followed England in declaring war on Germany. Peggy wrote to Herbert Read with regret, informing him that their plans had been forestalled by the war, and later sent him half of his proposed five-year salary as quittance. Read was disappointed, since in spite of the dramatic climate, he still thought London the appropriate setting for the museum. However, he bore no grudges and once the financial arrangements were taken care of, decided to call her Peggy, and they became the best of friends.

Clearly, it was no longer the time to be founding a museum, much less to be borrowing pictures. Discussing the future with Nellie, Peggy toyed with the idea of finding a château and setting up an artists' colony. Her guests would donate works for the future museum in exchange for room, board, and a small stipend. However, she quickly realized that it would be impossible to lodge under the same roof a group of people who often refused to dine together and were frequently not even on speaking terms. There were no protests when she abandoned the plan.

Before returning to Paris, Peggy and Nellie went to visit the cubist painter and theorist, Albert Gleizes, who was living with his wife on their large farm near Saint-Rémy-de-Provence. They had a handsome Provençal house in which they entertained generously. Meals were vegetarian and at unpredictable hours, but the food was delicious. Mrs. Gleizes had been loaned a donkey by the local community and "had serious

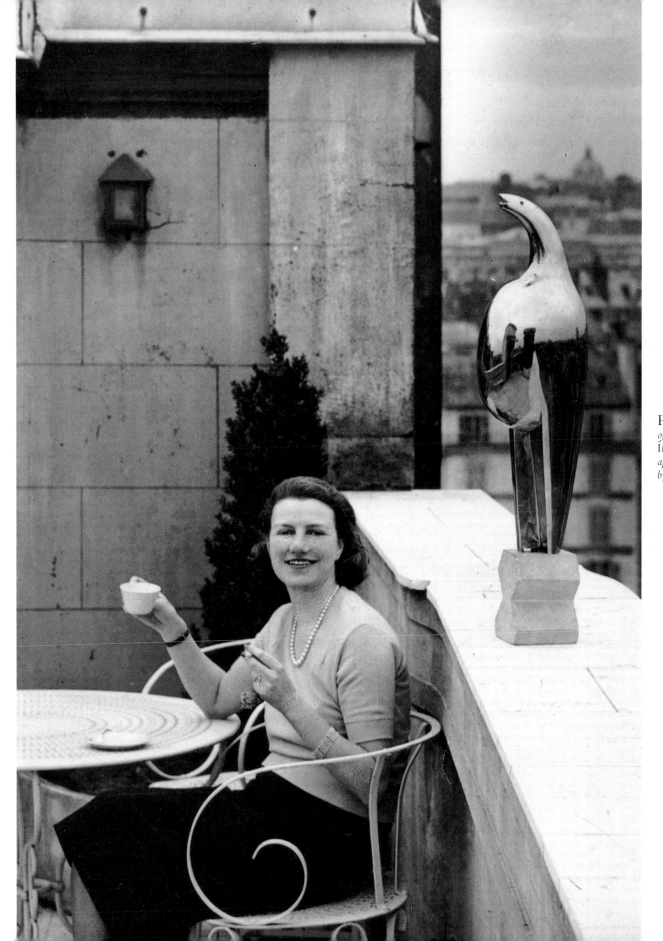

*Peggy on the terrace
of Kay Sage's
Île-Saint-Louis
apartment with* Maiastra
by Brancusi in 1940

intentions of raising enough food to help save France from starvation." She asked Peggy to join in her efforts, but Peggy reflected, "vague as my project was, I felt hers was even more so."[1]

Back in Paris in early October, Peggy again met up with Tanguy. He was about to leave for New York to join the wealthy American Kay Sage, a surrealist painter in her own right, whom Tanguy would later marry. Tanguy spent his last day in Paris with his first wife, Jeannette. As he was leaving he entrusted her to Peggy, who reciprocated by asking him to look after Djuna who, in deteriorating health, was sailing on the same boat. Late one evening Peggy accompanied them to the Gare d'Austerlitz, where she finally sensed the overwhelming presence of war in the dimly lit station. Still, Peggy claimed she "did not have the slightest desire to leave, and was not in the least afraid."[2]

Rivals no longer, Peggy and Jeannette became fast friends and Peggy was able to buy a long-coveted painting, *Palais Promontoire*. Tanguy asked her to pay Jeannette in monthly installments, so that she would be cared for after his departure. In his house on the Rue Hallé, Marcel Duchamp reviewed Herbert Read's list with Peggy, while through Mary Reynolds she again met Howard Putzel, a Los Angeles art dealer who had introduced surrealism on the West Coast. They had known each other slightly during the Guggenheim Jeune period and he was most enthusiastic about helping her assemble her collection. After the Christmas holidays, spent in Mégève with her children, Peggy moved into Kay Sage's apartment, left empty by Tanguy. It was on the seventh floor of an old building at 18, Quai d'Orléans on the Île Saint-Louis. Peggy was moved by the beauty of the setting: "The Seine played the most lovely reflections on the ceiling of my bedroom; I always lay in bed Sundays watching this. I was happy as all my life I had wanted to live by a river."[3] Peggy now had complete control of the funds she had set aside for the museum, and she avidly applied her new motto: "Buy a picture a day."

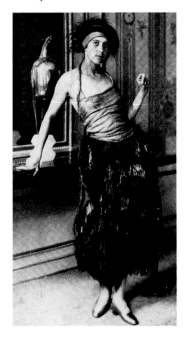

The couturier Paul Poiret's sister, who sold Peggy Maiastra, *her first work by Brancusi*

Howard Putzel and Nellie competed with each other to escort her to studios and galleries to search out artworks. There was a sense of an impending doomsday in the French capital and everyone was fleeing. Once the news of Peggy's buying spree had spread, people went directly to her, sometimes arriving at her apartment with paintings to sell before she had gotten out of bed in the morning.

Peggy had long wanted to acquire a Brancusi bronze. She had known the sculptor since the early 1920s and had no qualms about arriving unannounced at his studio on Impasse Ronsin. He lived there amid monumental sculptures and working tools, and every surface was covered with a fine white dust. Peggy described him as a "marvelous little man with a beard and piercing dark eyes. He was half astute peasant and half real god. . . . He liked to go to very elegant hotels, . . . arrive dressed like a peasant, and then order the most expensive things possible."[4] Brancusi was delighted to renew his friendship with "Pegitza" and often invited her to eat Rumanian meals, cooked with the same furnace in which he melted his bronze. One day, while Brancusi was serving her lunch— his favorite dish was burnt cutlets— bombs started exploding outside. Brancusi, realizing the danger, made her move from the table under the studio's glass roof into the smaller

side room. But Peggy, like so many Parisians, still refused to face up to the reality of the war, and kept running back to the table to retrieve bits of food or wine. As Peggy discovered, financial discussions with him were often delicate, and "we ended up in a terrible row, when he asked four thousand dollars for the _Bird in Space_."[5]

Constantin Brancusi, Marcel Duchamp, and Mary Reynolds, an inseparable trio

After their disagreement, Peggy put the _Bird in Space_ momentarily out of her mind and bought one of the artist's early works, _Maiastra,_ from the sister of the couturier Paul Poiret, for only a thousand dollars. Laurence Vail found the situation amusing and suggested that she should simply marry Brancusi and inherit his sculptures. Peggy replied that such a plan would never work since he would rather sell her everything and then "hide all the money in his wooden shoes."[6] Nellie van Doesburg went to Impasse Ronsin, and, deploying considerable diplomatic skill, reopened negotiations. By paying in francs, Peggy saved a thousand dollars on the exchange rate. Brancusi gave in, but maintained that he had somehow been tricked. For weeks he hand-polished Peggy's _Bird in Space_ and when she arrived to pick it up, he was weeping to lose his favorite sculpture.

The young abstract painter Jean Hélion had joined the French army and was stationed near Paris when Nellie contacted him, hoping to buy one of his paintings on Peggy's behalf. When Hélion arrived in Paris and met the elegantly dressed and brightly made-up Peggy and Nellie, he claimed they "were the first paintings he had seen for a long time."[7] The threesome crisscrossed Paris seeking out his pictures, which had been scattered amongst friends. Hélion found _The Chimney Sweep,_ a large 1936 abstract work, in an attic. Peggy bought it on the spot for two hundred and fifty dollars. When they parted, she never expected to meet Hélion again and never suspected that he would one day marry her daughter. The Belgian surrealist René Magritte, hearing of Peggy's activities, sent her _La Voix des Airs._ For only several thousand dollars, Peggy managed to acquire a great number of exceptional paintings such as Picabia's _Très Rare Peinture sur la Terre_ and _La Valse_ from Georges Braque's cubist period.

Peggy's historical and "unprejudiced" collection needed a work by Salvador Dalí. While her husband was away in Arcachon, Gala invited Peggy to their remarkable apartment on an impasse called the Villa Seurat. Gala advised Peggy not to waste her energies on so many artists and to concentrate, as she did, on a single genius. Peggy ignored this advice, but did buy _The Birth of Liquid Desires,_ which she found "horribly Dalí." One day she spotted a damaged Giacometti plaster cast in a gallery and decided to visit the artist to see if it could be repaired. She found him in his tiny studio off the Avenue du Maine, where he "looked like an imprisoned lion, with his lionesque head and an enormous shock of hair." He showed her another plaster in perfect shape, and agreed to have it cast in bronze. A few weeks later Giacometti appeared on the terrace of her Île Saint-Louis flat, carrying in his arms something that looked like "a strange medieval animal."[8] It was _Woman with her Throat Cut,_ and Peggy was the proud owner of the sculptor's first work in bronze.

Harold Putzel insisted on taking Peggy around to meet Max Ernst, and, as usual, she resisted for no particular reason. She was aware of Ernst's reputation, which was fueled not

only by his paintings and collages, but also by his striking appearance and his success with women. When she arrived in his studio, Peggy found the charming Max with "his ladylove," the beautiful Leonora Carrington at his feet. This young, gifted Irish artist produced extraordinary paintings in the best surrealist tradition. Peggy wanted to buy one of Ernst's paintings, but Putzel intervened, claiming that it was "too cheap." Instead, Peggy purchased Carrington's *The Horses of Lord Candlestick,* which appealed to her because of the haunting mystery emanating from the fantastic beasts. Carrington later wrote of her obsession: "When I was a debutante, I went often to the Zoo. I went there so often that I was better acquainted with the animals than with the young girls of my age."[9] Not to be outdone, Nellie introduced Peggy to the Russian constructivist Antoine Pevsner and Peggy purchased one of his splendid, mathematically derived constructions. Man Ray, who was leaving for New York, sold Peggy a work from 1916 and several of his experimental "Rayograms."

Ever an optimist, in early April Peggy rented a palatial apartment on the Place Vendôme in which to house her collection. She then began expensive renovation based on designs by Georges Vantongerloo. Like many Parisians she was convinced that the Germans would be halted at the French border and remained unperturbed even when she heard that the rarer animals in the zoo had been evacuated. On 9 April 1940, as Hitler's troops invaded Norway, Peggy was in Léger's studio buying the 1919 painting *Les Hommes dans la Ville* for one thousand dollars. Peggy described Léger as a "terrifically vital man, who looked like a butcher."[10] Commenting on his work of this period, Léger wrote: "I never amused myself copying a machine. I invent images of machines as others, with their imagination, have invented landscapes. The mechanical element in my work is not a prejudice nor an attitude, but a means of giving a sensation of force and power."[11]

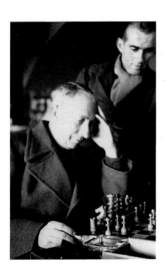

Jean Arp and René Char

Léger advised Peggy to entrust her collection to the Louvre for safekeeping. But the museum was having enough difficulty in storing its own masterpieces, and the curator judged Peggy's collection too modern to merit protection. As a last resort, the canvases were taken off their stretchers and sent to Maria Jolas, a friend of Peggy's who had rented a château near Vichy as a refuge for her bilingual school. Hidden under the bales of hay in the barn, the precious crates finally seemed safe from Nazi hands.

Three days before the German army marched into Paris on 14 June 1940, Peggy, whose visa had expired, decided to head south with Nellie and her two Persian cats. Her little Talbot sputtered along among the crowds of refugees choking the roads. They met up with Laurence and the children in Mégève, then drove on to Veyrier on the Lac d'Annecy, where Peggy rented a house for the summer. Jean Arp and his wife Sophie soon joined them. Peggy convinced Arp to write a preface for the catalogue of her collection. Arp was fiercely anti-Nazi and wanted to get to the United States to set up a New York Bauhaus. His hatred of all things German was so intense, Peggy remarked, that "if Beethoven or Mozart came on the air, he immediately turned off the radio."[12] At the end of the summer, to evade the advancing Germans, Giorgio Joyce shipped Peggy her collection so that she might find it another safe haven. André Farcy, the curator of the

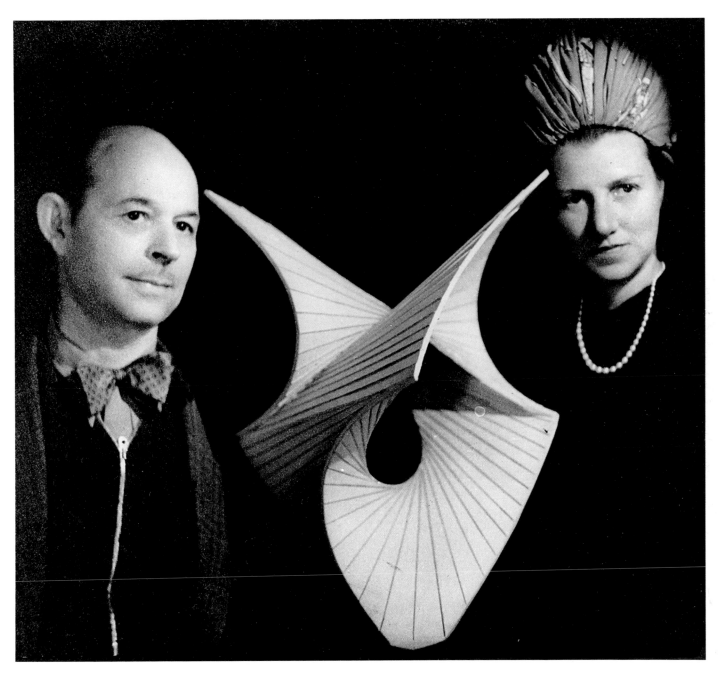

Peggy and Antoine Pevsner
with Surface développable
in the artist's Malakoff studio,
1939

Salvador Dalí, André Pieyre de Mandiargues, Leonor Fini, and Gala at Arcachon in 1940

museum in Grenoble, came to Peggy's rescue and stored the pictures. Although Peggy had free access to them and could photograph or show the paintings to friends, she was never granted her hoped-for exhibition because of Farcy's fear of the Vichy regime. While Peggy was in Grenoble, the painter Robert Delaunay arrived to conclude negotiations on the sale of a picture. He offered her a work from his *Disque* series at a reasonable price and restored a Gleizes that she had bought in Paris from Raymond Duchamp-Villon's widow. In exchange she gave him her cat, Anthony, who took to the painter like a charm.

With the threat of total occupation, Laurence and Peggy decided to take the necessary steps to depart for New York with the children in the spring of 1941. But Peggy refused to leave her collection behind. At that point, René Lefèvre-Foinet—a friend who had handled her art shipments between Paris and London—miraculously appeared. He had the brilliant idea of hiding the paintings in cases filled with household linen. The bill of lading read "household goods," a classification which Mr. Manson, the ex-director of the Tate Gallery, would no doubt have endorsed.

That winter Kay Sage sent Peggy a telegram asking her to pay the fares of five eminent European artists to America: André Breton, his wife Jacqueline and their daughter Aube, Max Ernst, and the surrealists' doctor, Pierre Mabille. Peggy pointed out that Dr. Mabille, Jacqueline, and Aube were not important artists, but she did pay the passage of the Breton family, who sailed for Martinique in late March, and she promised to help Max Ernst. Peggy also wanted to do something for Victor Brauner, who was Jewish and had pleaded for her help, but because of various visa problems—mainly due to the tight American quota for Rumanian immigrants—she never succeeded.

During her efforts for Ernst and Brauner, Peggy met Varian Fry, who was running the Emergency Rescue Committee in Marseille. The group collected money to help refugees escape the Gestapo and get to the United States via Spain, Africa, or Portugal. A priority list of about two hundred intellectuals, artists, and resistance workers, who were likely to be interned by the Germans had been passed to the French committee. Eleanor Roosevelt's influence often helped waive visa quotas, but the French committee was responsible for getting exit visas from France and supporting the refugees during their often long wait for a boat out. Along with Varian Fry, the committee included Daniel Bénédité and a young American named Mary Jayne Gold. The committee was installed in the Château Air-Bel near Marseille, which belonged to an eccentric ornithologist. It was comfortably furnished, but, due to lack of fuel in an unusually bitter winter, extremely cold. When Peggy visited in the winter of 1941, she found the Breton family along with several artists waiting to book passage. Among them were Oscar Dominguez, André Masson, Wifredo Lam, and Marcel Duchamp. Despite the war, the cold, and the lack of food, Breton kept up his court and life was festive. Afternoons would find the group in impassioned discussions at the Brûleur de Loups Café, while evenings were devoted to surrealist games at the château. When the Vichy leader Maréchal Pétain visited Marseille in December, the guests of Air-Bel were forced onto a ship anchored in the harbor and—along with other "undesirables"—held incommunicado for three days. The American Consul secured their release, but when Peggy considered joining the group, he advised her to steer clear of the committee.

To compensate her for the expenses she was incurring on his behalf, Laurence and René Lefèvre-Foinet advised Peggy to ask Max Ernst for a painting. On 1 April, when she returned to Air-Bel to conclude the arrangement, the playful atmosphere had turned to gloom. The Breton family had departed for Martinique and those left behind were growing desperate. Max Ernst greeted her cheerfully, but Peggy noticed that he had aged considerably due to the strain of a year spent in various internment camps and the disappearance of Leonora Carrington. At this point he knew only that she had reportedly gone insane and was somewhere in Spain. Peggy found Max's paintings magnificent and they quickly reached an agreement on price. For two thousand dollars, she received a number of works, including *Petite Machine Construite Par Minimax Dadamax en Personne* dated 1919, and the 1935 *Garden Airplane Trap*. Among the numerous collages was the 1932 *Le Facteur Cheval* which Brauner had discovered after much searching. To settle the deal, Max opened a bottle of fine wine which came from his vineyard at Saint-Martin d'Ardèche.

The next day, Ernst invited Peggy and the Air-Bel residents to celebrate his fiftieth birthday at a restaurant on the old port. Peggy was fascinated by Max's patrician beauty and his reputation as a Don Juan. He was intrigued by her notoriety as a vamp, the sparkle in her eyes, and the vivacity of her repartee. At the end of the dinner he leaned towards her and whispered in her ear: "When, where, and why shall I meet you?" Peggy replied in the same confidential tone: "Tomorrow at four in the Café de la Paix and you know why."[13]

Peggy's affair with Max Ernst may have begun as a whim, but it rapidly blossomed into an irresistible passion. To help him escape from the Nazis, Peggy took in hand the interminable administrative problems involved in getting a passport and visa. Max was worried about Peggy's frantic activities, and warned her that, if questioned by the police, she should stress her American nationality. Above all she should never admit to being Jewish, since Jews were beginning to disappear from Marseille. One morning, when Peggy was finishing breakfast in bed, a Gestapo officer arrived and insisted that she accompany him to the station. He escorted her downstairs, where his superior was waiting in the hotel lobby flipping through Peggy's passport. Luckily, France had just received badly needed food supplies from the United States and, begging her pardon, he politely handed back the papers. Other threats to Peggy's amorous idyll were more persistent. Max was an inveterate lady's man and Peggy had difficulty controlling her jealousy. In Marseille, Max had found his other young love, Leonor Fini. She was a free-spirited, dark-haired beauty of Argentinean–Italian parents and Peggy believed Max's praise of her work had more to do with her charm than her talent. Even so, she was talked into buying Fini's *La Bergère des Sphynxs*.

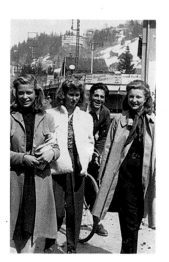

Jacqueline, Pegeen, and Bobby at Mégève just before the big departure

Meanwhile, Laurence's marriage was breaking up. In January 1941, Kay had taken the two youngest children and left for Cassis where she hoped to get a visa for her lover, a refugee Austrian baron named Joseph von Franckenstein, who tutored the Vail children. Laurence joined Peggy in Marseille and they undertook a lengthy procedure to get all the permits together for leaving the country. Kay had booked ten seats on the Pan American Clipper, a seaplane that flew from Lisbon to New York. Nine tickets were destined for Kay, Laurence, Peggy, and the six children. Peggy claimed the tenth place for Max, while Kay insisted on giving it to the baron. Laurence put his foot down. He was already traveling with two ex-wives, six children, and Peggy's lover, and thought that the family was sufficiently extended. On 6 May 1941 Kay's baron escaped on the S.S. Winnipeg, which was sailing for Martinique. The tenth Clipper seat was then earmarked for Jacqueline Ventadour, a friend of Pegeen's.

Once everyone had papers in hand, Laurence left for Lisbon with the children. Max followed shortly afterwards with a roll of canvases in his suitcase. Peggy had to stay on in Marseille for another three weeks as there were lengthy delays in getting the money for the trip from the bank. Finally she and Jacqueline caught the train for Lisbon. Laurence, Sindbad, Pegeen, and Max were waiting for them at the station. Peggy had missed Max terribly, and immediately noticed that he looked odd. She had hardly stepped down onto

*Jacqueline, Aube, and
André Breton with Peggy
at Air-Bel, 1941*

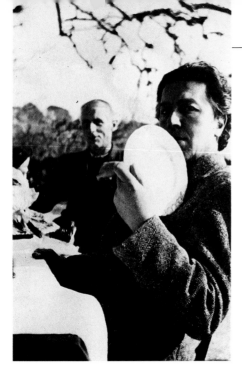

Max Ernst and André Breton at Air-Bel in 1941

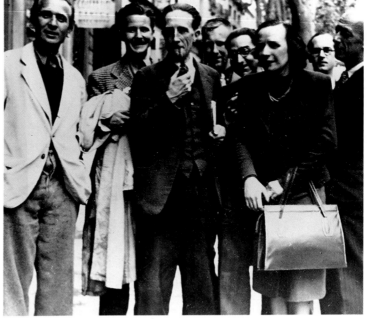

On the streets of Marseille, 1941. In the foreground, from left to right: Hérold, Duchamp, and Nellie Van Doesburg; behind to the right: Victor Serge and Varian Fry

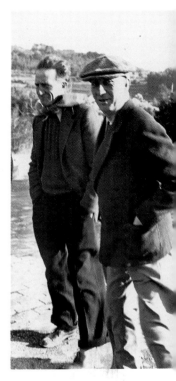

Duchamp and Arp at Air-Bel

the platform when he took her aside and whispered that he had found Leonora in Lisbon, where she was living with a Mexican diplomat.

Peggy was shattered. Her first thought was to go back to England to help in the war effort. She then toyed with the idea of marrying an attractive Englishman she had met on the train. Laurence, who was equally miserable, tried to cheer her up. For two weeks she hardly saw Max. He spent his days with Leonora and his evenings with Laurence listening to the languid melodies of the fado. Occasionally she joined them but her heart was not in it. Surprisingly, the most amusing evening that Peggy recalled was a dinner with Laurence, Kay, Max, Leonora, her lover Renato, and Sindbad. As might be expected there were terrible rows, but the party finished at dawn with wild dancing in a nightclub.

While they awaited their flight, the entire group settled on the coast at Estoril. Peggy resumed her affair with Max, but her life was difficult as he spent his time waiting for calls from Leonora. For her part, Kay was in a clinic for sinus trouble. The Vichy-registered S.S. Winnipeg had been captured by the Allies at sea, and Kay kept telephoning Laurence asking him to send expensive telegrams regarding the baron's safety. Peggy and Laurence spent hours on the terrace of a little English café on the seashore, trying to cheer themselves up, each wondering how to help the other. Everyone ate together at an

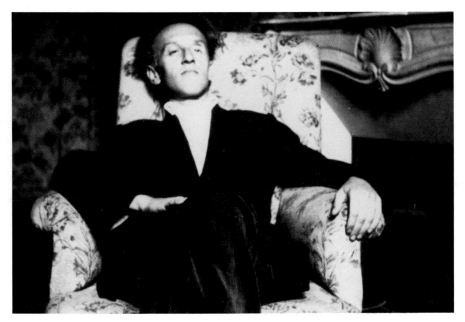

Victor Brauner in one of the rare armchairs at Air-Bel

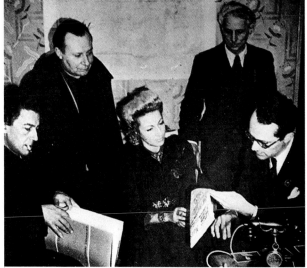

*André and Jacqueline Breton, André Masson, Max Ernst,
and Varian Fry at the office of the Emergency Rescue
Committee in Marseille, 10 February 1941*

immense table in the center of the hotel's dining-room. Peggy sat at the head with Laurence and Max at either hand and a string of children—from two-year-old Clover to eighteen-year-old Sindbad—stretched out along each side. The hotel staff were somewhat perplexed by this unusual arrangement, as they could not sort out the couples. One day Peggy called from Lisbon. The hotel porter, not knowing to whom he should deliver her message, stationed himself in Peggy's spot between Max and Laurence, and announced in a deadpan voice, "Madam arrives on the nine o'clock train."[14]

LIFE WITH MAX ERNST

*The Pan American
Boeing B-314*

Prince Max on his throne

On 13 July 1941 the Pan American Clipper took off from Lisbon with Laurence, Peggy, Kay, Max, Sindbad, Pegeen, Bobby, Apple, Kathe, Clover, and Jacqueline on board. In Peggy's words they were: "one husband, two ex-wives, one future husband and seven children."[1] The parents counted their children and made sure they were all safely strapped in. After a refueling stop in the Azores, Peggy looked out of the window and recognized with dismay the very ship that was taking Leonora Carrington and her new husband to America.

Thirty-six hours after departure, the Clipper touched down at the La Guardia Marine Air Terminal. Max's twenty-one-year-old son, Jimmy Ernst, was waiting to greet them. He had left Europe three years earlier and was now working as a mail clerk at the Museum of Modern Art. Through the museum's director, Alfred Barr, Jimmy had heard that Max was traveling with the Guggenheim heiress, who had gone to great lengths helping artists escape through Marseille. He was disconcerted to see a woman in a huge straw hat surrounded by photographers. The next day the photo was in all the newspapers, with the caption: "While Old World capitals collapse, Miss Guggenheim saves artistic treasures." Peggy was unlike his father's previous conquests, who were all classically beautiful, nor did she correspond to the image of the "dollar princess" who had been the subject of cocktail party gossip for weeks. She had an air of vulnerability: "The anxiety-ridden eyes were warm and almost pleading, and the bony hands, at a loss where to

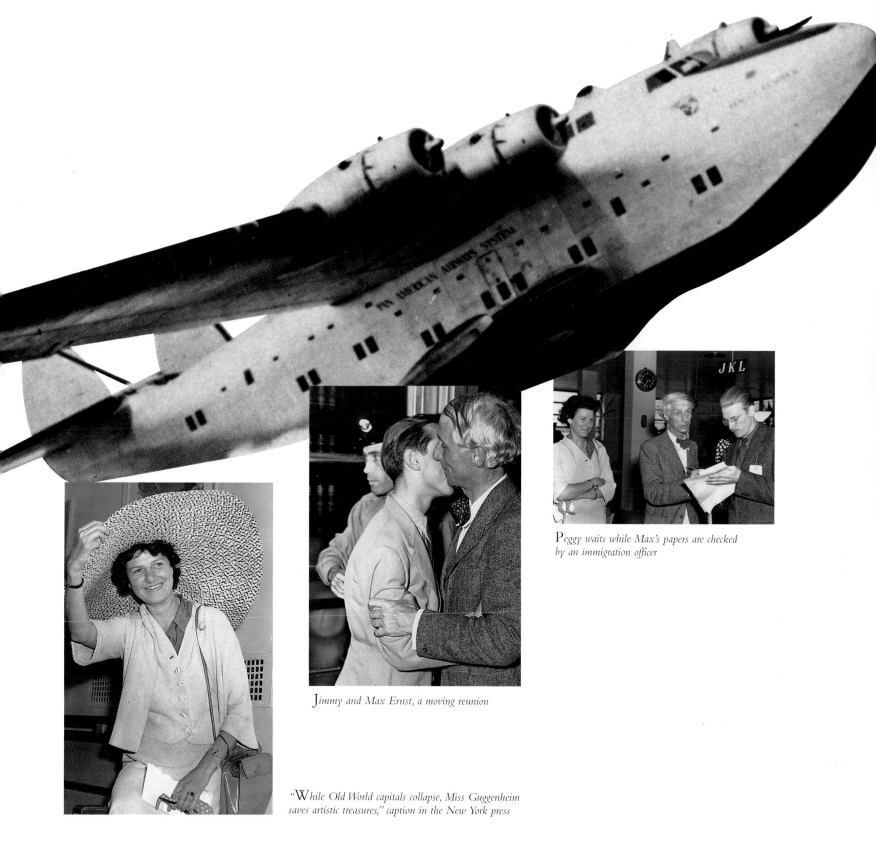

Peggy waits while Max's papers are checked by an immigration officer

Jimmy and Max Ernst, a moving reunion

"While Old World capitals collapse, Miss Guggenheim saves artistic treasures," caption in the New York press

107

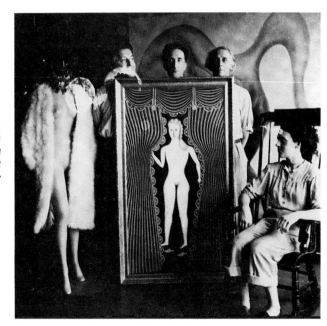

André Breton, Marcel Duchamp, and Max Ernst present Nude at the Window *by Morris Hirshfield to Leonora Carrington; the mannequin at the left is wearing Peggy's feather cape*

go, moved like ends of broken windmills around an undisciplined coiffure of dark hair. There was something about her that wanted me to reach out to her, even before she spoke."[2] Anxiously she told him that his father needed help. Despite Max's entry visa, his German passport had caught the eye of the immigration officials, who were reluctant to let him into the country. Jimmy managed to get into the room where his father was being held and embraced him warmly. Asked if he knew Max, he replied spiritedly, "This is a great artist. The Germans have burned his paintings in public. They would shoot him if they could get hold of him."[3] The explanation failed to satisfy the authorities and Max, who was terrified at the idea of being refused entry, was shipped off to Ellis Island.

In order to extricate Max, Peggy mobilized everyone she knew in New York: Nelson Rockefeller, John Hay Whitney, the Guggenheim cousins, Edward E. Waeberg, the directors of Lehman Brothers and the Morgan Bank, Eleanor Roosevelt, and finally Alfred Barr. Ultimately, however, it was the testimony of Jimmy Ernst that secured Max's release. As Peggy recalled: "He looked so sweet with his wonderful, big blue eyes. I knew Max was saved when Jimmy was called as a witness."[4] While representatives of Peggy's big-name battalion waited in the hallway to testify, Max was released into Jimmy's custody.

Peggy and Jimmy hit it off straight away and she hired him as a secretary to catalogue her collection. Having suffered a number of emotional blows herself, her sympathy went out to this young man who had had a lonely and difficult life. Jimmy was very worried about his mother, the art historian and writer Lou Straus-Ernst, who, being

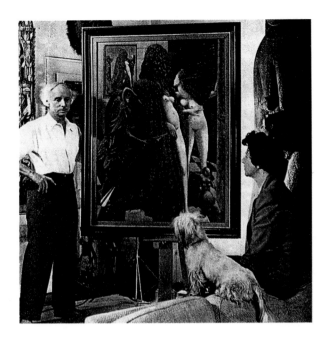

Max, Kachina, and Peggy looking at La toilette de la mariée _(Attirement of the bride)_

Jewish, was in grave danger in occupied France, where she was living under the protection of Jean Giono in Manosque. Peggy tried to use her influence to get Lou a visa, but was unable to save her from being sent to Auschwitz, where she would lose her life. "I immediately took Jimmy to my heart and became a sort of stepmother to him," she remarked, "In a way I felt like Max's mother too. It seemed to me he was a baby deposited on my doorstep and that I had to look after him."[5]

André Breton and his family had arrived in New York in late May 1941 and Kay Sage had set them up in a comfortable apartment in Greenwich Village. Peggy dropped in to see Breton and was amused by the fact that, although he was worried about supporting a family in America, he was determined not to learn English. To help him get through what promised to be a difficult first year, she agreed to pay him a stipend of two hundred dollars a month. Breton was very anxious to get Ernst into his circle. The surrealists were continually involved in a complicated game of musical chairs with Breton directing the music. Max was one of the few surrealist stars who had not succumbed to Breton's influence in his quarrels with Paul Eluard, and he would not stand for Breton's latest decree that his close friend Eluard was a German collaborator. However, no objections were heard when Breton declared Salvador Dalí a fascist for his support of Franco, nor when he coined the anagram "Avida Dollars" from the materialistic Dalí's name.

Max dragged Peggy around to all the museums in town, some of which, such as MoMA, owned his works. As for her uncle's Museum of Non-Objective Art, dubbed "Bauer House" by Max, Peggy had not forgotten the Baroness Rebay's haughty letter

and she found the collection laughable. Some twenty important works by Kandinsky were overwhelmed by over a hundred mediocre Bauers in gigantic silver frames. On the other hand, in their apartment at the Plaza Hotel, Peggy's Uncle Solomon and Aunt Irene lived in the midst of some of the finest paintings by Picasso, Seurat, Braque, Klee, Kandinsky, and Chagall. Peggy suggested to her aunt that the Bauers in the museum be burned and replaced by the Plaza collection. Max's favorite institution was the Museum of Indian Art, where Breton introduced him to the wonderful collection of pre-Colombian art. Breton was now often in the company of the Chilean painter Matta, a second-generation surrealist who had been his protégé in Paris. He took Matta and Max to a little antique shop on Third Avenue where they spent hours searching for treasures of primitive art.

One evening, not long after his father's arrival, Jimmy encountered Leonora Carrington in a drugstore on Columbus Circle. She informed him that she had come to the United States with many of the paintings that Max had done at Saint-Martin d'Ardèche. When he heard this news, Max was thunderstruck and could not wait to see her again. He ignored Peggy, oblivious to the extreme pain that it caused her, and spent most of his time with Leonora. While Peggy admired Leonora's talent as well as her personality, she was bitter about Max's distant behavior towards herself. He was always extremely intimate with Leonora, while with Peggy he kept a certain reserve, even using the formal *vous* form when addressing her in conversation. Peggy's younger sister Hazel had just remarried and she invited Peggy to visit her in California. Peggy saw this as an

Peggy and Max at Hazel's home in California, 1942

Peggy picnicking with Max and Marc Chagall in 1942

excellent opportunity to get Max out of New York and away from Leonora. It was also an opportunity to find a home for the museum she was still dreaming about. Jimmy, Pegeen, Max, and Peggy flew to San Francisco and visited the city before flying on to Hazel's house at Santa Monica. Peggy scoured the state in search of the perfect spot for her museum. Several disasters were narrowly averted. Among them were Charles Laughton's charming Pacific Palisades residence located on top of a three-hundred-meter cliff that was about to collapse; an entire canyon for forty thousand dollars including an unfinished castle with over fifty rooms on a hill overlooking Malibu; a bowling alley; a pair of churches in fake adobe; and Ramon Navarro's house, of which the garage alone could have housed the whole collection.

At Hazel's house in Malibu, Max painted all day on the veranda. Peggy's nights were particularly agitated. Because she and Max were not married, Peggy had been assigned Pegeen as a roommate. In order to avoid shocking the Irish servants, she crept from room to room before being able to join Max. These nocturnal wanderings were the subject of much banter over breakfast.

In Hollywood they met up with Man Ray and his new wife, Juliette, along with other old friends from Paris. They then visited Walter Arensberg's Victorian mansion, which was a museum in itself. Every room, every inch of wallspace, even in the bathrooms, was covered by artworks. On view were almost all of Duchamp's works, several Brancusis, as well as paintings by Rousseau, Picasso, Klee, Miró, and Kandinsky. The cubist era was exceptionally well represented, but that was where Peggy's jealousy

ended. None of the later work measured up to the paintings in her collection. Arensberg's collection stopped where Peggy's began.

Peggy finally decided it was time to head east. She bought a silver Buick convertible and Jimmy taught his father to drive. Jimmy later remembered an eerie moment in the trip. As they were crossing Arizona, Jimmy recalled, Max went white: "He was staring at the very same fantastic landscape that he had repeatedly painted in Ardèche, France . . . without knowing of its actual existence."[6]

Shortly after the attack on Pearl Harbor, Peggy decided that she could not go on "living in sin with an enemy alien," overriding Pegeen who pleaded, "Mama, how can you force the poor thing to marry you? Look how miserable he is."[7] Peggy ended up convincing Max that marriage would be the best way for him to ensure that he would not be deported. Peggy already saw quite clearly that the day Max no longer needed her help, he would lose interest in her. They first planned to marry in Maryland, because it was supposedly quicker, but it turned out to be impossible since their divorce papers were in French. They drove on to Virginia, where the couple simply paid the judge a ten-dollar fee and the marriage was celebrated. Thus Peggy became "for better and for worse" the third Mrs. Ernst.

Marriage failed to provide Peggy with the sense of security she craved. Leonora was ever-present in Ernst's thoughts and Peggy, at her wits' end, sought refuge in Laurence's arms. Trouble was brewing. When she spoke of Laurence, Max referred to him ironically as "your husband." Peggy once told Max that she thought of him as a foundling and he replied that she was a lost little girl. She was amazed that he understood her so well. Max went on depicting Leonora in his paintings, but never Peggy, and she took this to be a sign that he did not truly love her. Then one day she noticed a small painting on his easel. "In it was portrayed a strange figure with the head of a horse, which was Max's own head, and the strange body of a man dressed in shining armor. Facing this strange creature, and with her hand between his legs, was a portrait of me. Not me as Max had ever known me, but myself as my face appeared as a child of eight."[8] Max elaborated on this theme and went on to paint a huge canvas, *The Antipope*. The art collector Sidney Janis claimed that the ogress in this later version was Peggy.

While Sindbad prepared his entrance exams for Columbia University, Pegeen was admitted as a boarder at Lennox School to prepare for entry to Finch College. Peggy had found a huge triplex on Beekman Place, which was some way from the center but ideal for a museum. Moreover it was on the East River and the hastily hung paintings shimmered once again in the reflections from the water. Pegeen had the whole second floor and Max had his studio on the third where he arranged his collection of kachina dolls, peace pipes, African sculptures, Aztec pottery, Navajo arrows, and Inuit walrus tusk carvings. Jimmy had his desk in a corner of the enormous salon. Besides working on the catalogue and researching he had to keep the Brancusi sculptures polished. His position was strategic, and despite himself he became the go-between in a perpetual conflict. He was also the bookkeeper of a confidential agreement between Peggy and his father. Peggy was still giving Laurence an allowance of two hundred dollars a month and Max

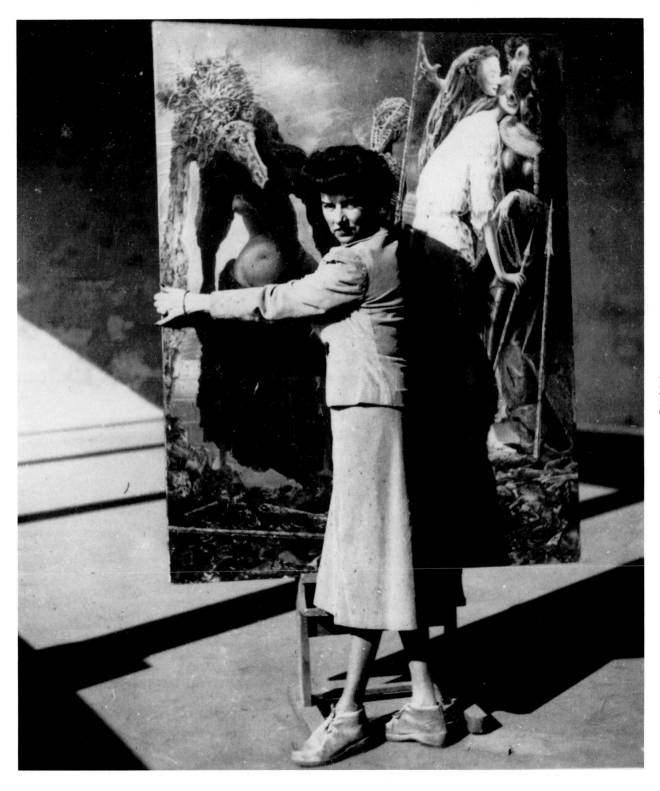

Peggy carrying
The Antipope
by Max Ernst

In the gallery of the triplex, from left to right: Leonora Carrington, Fernand Léger, John Ferren, Berenice Abbott, Amédée Ozenfant, Peggy, Frederick Kiesler, Jimmy Ernst, Stanley William Hayter, Marcel Duchamp, Kurt Seligmann, Piet Mondrian, André Breton, Max Ernst, New York, 1941

saw no reason why she should not look after his needs as well. She was not too pleased at having to support two husbands at once, so he suggested that she choose a picture each month for her personal collection. Max was in a very productive phase and was also finishing work he had brought over from Europe such as _Night and Day._ Each time he sold a painting he would add a new piece of American Indian, Pre-Columbian, or Polynesian art to his collection. One day he came home with a little ball of white fur in his arms. It was a Lhassa Apso puppy he had exchanged for a painting. At first Peggy was annoyed by this unusual deal, but she soon fell in love with Kachina, who became the prolific ancestor of a dynasty of Tibetan terriers.

Peggy spent months trying to get Nellie Van Doesburg to New York. In August, when she finally obtained an entry visa in Washington, it was, once again, too late— Nellie could no longer get out of France. Peggy left the capital and joined Max and Pegeen, who were staying with Matta at Wellfleet, Massachusetts near Cape Cod. The three of them then rented a summer house in Provincetown. As Peggy and Max were strolling down the street their first day in town, an FBI vehicle pulled up, a hand came out of the window, grabbed Max by the wrist and forced him into the car. The only

Max in his armchair, with Pegeen, Peggy, and friends during a party

explanation given to Peggy was that they were taking her husband for a ride. A few hours later, very shaken, he returned home. The agents had tried to make him denounce Matta as a spy by asking him how many ladders Matta had on his roof. Max had understood the question as how many letters Matta had in his name. He innocently answered "five." Peggy could not help pointing out to her daughter that they had only let Max go because he was married to an American.

The Guggenheim-Ernst triplex on Beekman Place soon became the natural meeting place for exiled European artists in New York. They may have been impressed by the city at first sight, but they soon began to miss the café life they had known in Europe. If the theorists of surrealism were deprived of a suitable forum to air their ideas on a daily basis they were in danger of losing their _raison d'être_ and their movement was destined to

From left to right: Max Ernst, Peggy, Roberto Matta, Pegeen, and friends, Connecticut, 1943

atrophy. Peggy provided that setting—she was not only a wonderful hostess, she also had a talent for mingling guests. The atmosphere was lively and eclectic. Artists, writers, actors, and musicians flocked to her parties where they could meet a Seligman or a Guggenheim who might follow their famous cousin's lead and sponsor some cultural project. A magnet for all the avant-garde movements, Hale House, named for the patriot Nathan Hale, became the center of a new *vie de bohème* which Peggy alone was capable of recreating on the other side of the Atlantic. Hundreds of guests in extravagant costumes flocked to the house-warming. Leonora Carrington in a Guatemaltec blouse was more stunning than ever; Jacqueline Breton wore a Mexican dress and Navajo bracelets; and Peggy was dressed in a strange costume which Pegeen had devised for her—the dress had an enormous pink belt and tiny gold Calder mobiles hung from her ears. A terrible fight broke out between Nicolas Calas who was a giant and Charles Henry Ford who was not. Jimmy rushed around, taking down the Kandinskys to save them from being splattered with blood. When Barr asked Jimmy why he was saving Peggy's paintings before his father's, he confusedly muttered that the blood would be less visible on the Ernsts than on the Kandinskys.

The Ernsts' kitchen was open to anyone who wanted to cook. Max specialized in an extremely hot curry, Peggy's *plat de résistance* was chicken in chocolate sauce, an old Mayan recipe that Breton had found in Mexico. The poet had not gotten over his penchant for the Truth Game, to which Peggy was no stranger—she had played it often enough at Hayford Hall. "We sat around in a circle while Breton lorded it over us in a true schoolmasterly spirit," Peggy remembered. "It was ridiculous and childish, but the funniest part was the seriousness with which Breton took it. He got mortally offended if anyone spoke a word out of turn; part of the game was to inflict punishment on those who did so. . . . Breton ruled us with an iron hand, screaming '*Gage!*' at every moment."[9] The exiled artists had developed a taste for carefully posed photographic sessions in the apartment. Max, who was very photogenic, found this game especially exciting. The rules were immutable. The Maestro would take his place on the throne, an old Victorian stage prop, some ten feet high. The only person apart from Max who was allowed to sit on it was his "honeychild" Pegeen. Once installed, he would stare into the lens as though he were trying to expose the film by sheer mental power. Berenice Abbott came to photograph him for *View* magazine, which devoted an issue to Max. Apart from an article for *Vogue,* Max refused to be photographed with Peggy. On the other hand, Marcel Duchamp, who declined being shot with "the artists in exile" in the Pierre Matisse Gallery, had no objection to having his picture taken at Beekman Place among friends.

The war of "isms" had survived the Atlantic crossing and Breton's coterie was always ready to pounce upon a young futurist or a leading abstract painter. It was in an atmosphere far from amiable on a spring day in 1942, that Piet Mondrian was invited to lunch at the triplex. "Mondrian is a very nice man. *Mais, mon Dieu,* what can one say for these cold Abstract arrangements that are the very denial of *la peinture?*" declared Max

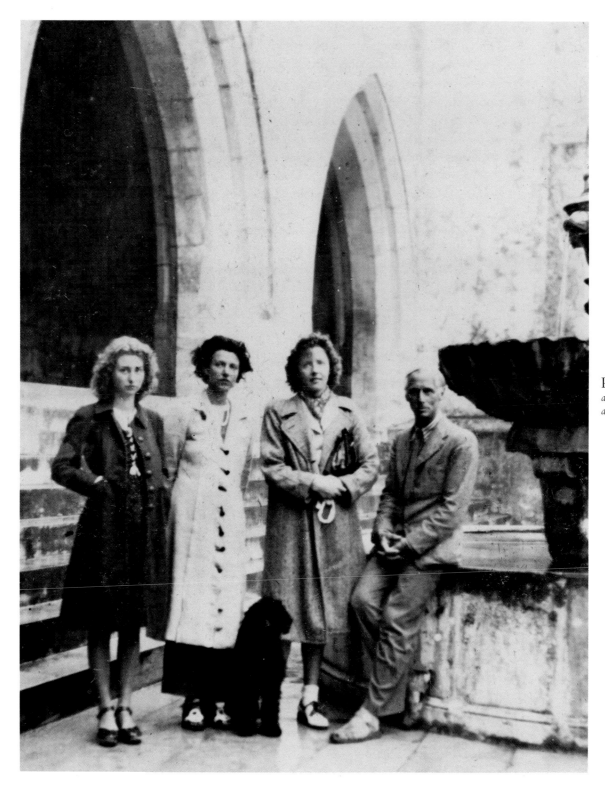

Pegeen, Peggy, a friend, and Max Ernst visiting a monastery

from his Victorian throne at the head of a table where André Breton, Yves Tanguy, Marcel Duchamp, and Jimmy Ernst were waiting for Mondrian to join them. The painter was studying each work with interest as Peggy guided him through her collection. When he pointed to a large Miró, then a Kandinsky, asking his hostess the name of the artists, the other guests, delighted by the naïveté of their prey, were unable to hold back their laughter. Mondrian sat down at the far end of the table and faced them. He thoughtfully stroked his chin, as was his habit, while discussing a mutual passion for jazz and boogie-woogie with Jimmy. The guests put on their best manners through soup, salad, and entrée, but with the coffee Breton attacked: "Of course, my dear Mondrian, we all respect your aim at a form of painting that seeks to cleanse the vision absolutely of the irrational and that, of course, means dreams as well as reality. We would be very interested to hear your opinion of other painting, let us say Surrealism, which seeks to elaborate these elements rather than erase them." Total silence followed, broken finally by Duchamp: "What, for example, do you think of the work of our friend Yves Tanguy here?" Mondrian continued to thoughtfully massage his chin, then in a slow, calm voice, responded: "I enjoy conversational games as much as you do, but I shall not indulge in them. I have seen Tanguy's exhibition at Pierre Matisse several times and found it very beautiful but also very puzzling. Yves' work is much too Abstract for me." Breton was dumfounded: "Too Abstract? For you?" Mondrian quietly answered: "My dear Breton, you seem to have a very fixed idea about Abstraction. I certainly do not fit into your concept of it and I don't mean to play with words when I say that I consider my way of painting to be a deep involvement with reality. I may well be mistaken in my feeling that Tanguy's paintings are getting too cold for me and too Abstract, and I also have no doubt that when he reaches his destination, as I expect to reach mine, we will both discover that we are still living on the same planet . . . together. In art the same elevator goes either to the basement or to the penthouse." Tanguy rose and hugged Mondrian: "That, dear master, we must accept without qualification." His laughter was so contagious that soon Duchamp and Ernst had joined in. Even Breton could not resist such a gracious response. Watching them, Jimmy could not help but wonder, "Had they indeed discussed principles . . . a credo? Or was it just like any other game played with artificial gaiety at a kid's birthday party?"[10]

One evening, during a party given for Peggy's birthday, Duchamp kissed her passionately for the first time in twenty years. Since they had been friends for such a long time she found the kiss almost incestuous. However, shortly thereafter, when Duchamp was dining with Peggy and Max, she drank more than was wise. She left the room and reappeared in a raincoat made of transparent green silk. Max was furious and asked Duchamp what his intentions were. The latter seemed to have no intentions at all, and to liven things up Peggy started to hurl violent abuse at Max. He in turn, lost all self-control, and began slapping her under the unblinking eyes of Duchamp, who had seen it all before. Terrible fights broke out over the slightest pretext: they would argue about who would drive the car; Peggy would get angry at Max for borrowing—without ask-

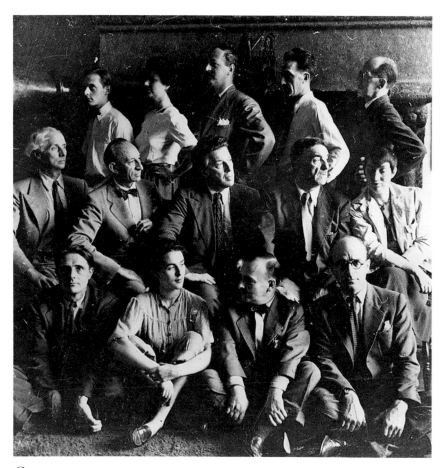

Group portrait at the triplex.
Back row from left to right:
Jimmy Ernst, Peggy, John Ferren, Marcel Duchamp, Piet Mondrian;
middle row from left to right:
Max Ernst, Amédée Ozenfant, André Breton, Fernand Léger,
Berenice Abbott;
front row from left to right:
Stanley William Hayter, Leonora Carrington, Frederick Kiesler,
Kurt Seligmann, New York, 1941

ing—her precious scissors, those that she had used to trim John Holms's beard; Max would complain that Peggy was too long in recuperating when sick. The supercharged atmosphere in the magnificent dwelling hardly made for peace. Peggy admitted that peace was "the one thing that Max needed in order to paint." She added that "love was the one thing that I needed in order to live. As neither of us gave the other what he most desired, our union was doomed to failure."[11]

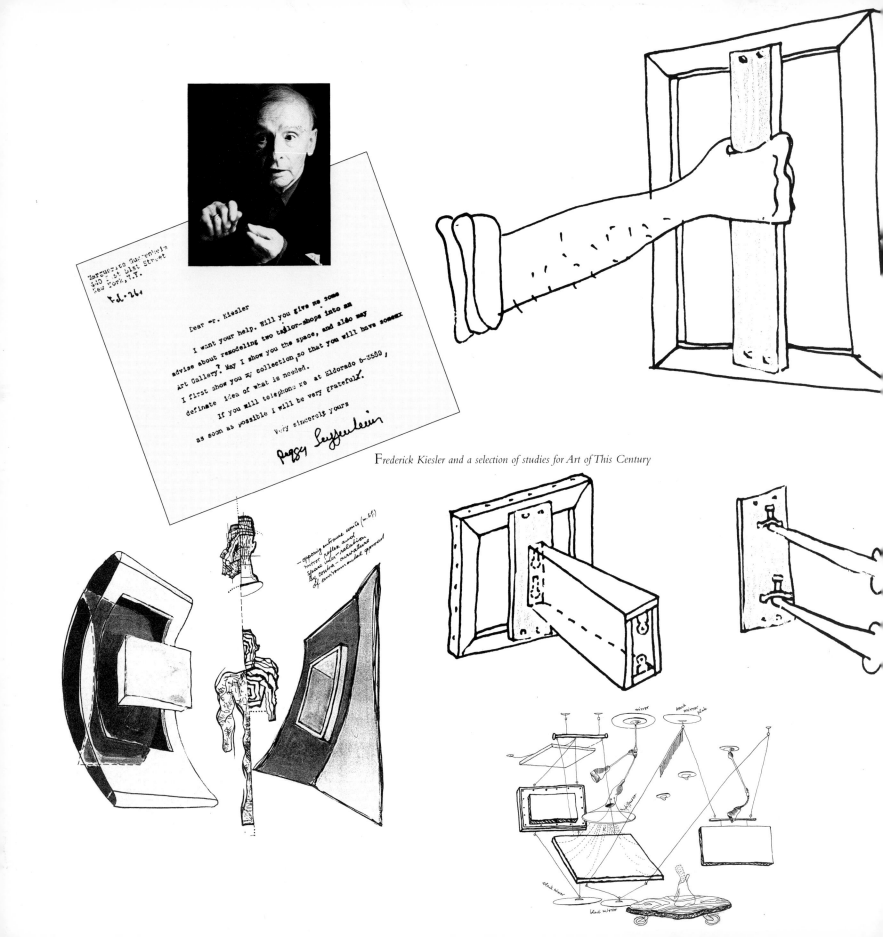

Frederick Kiesler and a selection of studies for Art of This Century

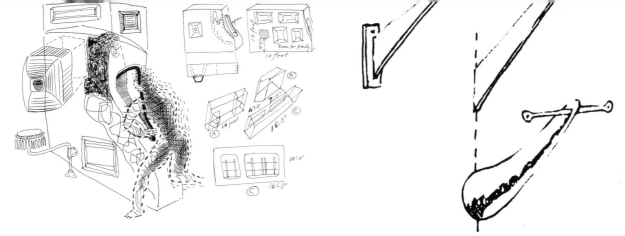

ART OF THIS CENTURY

Toward the end of the winter of 1942, Peggy began a determined search for an appropriate space to exhibit her collection. However, mysterious obstacles were met each time she sought a lease in midtown Manhattan. Through his friends employed at the Museum of Non-Objective Art, Jimmy discovered that the Baroness Rebay had been using her influence with real estate agencies to block all of Peggy's plans. She accused Peggy of encroaching on her territory, and even worse, of trying to commercialize the Guggenheim name, which, thanks to her, had become, "known for great art."[1] Finally, despite these insidious machinations, Peggy found two former tailor's workshops on the top floor of a building at 30 West 57th Street. To transform the lofts into a gallery, Howard Putzel advised Peggy to contact Frederick Kiesler, a Viennese architect of Rumanian origin, who had been a member of De Stijl. He had been living in the United States since 1926, taught at Columbia University, and was the Director of Scenic Design at the Julliard School of Music. Peggy wrote to Kiesler on 26 February 1942 inviting him to see the space and her collection.

Kiesler's fundamental concept was that there should be no interruption between a work and its environment, a revolutionary idea which delighted Peggy. In a preliminary note on designing the gallery, Kiesler proposed a method of "spatial-exhibition" which he had used as early as 1924 at the Festival of Art and Music in Vienna. This method, using what he called L and T units, aimed at making the whole room transparent, presented paintings without frames, and sculptures on cantilevers. For Kiesler the suppression of frames was not simply a way of going against the grain, it went much deeper for him. Not only had the frame become "a decorative cipher without life and meaning," it was "at once symbol and agent of an artificial duality of 'vision' and 'reality,' or 'image' and 'environment,' a plastic barrier across which man looks from the world he inhabits to the alien world in which the work of art has its being." Kiesler went on to say that it was incumbent upon contemporary architects to develop

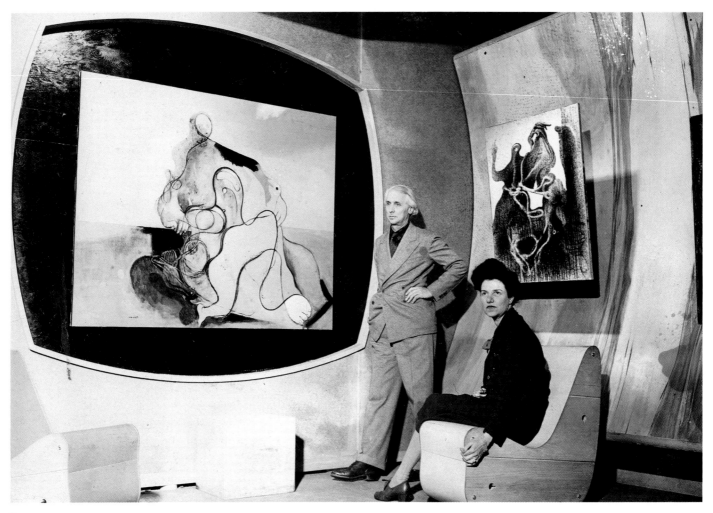

Peggy and Max at Art of This Century with Ernst's Couple zoomorphe *and* Le Baiser *(The Kiss) October 1942*

techniques which would once again make patent the original unity. "Primitive man knew no separate worlds of vision and of fact. He knew one world in which both were continually present within the pattern of every-day experience. And when he carved and painted on the walls of his cave or the side of a cliff, no frames or borders cut off his works of art from space or life—the same space, the same life that flowed around his animals, his demons and himself."[2]

Kiesler began work in absolute secrecy in early March; apart from Peggy, no one was permitted to see the drawings or visit the site. Leaving Kiesler to supervise the genesis of his project which was to become "a demonstration of a changing world,"[3] Peggy set out to find the missing works on the Read-Duchamp list which she had not been able to acquire in France due to the war. In a few months, with the help of Duchamp, Breton,

Ernst, and Putzel, she was able to notch up a series of masterpieces: a 1911 Duchamp, *Jeune homme triste dans un train,* as well as his famous *Boîte en valise;* three Picassos: *Le poète, L'Atelier,* and *Pipe, verre, bouteille de Vieux Marc;* two De Chiricos: *La tour rouge* and *Le doux après-midi;* Miró's *Peinture* and *Femme assise II;* a purist Ozenfant, as well as works by Calder, Archipenko, Lipchitz, and seven Max Ernsts of various periods. She exchanged an Ernst for a Malevich with Alfred Barr. Her collection now covered a period of thirty years and was made up of 170 works by sixty-seven artists. Peggy then became obsessed with her catalogue. She realized how necessary it would be to give meaning to a collection that represented so many different tendencies and, despite its intense energy, would probably be confusing to the average viewer. She called upon Breton's editorial experience and Laurence Vail's imaginative suggestions. They decided to include texts by Mondrian and Arp as well as manifestoes of the various artistic movements; amongst the illustrious signatories were Kandinsky, Picasso, Ernst, De Chirico, and the Italian futurists. The eclecticism and the diversity of the views expressed transformed what might have been a simple inventory into a true anthology of twentieth-century art. Peggy ran back and forth to her publisher, Inez Ferren, with photographs and text to accompany last-minute additions. Max executed a superb drawing for the cover which was printed on a yellow background. Opposite each reproduction, a close-up of the artist's eyes was accompanied by a personal statement. Facing *Maiastra* Brancusi wrote: "Simplicity is not an end in art, but one arrives at simplicity in spite of oneself, in approaching the real sense of things."[4] Kandinsky found that "A vertical associated with a horizontal produces an almost dramatic sound,"[5] and Laurence Vail quipped: "I used to throw bottles and now I decorate them."[6] Vail had translated most of the texts, including Breton's preface that gave a brief history of surrealism.

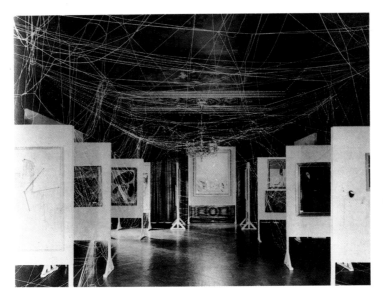

For the installation of the surrealist exhibition to benefit the Coordinating Council of French Relief Societies in October 1942, Marcel Duchamp crisscrossed five miles of string between the paintings

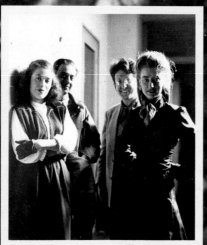

Jacqueline, Sindbad, Jean, and Pegeen, the four lovers

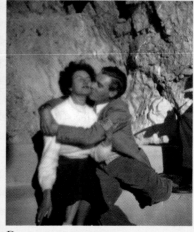

Peggy in the arms of her favorite co-tenant Kenneth McPherson

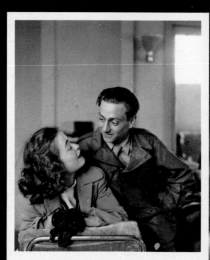

Jacqueline Ventadour and Sindbad in 1945

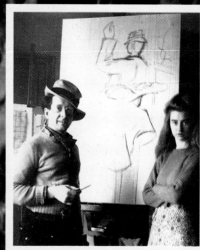

Jean and Pegeen, the painter and his model

machine to cover his canvases with drip paint. It had shocked me terribly at the time, but now I accepted this manner of painting unhesitatingly."[22] However, it could not be installed since it largely exceeded the dimensions of the wall destined to receive it. Coolly, Marcel Duchamp amputated the excess with a large pair of scissors, saying that this kind of painting did not need it. The work was unveiled to the public, *in situ*, during Pollock's second exhibition in 1945, and was regarded by critics as one of his masterpieces. Peggy loved the mural but Kenneth, who preferred a more traditional décor, could not stand it; he prevented her from lighting the work, claiming that the built-in spotlights would blow all of the fuses in the house. Peggy later donated the painting to the University of Iowa, where it was comfortably installed in the students' dining hall. A friend of Kenneth's, Jean Connolly, the wife of the brilliant British writer Cyril Connolly, moved into the duplex. An intelligent brunette with an agreeable personality, Jean was in love with Laurence Vail and they would soon marry. During the summer of 1943, Peggy, Sindbad, Laurence, and his younger daughters went to Connecticut for the holidays. Pegeen had flown to Mexico with Barbara Reis, the daughter of Peggy's lawyer. Her parents became very worried when she had not returned by the end of October. As they later discovered, after a stay on Erroll Flynn's yacht, which was anchored in Acapulco Bay, she had fallen in love with a young man who dived perilously from the top of the cliff for the pleasure of the tourists. His family had adopted Pegeen. These simple people, who could not speak a word of English, adored this blonde goddess who had come from the sea. When Leonora Carrington, who lived in Mexico, saw Barbara Reis without Pegeen, she immediately cabled New York. After countless phone calls to Mexico to try to trace Pegeen, Laurence flew down to Acapulco and brought his daughter home. Pegeen arrived at her mother's doorstep dressed in a simple raincoat with only a tiny bag. She had lost all of her luggage at the border and she looked so destitute that Peggy was overcome with pity. Pegeen wanted, at all costs, to go back to marry her Mexican boyfriend, but shortly afterwards, encouraged by her parents, she moved into an apartment with Jean Hélion, with whom she fell in love. A few months later, to the great relief of Peggy and Laurence, they were married.

Background: Pegeen in Acapulco during her idyll with a death-defying cliff diver

Despite the critical success of Pollock's exhibition in November 1943, apart from the sale of *Guardians of the Secret* to the San Francisco Museum and *She Wolf,* which was purchased by MoMA for $650—regarded as a fabulous price at the time—no buyers appeared for pictures as important as *Male and Female, The Moon-Woman Cuts the Circle, The Mad Moon Woman,* or *Stenographic Figures.* These pictures, with their totemistic titles, were lacerated by violent brush strokes and slashed with blood red stripes. James Johnson Sweeney wrote of them in the catalogue preface: "Pollock's talent is volcanic. It has fire. It is unpredictable. It is undisciplined. It spills itself out in a mineral prodigality not yet crystallized. It is lavish, explosive, untidy."[23] Peggy credited Sweeney's preface and overall support with instilling a certain confidence in the public and she often referred to Pollock as their "spiritual offspring."[24]

After showing William Baziotes, Mark Rothko, Hans Richter, Clyfford Still, Jean Arp, and David Hare, Peggy organized another major women's exhibition in July 1945. It included works by Virginia Admiral, Leonora Carrington, Pegeen, and the sculptor Louise Bourgeois. From the first Spring Salon through several one-man shows, Peggy fought tirelessly for Pollock and in 1945 she doubled the amount of his contract to three hundred dollars a month. At the time this was extremely difficult to justify in business terms since his paintings never sold for over one thousand dollars. Lee Krasner did not forget Peggy's role in launching her husband and the New York School and recognized that her "achievement should not be underestimated; she did major things for the so-called Abstract-Expressionist group. Her gallery was the foundation, it's where it all started to happen. There was nowhere else in New York where one could expect an open-minded reaction. Peggy was invaluable in founding and creating what she did. That must be kept in the history."[25]

In March 1946 Peggy published her memoirs under the title *Out of This Century*. Cautiously, she disguised the protagonists of her life with transparent pseudonyms; Laurence Vail became Florenz Dale; Pegeen, Deirdre; Roland Penrose, Donald Wrenclose; Garman, Sherman; Clotilde, Odile; Leonora, Beatrice; but curiously, Marcel Duchamp became Luigi. The immediate scandal her book caused delighted her; she had kissed and told about all her many love affairs and was unsparing in her account of her differences with Baroness Rebay. Her Guggenheim uncles dispatched employees to all the bookshops in town to try to buy the entire print run and hush up the matter. Peggy blandly denied having said anything awful about the Guggenheims—only the Seligmans. It was good business for the publisher who sold six thousand copies in a few hours. Katherine Kuh, a critic who was to become curator of the Art Institute of Chicago wrote: "A supreme masochist, she is as relentlessly honest about herself as she is about her 'friends.' She leaves us with the picture of a lonely woman, too hard, too hurt, to have retained normal sensitivities."[26] In *View* magazine, on the other hand, Everett McManus was touched by Peggy's confessions and found: "The book convinces us the way Flaubert convinces of Madame Bovary, because it is about the feelings of a woman—not necessarily of a particular woman but of a modern woman. . . . Miss Guggenheim should be praised for taking positive advantage of everything money could buy for her. One might criticize the author's taste, among other points, but she is never ridiculous. Most of her dignity, I would hazard, lies in her apparent awareness of the established tenet that money can not buy happiness if happiness is based, as we suppose on love."[27]

As soon as the armistice was signed, most of the artists in exile and many of Peggy's friends, including Kenneth McPherson, returned to Europe. The gallery was not doing as well as Peggy had hoped, and Pegeen and Sindbad were living in Paris. Peggy had once told Robert Motherwell that she belonged to Hemingway's generation and would go back to Europe when the war was over. So, in the summer of 1946, she set out for France to join her children. Sindbad had married a childhood sweetheart, Jacqueline

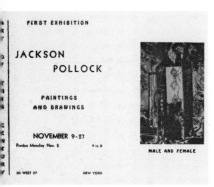

Catalogue for the first Pollock exhibition

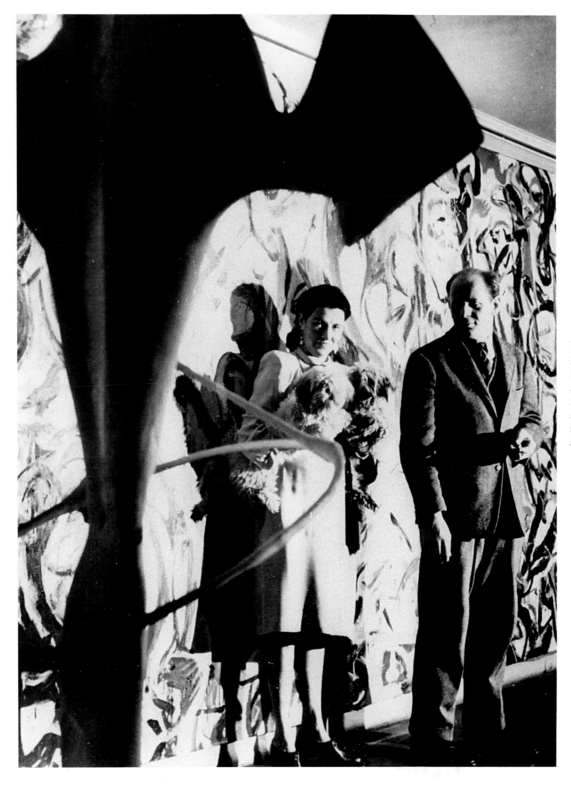

Peggy and Jackson Pollock before the gigantic mural which he created for Peggy's duplex. The painting was too long, so Duchamp picked up a pair of scissors and, with Pollock's approval, shortened it by eight inches

Pegeen painting

Catalogue
for Jean Hélion's exhibition

Ventadour, and was working as an interpreter for the Allied Forces. Peggy found Paris changed. The surrealist movement had broken up, and since the Liberation, everyone's energies were directed toward national reconstruction. There was no one she knew on the café terraces. Peggy pressed on to Venice with Mary McCarthy, who would later give an account of their trip in *The Cicerone*. Peggy is portrayed as Miss Polly Grabbe, an heiress with a passion for modern architecture and a collector of husbands, who is looking for a palace in Venice. On the way she devours all the men she comes across. For Polly, "Men were an international commodity of which one took advantage, along with the wine and the olives, the bitter coffee and the crusty bread."[28]

The 1946 autumn season of Art of This Century opened in October with a retrospective of Hans Richter. In January 1947 Jackson Pollock's fourth show presented the series *Sounds in the Grass* and *Accabonac Creek*, followed by a *Memorial Showing* of Morris Hirshfield's last paintings. The spring of 1947 included shows by Richard Poussette-Dart and David Hare. The gallery's final event was the first American exhibition of Theo van Doesburg. Art of This Century closed its doors for the last time on 31 May 1947. Clement Greenberg wrote of Peggy's achievements in *The Nation,* "Her departure is in my opinion a serious loss to living American art. The erratic gaiety with which Miss Guggenheim promoted 'non-realistic' art may have misled some people, as perhaps her autobiography did too, but the fact remains that in the three or four years of her career

as a New York gallery director she gave first showings to more serious new artists than anyone else in the country. . . . I am convinced that her place in the history of American art will grow larger as time passes and as the artists she encouraged mature."[29] Since her return from Europe, Peggy's main preoccupation had been to try to find a gallery which would take over her contract with Pollock. No one was interested. The best she could do was to get Betty Parsons to offer him a show—at his own expense.

Freed at last of her obligations, Peggy obtained a visa to "study European art" through the good offices of the French cultural attaché, the anthropologist Claude Lévi-Strauss. Before leaving, she had Art of This Century completely destroyed. This was the end of the magical gallery that had given birth to a whole generation of artists that Peggy called her "war babies," where the pictures floated in space, in tune with the spirit of the times. It had fulfilled its innovative purpose, a catalyst between the continents, between generations, and between creative forces. Leaving her collection in storage, Peggy flew to Paris with her two dogs and a hazy dream of a Venetian palace.

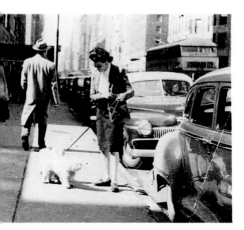
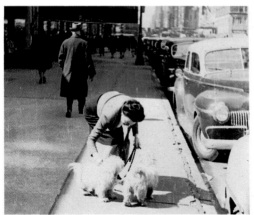
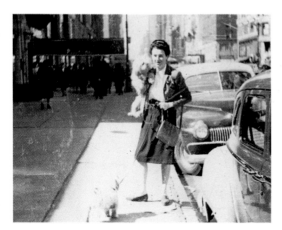

Peggy with her dogs near Art of this Century, shortly before her departure for Europe

Peggy's travel scrapbook from her trip to Venice in 1921

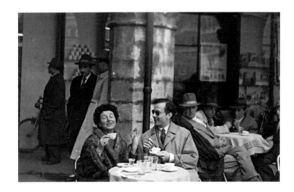

Peggy with Vittorio Carrain, her secretary and confidant

136

CLOCK TOWER
PIAZZA SAN MARCO

VENETIAN RENAISSANCE

Venice was iridescent in the morning mist on a fine summer day as Peggy, newly arrived from New York, made her way across the deserted Piazza San Marco. She took a seat on the terrace of the Café Florian, ordered a cappuccino, and lit a cigarette. War had passed through Europe without leaving a blemish on the immortal city of the Doges. Peggy remembered her visit to Venice the previous summer when, although traveling with Mary McCarthy and her husband, she had been lonely and had felt a need to meet new people in the city she loved. The owner of a cafe at the Rialto suggested that she go to the Angelo restaurant, near San Marco—a haunt for local artists, where the owner, Renato

Carrain, offered meals in exchange for pictures. "And ask for Vedova," he added. "Vedova—All'Angelo, Calle Larga San Marco 403," Peggy noted on a match box.

On foot she crossed the piazza, paused to caress the marble lions outside the basilica, walked through the arched passage that pierces the clock tower _dei due Mori_, and was soon swallowed up by a narrow street. A short distance away stood the Angelo. In a mixture of French, Italian, and English, Peggy haltingly asked a waiter if Vedova was around. He pointed out a tall young man with a black beard seated at a nearby table; he was finishing a meal with a friend. Emilio Vedova was at first startled to be accosted by this woman, who seemed at once shy and provocative, dressed as she was in a gaily striped orange and green dress, suntanned to the color of gingerbread, and studded in copper jewelry. When Peggy introduced herself, Vedova was amazed. He had already heard of her, of her New York gallery and her wild escapades with the greatest artists of the time. He and his friend, a Venetian abstract painter named Giuseppe Santomaso, gave Peggy a warm welcome; the two of them soon became her friends and her guides in the Italian art world. She was astonished by how well-versed they were in modern art and the New York scene. They even had a catalogue from her Uncle Solomon's museum. This was all the more surprising since Mussolini's fascist regime had been hostile to the various intellectual and artistic movements that had developed in Europe and America, banning the import of most art books and publications. When Peggy returned to Venice in 1947, her reputation as an enlightened art lover and female Casanova (in Herbert Read's words) created a stir among the Venetian artists. The Angelo soon became her regular restaurant and she spent long evenings in endless discussions with her inseparable friends. Santomaso tutored her in Venetian history, while Vedova, a partisan turned Communist, painted abstract paintings. "He was very young and mad about lovely young girls,"[1] recalled Peggy affectionately. When Peggy announced her intention to settle permanently in Venice, it seemed like the whole town began searching for a suitable _palazzo_. Art students, café waiters, architects, gondo-

Relaxing with her dogs _The Angelo became her canteen. Here with Santomaso, Pallucchini, and friends_ _At work with her dog_

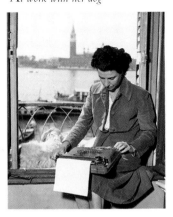

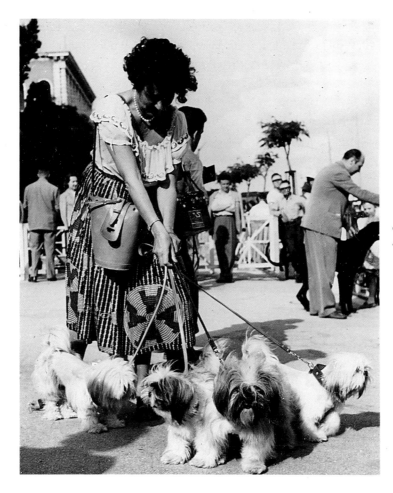

The Venetians nicknamed her "l'americana con i cani"

liers, or friends of friends, everyone studied the façades that lined the canals, hoping to find one that would take the fancy of the _collezionista americana_.

In November, Laurence Vail and his new wife Jean Connolly came to meet Peggy and travel with her to Capri. Dressed in an orange pullover and sandals, she rented the splendid hilltop Villa Esmeralda for the winter. Kenneth McPherson and many friends, both old and new, were on the island. Life was free and stimulating. It was a sort of earthly paradise. "People do mad things and no one can be held responsible for their actions. . . . There is an intense social and sexual life in Capri. One need never be alone for five minutes,"[2] Peggy confided in a letter to Clement Greenberg. The only thing she missed about New York was the opportunity to buy paintings. Having heard that Baziotes had received the Chicago Prize, she added that she was still pleased even though Pollock had not won. Pegeen came to join her for ten days with her first son, Fabrice, named after the hero of Stendhal's _The Charterhouse of Parma_. Before leaving the island, Kenneth gave her White Angel, a Tibetan terrier he had bought from Max in New York. Peggy was

charmed by the little dog, "She was my favorite; she was warm and wonderful and seemed so human."[3]

Peggy moved into the Palazzo Barbaro on the Grand Canal in the spring of 1948. It was in this same palace that her favorite author, Henry James, had written *The Wings of The Dove.* Sindbad and Jacqueline came from Paris for a short visit. Then her lawyer, Bernard Reis, and his wife, Rebecca, brought her a male Lhasa Apso from New York as a "fiancé" for "her daughters." Touched by this gesture she gave them *The Cathedral* by Pollock as a Christmas gift. This was one of Peggy's eighteen Pollocks that she gave to friends—many others were eventually donated to museums. Mary McCarthy visited and read aloud passages from her novel that caricatured Peggy as the avaricious Miss Polly Grabbe; the writer was surprised by her friend's failure to respond. Peggy later said that she had been unwell the day that Mary came and she had slept through the reading, "I never heard a word. Later, I was furious."[4]

With a work by Pegeen on the steps of her pavilion at the 1948 Venice Biennale

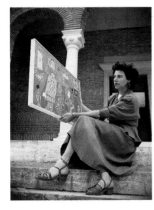

From left to right: Rodolpho Pallucchini, Marc Chagall, and Giuseppe Santomaso leaving Peggy's exhibition at the Biennale

Peggy receiving the Italian president, Luigi Einaudi, at the entrance to her pavilion

Between the beaches of the Lido or the small islands in the lagoon for sunbathing, and the churches or *palazzi* for taking in Carpaccio and Tintoretto, life in Venice seemed like an unending holiday. Still, boredom was beginning to set in when Santomaso suggested that Peggy take her collection out of storage in New York and show it at the 1948 Biennale. This international contemporary art exhibition, which normally takes place every two years in Venice's public gardens at the tip of the city, had been interrupted by the war. Each participating nation is responsible for its own pavilion, and when the Biennale started up again in the summer of 1948, the Greek pavilion was vacant, since that country was still caught up in civil war. Santomaso was able to persuade the Biennale's secretary-general, Rodolfo Pallucchini, to let Peggy take the empty space. Pallucchini was a great Renaissance specialist and somewhat reticent about later periods. Peggy described him as "very strict and tyrannical. He reminded me of an Episcopalian minister."[5] She thought it must have taken considerable courage for him to fill his post as a purveyor of modern art. While Carlo Scarpa, Venice's most modern architect, was restoring her pavilion, Peggy strolled in the alleys of the gardens, breathing the perfume of the lime tree

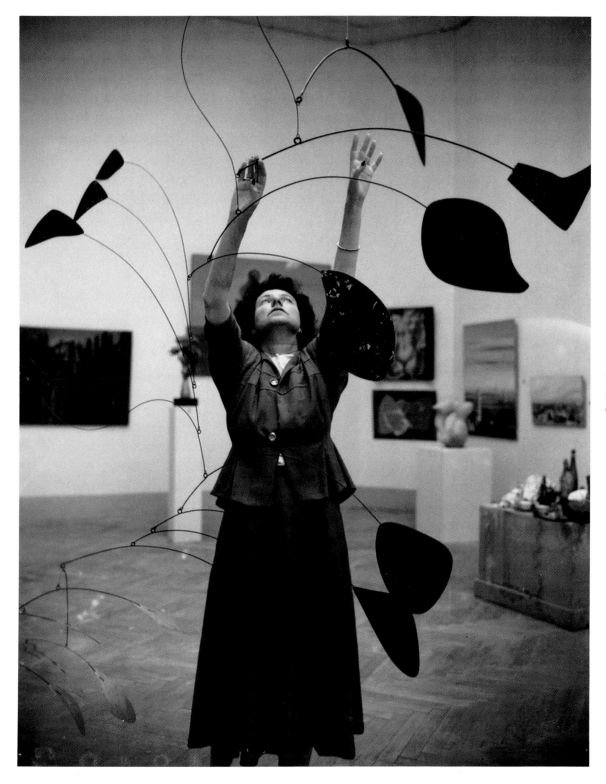

*Hanging the Calder
mobile in her pavilion
at the Biennale*

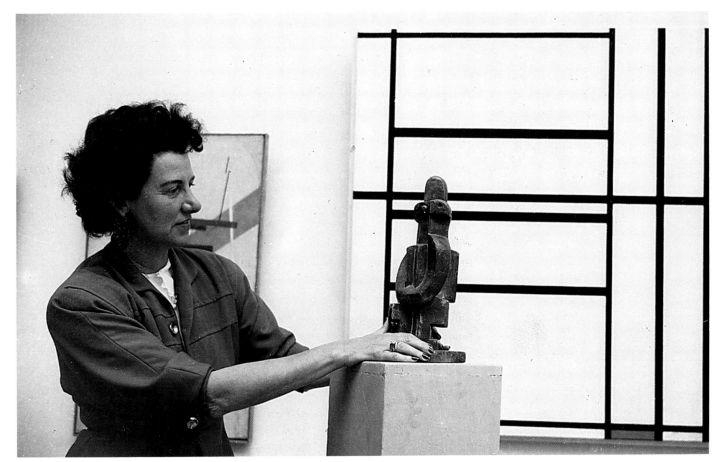

P_lacing a sculpture by Lipchitz in front of a Mondrian_ Composition

blossoms, and holding animated discussions with Umbro Apollonio, Pallucchini's assistant. Like most of his compatriots, he had never heard of Brancusi, Arp, Giacometti, Pevsner, or Malevich. Peggy's Lhasa terriers soon became the Biennale's mascots. The Paradiso restaurant at the gates of the _giardini_ would offer them chocolate ices, then they would dash excitedly through the shrubbery to their mistress's pavilion. If the dogs got lost in the maze of pathways, she always found them at the Picasso exhibition and credited their good taste to days spent browsing in her New York gallery.

Peggy was both excited and nervous about the exhibition. She was not at all sure that her collection was complete enough to participate in such an international event. But when she "saw the name of Guggenheim appearing on the maps in the Public Gardens next to the names of Great Britain, France, Holland, Austria, Switzerland, Poland, Palestine, Denmark, Belgium, Egypt, Czechoslovakia, Hungary, Romania," she was thrilled and gloried in the moment: "I felt as though I were a new European country."[6]

Shortly before the opening, Palluchini had a drawing by Matta removed from the Guggenheim pavilion because he found it too erotic. Then, at the last minute, Count Elio Zorzi, who ran the press office, informed Peggy that President Luigi Einaudi would be visiting the pavilion. He sternly requested that she provide him with an overview of modern art during his five-minute visit. Stranded in Venice with neither hat nor gloves, she had to borrow the appropriate accessories—including a girdle and stockings. To replace the requisite hat, she wore gigantic Venetian glass-bead earrings in the shape of daisies. Peggy had barely had time to greet the president when the entire party was whisked away by the press, but she was delighted to be photographed with the entire official cortège beneath the Calder mobile.

Between 6 June and 30 September thousands of visitors viewed the collection. The Peggy Guggenheim pavilion was the most popular in the entire Biennale. While the other thirteen pavilions presented various "official" views, they were out of touch with what was really happening; only Peggy gave a truly international perspective on modern art. Among her illustrious visitors was the art historian, Bernard Berenson, author of the famous "seven points." Peggy nearly fainted as he walked up the steps to greet her. When she told him that she had read all of his books and how much she admired them, Berenson replied, "Then why do you go in for this?" Peggy answered that she felt a duty to help contemporary artists and added that, in any case, old masters were too expensive for her. "You should have come to me, my dear, I would have found you bargains,"[7] Berenson retorted. He was horrified by a small bronze reclining figure by Henry Moore, which he found "distorted." Even so, the critic admitted that the Pollocks would make beautiful tapestries and that the Ernsts would be interesting, had they not been so sensual: he had a profound distaste for sex in art. As he was leaving, the eighty-five-year-old critic asked her to whom she planned to bequeath her collection. Peggy smiled and said "To you, Mr. Berenson." When recalling this incident, Peggy laughed and concluded: "He nearly had a fit!"[8]

Another less courteous visitor was so enamored of a small bronze by David Hare that he left with it in his pocket. A second disaster was avoided by the publisher, Bruno Alfieri, who saved a Calder mobile in the nick of time. It was laying in pieces on the floor, and the workmen, thinking it was scrap metal, were about to throw it out with the trash.

Cubism, surrealism, and the New York School became the talk of the cafés and salons of Venice. As a result of all this publicity Peggy was assailed by artists wanting to sell their work. It got to the point where she had no peace—they even lingered in her hotel lobby. Vittorio

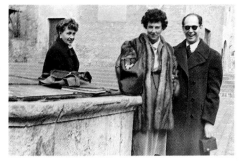

Peggy with Vittorio Carrain

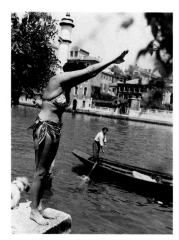

Gondoliers' delight

Carrain, a gifted, amusing young man who was one of the owners of the Angelo restaurant, did his best to protect her from these intrusions. He soon became her secretary, keeping her abreast of current events, since Peggy had renounced reading newspapers.

When the Biennale closed, she discovered that her pictures, which had been granted a temporary import license for the occasion, could remain in Italy only if she paid a three percent duty on them. The only way to reduce the tax was to send the collection out of the country and bring it back in at a much lower valuation. Peggy was trying to find a solution to the problem when Carlo Ragghianti, a noted critic came to her rescue. He suggested that she exhibit in Florence at the Strozzina, the cellar of the Palazzo Strozzi, where he was opening a modern art gallery. Due to limited space, the collection was shown through February and March 1949 in three separate stages: first cubist and abstract works, then surrealism, and finally young painters. It was an overwhelming success and Peggy became the darling of Florentine society.

Back in Venice Peggy met Roloff Beny, a young Canadian photographer. Returning from a trip to Greece, he had decided to approach the famous Miss Guggenheim whose memoirs he had read as a student at the University of Iowa. They quickly became friends. Soon afterwards, in June 1949, Peggy's collection was shown at the Palazzo Reale in Milan, with the proceeds going to the Italian Artists Association. The exhibit was such an enormous success that visitors had to rent catalogues while new ones were being printed. Despite, or perhaps

The original plan for the Palazzo Venier

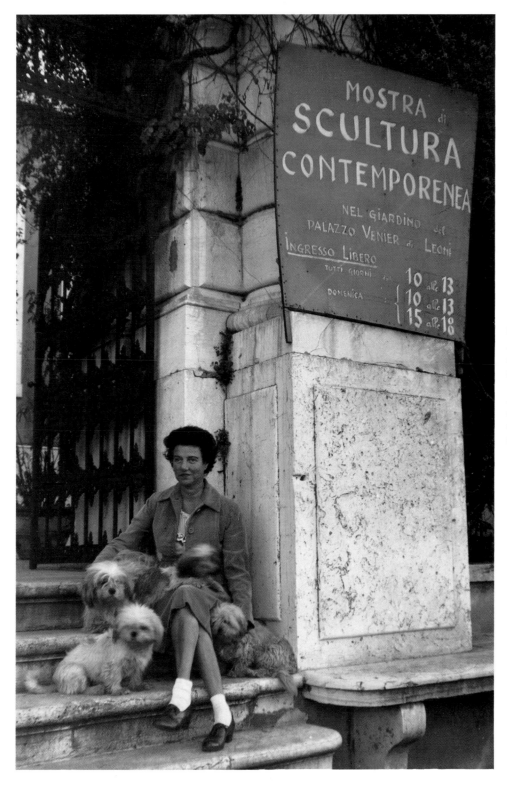

MOSTRA di
SCULTURA
CONTEMPORENEA

NEL GIARDINO del
PALAZZO VENIER di LEONI

INGRESSO LIBERO
TUTTI GIORNI del 10 alle 13
DOMENICA { 10 alle 13
{ 15 alle 18

On the steps of the Palazzo Venier. As she had done for the opening of Guggenheim Jeune, Peggy's first exhibition at the palazzo was a show of contemporary sculpture, September 1949

because of her growing celebrity, Peggy was no nearer to finding a satisfactory solution to her problems with customs. Her pictures were being stored at the Cà Pesaro, the Museum of Modern Art in Venice, by the curator, Dr. Guido Perocco, and Peggy was only allowed to take a few out at a time. However, the following year the museum put on a show of the Americans in the collection and the British Council held an exhibition of Peggy's works by English artists.

In the spring of 1949, Count Zorzi's secretary found Peggy her dream home—an unfinished palace near the Accademia that faced the Prefettura (prefect's palace) across the Grand Canal. The building had been begun in 1748 by the legendary Venier family, which had produced two of the city's doges and reportedly kept lions on their property. This legend, along with the eighteen carved marble lion heads that decorate the façade, gave the palace its name: Palazzo Venier dei Leoni. The Veniers had stopped construction midway, so the *palazzo non compiuto* had only one finished floor. Perhaps due to its incomplete state, the building was not classified as a hallowed national monument, and Peggy would be able to make the changes necessary to house her collection. During the war, the *palazzo* had been requisitioned by the Germans, then by the British and the Americans during their subsequent occupation of the city. However its notoriety in Venetian folklore was due to its

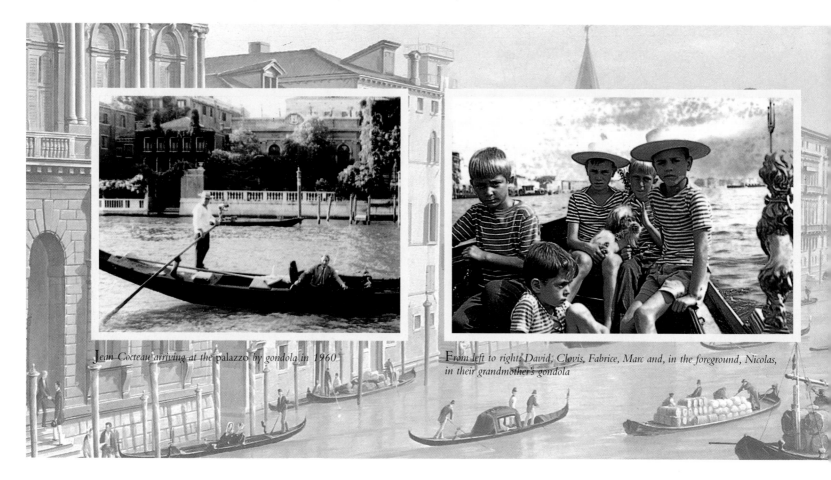

Jean Cocteau arriving at the palazzo by gondola in 1960

From left to right: David, Clovis, Fabrice, Marc and, in the foreground, Nicolas, in their grandmother's gondola

previous owners. Around 1910, Marchioness Luisa Casati moved into the premises. She was the lover of novelist and poet Gabriele d'Annunzio, who lived on the other side of the canal with the actress Eleonora Duse. The marchioness kept not lions but leopards—some said a black panther—among the cedars, magnolias, and acacias in the garden. The costume balls which she organized for the Russian critic and ballet producer, Diaghilev, were illuminated thanks to handsome young torchbearers, their bodies painted with gold leaf. A scandal forced the marchioness to leave Venice hurriedly and the _palazzo_ was left abandoned. In 1938, Lady Castlerosse purchased the now dilapidated palace and spent a fortune restoring it. She put in six luxurious bathrooms in black, pink, and green marble, had mosaic floors inlaid with mother-of-pearl, and covered the walls with stucco "icing." While Peggy appreciated the intricate floors and the sumptuous bathrooms, she had the walls stripped clean. The Guggenheim terriers replaced the Venier lions and the Casati leopards. The roof terrace became a sundeck and was equipped with deck chairs and swings. At first Peggy was anxious about the reaction of the prefect across the canal, but he gallantly commented, "When I see Mrs. Guggenheim sunbathing on the roof, I know the spring has come."[9]

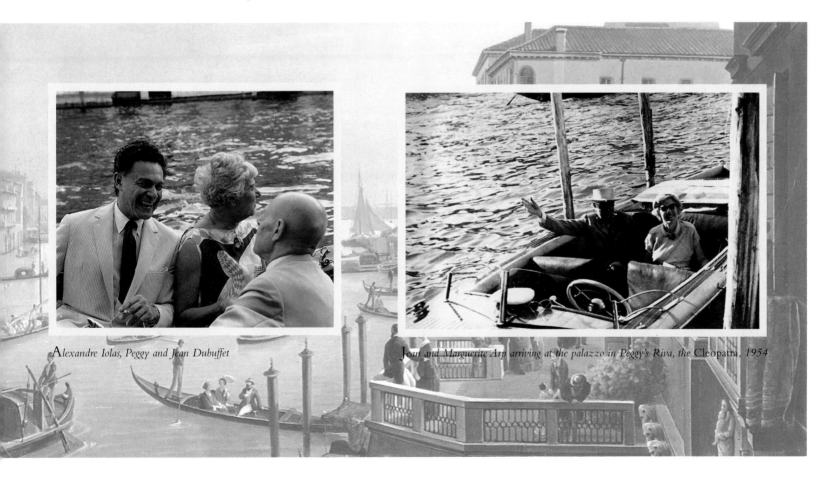

Alexandre Iolas, Peggy and Jean Dubuffet

Jean and Marguerite Arp arriving at the palazzo in Peggy's Riva, the Cleopatra, 1954

Jean Hélion and Pegeen

In the fall of 1949 Peggy organized a garden exhibition of sculptures by Giacometti, Arp, Brancusi, Calder, Lipchitz, and Marino Marini, whom she had recently met. She placed his bronze *Angel of the Citadel* on the terrace facing the Grand Canal. This was a statue of a horse and rider, his arms thrust out in ecstasy. "To emphasize this," Peggy wrote, "Marini had added a phallus in full erection. But when he had it cast in bronze for me he had the phallus made separately, so that it could be screwed in and out at leisure."[10] Peggy removed it scrupulously when she expected visits from church dignitaries or when religious processions passed by in boats on the Grand Canal. But one day, this fascinating detail had to be recast because a visitor, whether prude or libertine, had taken it away as a souvenir. This time it was welded permanently to its rightful proprietor.

Peggy was still trying to extricate her collection from the temporary importation controls, but she was able to lend her twenty-three Pollocks to the Correr Museum for the artist's first exhibition in Europe. Thousands of people saw the exhibit in this prestigious setting and it had a wide influence on young painters. "It was always lit at night," Peggy recalled, "and I remember the extreme joy I had sitting in the Piazza San Marco beholding the Pollocks glowing through the open windows of the museum."[11] Buoyed up by this success she organized a retrospective for her son-in-law, Jean Hélion, at the Palazzo Giustinian. Christian Zervos, the editor of *Cahiers d'Art,* wrote a long catalogue preface, which Peggy abridged. She showed three periods of Hélion's work: early naturalistic, abstract, then a return to almost total realism. Pegeen, who continued to paint, was promised an exhibition as soon as the *palazzo* was renovated.

Just as Peggy was despairing of resolving her problems with the customs authorities, the curator of the Stedelijk Museum offered to show the collection in Amsterdam through January and February 1951. From there it would travel to the Palais des Beaux-Arts in Brussels and the Kunsthaus Museum in Zurich. This was the answer to Peggy's prayers; once outside of Italy, she could re-import the paintings. At four o'clock one morning the collection slipped through an obscure alpine border post, where a sleepy official let the strange merchandise through at a ridiculously low valuation.

One day, while she was organizing the interior of the *palazzo*, Peggy noticed a small man in slippers puttering around the courtyard. It was Truman Capote. They got on so well that he moved in for two months, during which time he wrote *The Muses are Heard.* For once Peggy was portrayed in a better light than the other protagonists. From time to time, Truman declared that, despite the age difference, he dreamed of marrying her. When articles about Jackson Pollock started appearing in the States with no mention of Peggy's name, Capote got upset and said he would write to the papers to demand that they publish a correction. Naturally he never found time to carry out this project. For her part, Peggy was delighted to have found a companion who fussed over her. "He was keen on keeping his line and made me diet also," she recalled. "Every night he took me to Harry's Bar and made me eat fish. He only allowed me a light lunch of eggs. He is always madly amusing and I loved having him stay with me."[12]

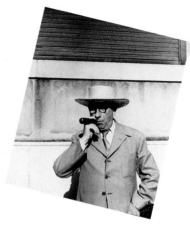

Jean Arp "smoking" the removable phallus of The Angel of the Citadel

Pegeen

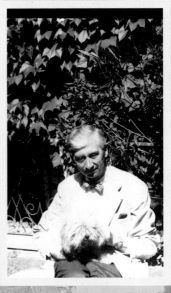

*Peggy, Pegeen, and her husband,
Jean Hélion carrying their son Fabrice on
the Piazza San Marco in Venice, 1950*

Roloff Beny and the vestal of the Arts

Sir Herbert Read with Sir Herbert, the terrier

Max Ernst and Victor Brauner fussing over the newest "beloved babies"

*Somerset Maugham and Emily Coleman in the garden
of the palazzo*

On the terrace with, from left to right: Ken Scott, Count Elio Zorsi, and Tennessee Williams

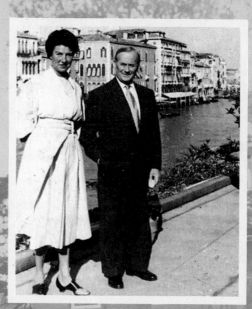

With Joan Miró in 1954

Truman Capote spent two months at the palazzo writing The Muses are Heard

Jean Cocteau wearing Peggy's glasses

Frederick Kiesler and Peggy

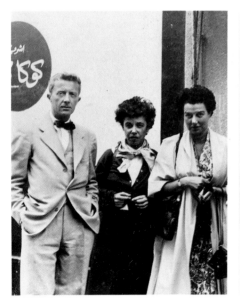

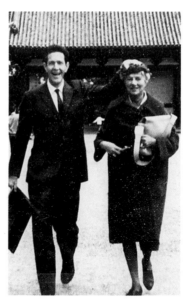

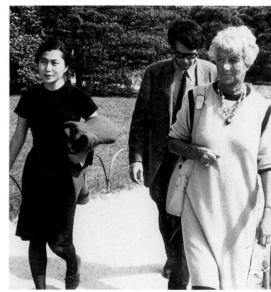

With Paul and Jane Bowles in Tangiers

With Tensing Norkay, one of the conquerors of Everest

With John Cage in Tokyo

With Yoko Ono in Japan, 1962

In the autumn of 1954, Peggy traveled to Sri Lanka to visit her old friend Paul Bowles. In the days of Art of This Century, when Bowles was essentially a composer, Peggy had produced a recording of his music. Peggy's companion for three years, Raoul Gregorich, had just been killed in an automobile accident and she hoped that a change of scene would help her get over her grief. Paul came to meet her at the Weligama station in a screeching ox-cart. Peggy later remembered that to reach Taprobane, his island property, "one had to pick up one's skirts and wade through the Indian Ocean. There was no bridge or boat. The waves usually wet one's bottom but the beauty of the surroundings made up for all the inconveniences. . . . It was fantastically beautiful and luxuriant, with every conceivable flower and exotic plant from the east. . . . It was another dream world, so different from Venice."[13] At night bats with large teeth and a three-foot wingspan, which the natives called flying foxes, took over the island's sky. But Peggy was more impressed by the beauty of the Singhalese fishermen who paddled their dugouts over the crests of the waves. After five weeks in Sri Lanka, Peggy set out alone. Her trip had been planned by the Indian ambassador to Colombo, Thakore Saheb, who was married to the sister of the Maharajah of Mysore. Even after cutting his proposed itinerary by half, the exhausted Peggy visited some twenty towns in less than six weeks. After meeting the Maharajah of Mysore she went to Chandigarh in Pakistan. This model town had been designed by Le Corbusier and was intended to provide affordable housing for the poor.

From left to right: Pegeen, Dorothea Tanning, Max Ernst, Peggy, Victor Brauner, and Tancredi, Piazza San Marco, 1954

She found it very socialist, but an excellent example of a modern city which respected the architect's theories of human proportions. She then moved on to Darjeeling, where she hoped to buy Tibetan terriers to put an end to the inbreeding at the *palazzo*. But she was disappointed by a visit to Tensing Norkay, who had climbed Everest with Sir Edmund Hillary. He had six Lhasa terriers, but was unwilling to part with a single one of them.

Back in Venice, invitations to Peggy's receptions became the ones most avidly sought after by visitors to the Venice Biennale. Young artists were dying to be introduced to her and dealers unfailingly turned up with tempting propositions, despite the assurance that she could no longer afford to buy what she would like, since art had become so commercial and prices had become excessive. She began collecting primitive art: totems, African masks, and pre-Columbian carvings. "It reminded me," she said, "of the days after Max had left our home, when he came back in the afternoons, while I was at the gallery, and removed his treasures one by one from the walls. Now they all seemed to be returning."[14] In 1954 the Biennale Prize was given *ex-aequo* to an old friend, Jean Arp and to her ex-husband, Max Ernst. Max, anxious to make peace, wrote in Peggy's guest book: "An old friend is come back forever and ever and ever."[15]

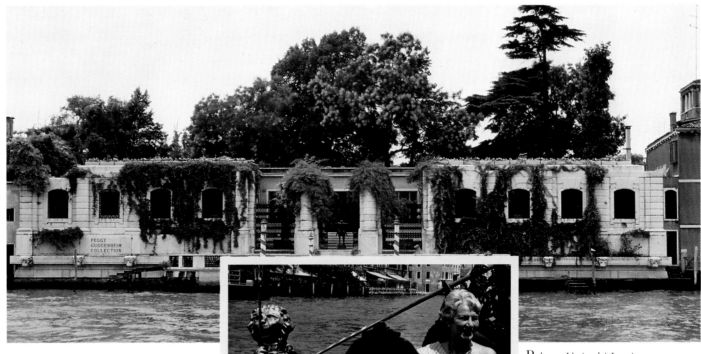

Palazzo Venier dei Leoni

THE LAST DOGARESSA

In the enchanted garden of the *palazzo*, Peggy installed a marble Byzantine throne. The enigmatic shapes of sculptures by Brancusi, Richier, or Giacometti awaited discovery in the luxuriant shrubbery. To guard the entrance to this already legendary space, Peggy commissioned Claire Falkenstein to create new gates; these are a magical weave of iron rods welded into a delicate interlace, inset with broken shards of colored Murano glass that gleam like precious gems. The changes she made within the *palazzo* were even more striking. Her bedroom, with a view of the Grand Canal, bore Peggy's most personal touch. Against the turquoise walls, shimmering like the water itself, stood the silver bed head with a swinging fish and butterfly, which Calder had made in 1946 in New York, but it seemed to have been made for its ultimate destination: Venice. The cherished marabou bed throw had survived the ravages of generations of dogs since Hayford Hall. One wall held *Chimpanzee* by Francis Bacon, "the only [painting] of his I have ever seen that didn't frighten me,"[1] remarked Peggy. An antique silvered Venetian mirror

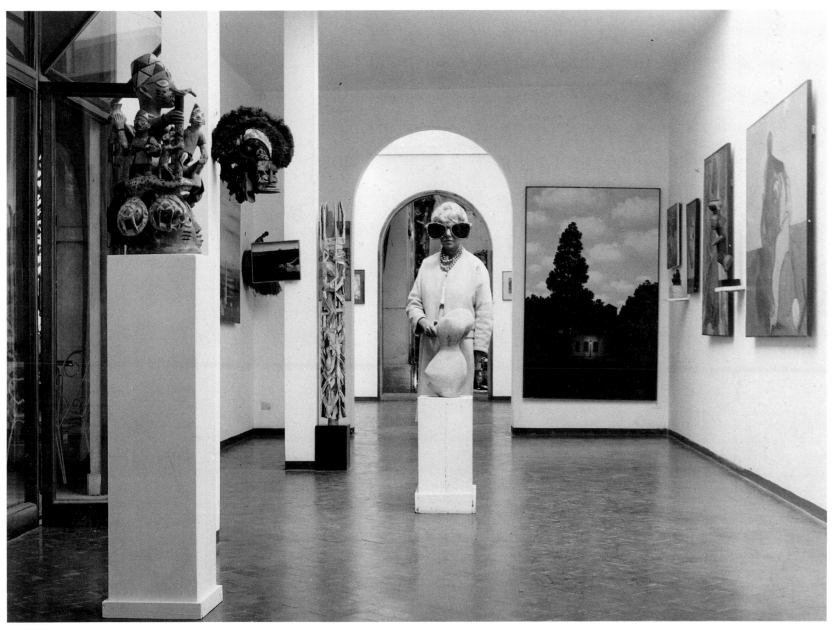

P*eggy, in her surrealist gallery, with the sculpture* Couronne de bourgeons I *(Crown of buds I) by Jean Arp; in the background,*
L'Empire des lumières *(Empire of light) by Magritte*

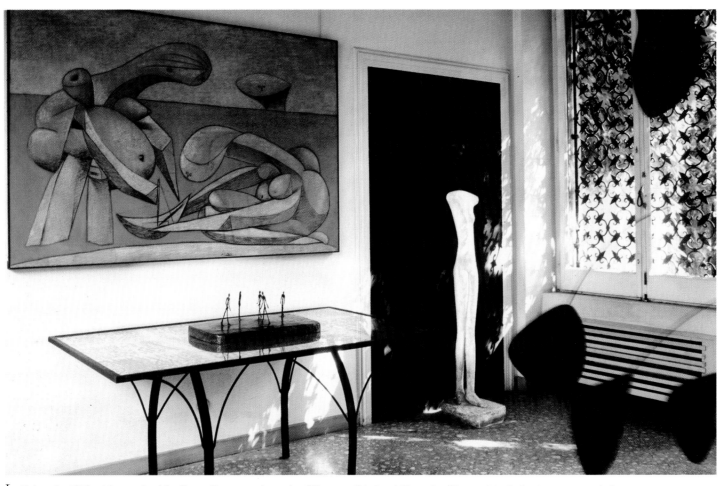

La Baignade *(Girls with a toy boat) by Picasso,* Femme qui marche *(Woman walking) and* Piazza *by Giacometti in the luminous entrance hall*

With *Giacometti*

With *Sindbad*

reflected Laurence Vail's bottles, Cornell's surrealist boxes, and the portrait of Peggy at the age of four by von Lenbach. Hundreds of earrings from all over the world covered one wall giving an exotic touch to this already fantastic ambiance. In the cubist dining room, the fifteenth-century furniture that she had bought with Laurence in the 1920s was allied harmoniously with works by Duchamp, Léger, Villon, Marcoussis, Gleizes, Metzinger, Braque, and Picasso as well as with primitive sculptures. The iron leaves of a large Calder mobile turned lazily before Picasso's *La Baignade* in the light and airy entrance hall where Peggy liked to be photographed. The staff quarters and the laundry had been transformed into galleries with the help of Matta, when he stayed with Peggy for several weeks. Downstairs, there were no less than twenty-three magnificent Pollocks in a gallery dedicated to the pioneer of abstract expressionism. Scattered throughout her home a pre-Colombian mask, an African carving, or a Polynesian ritual object shed a new perspective on the modernity of present-day art. As the *palazzo* became more and more crowded,

156

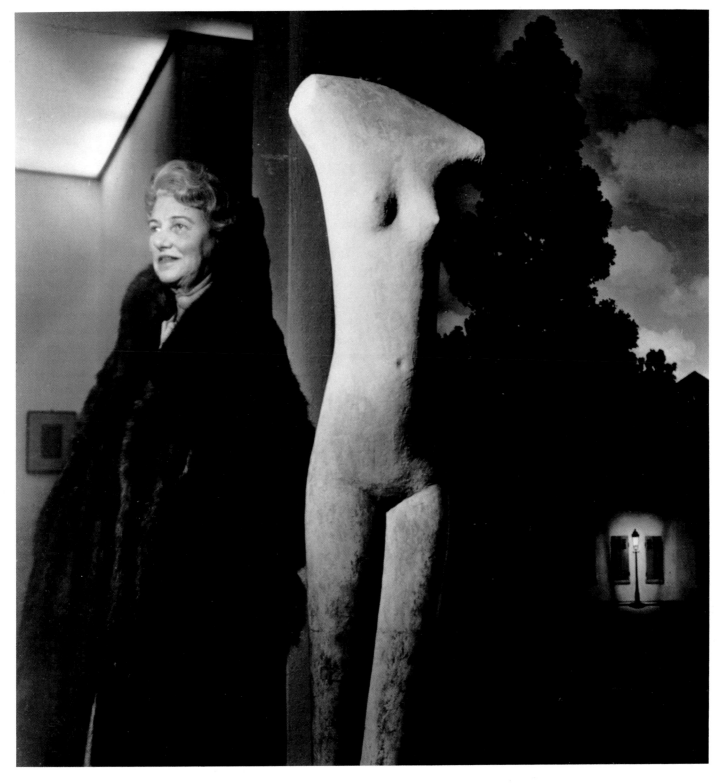

Right: *Peggy
stands with the*
Femme qui
marche *and*
L'Empire des
lumières *in
the mysterious
ambiance
of the* palazzo

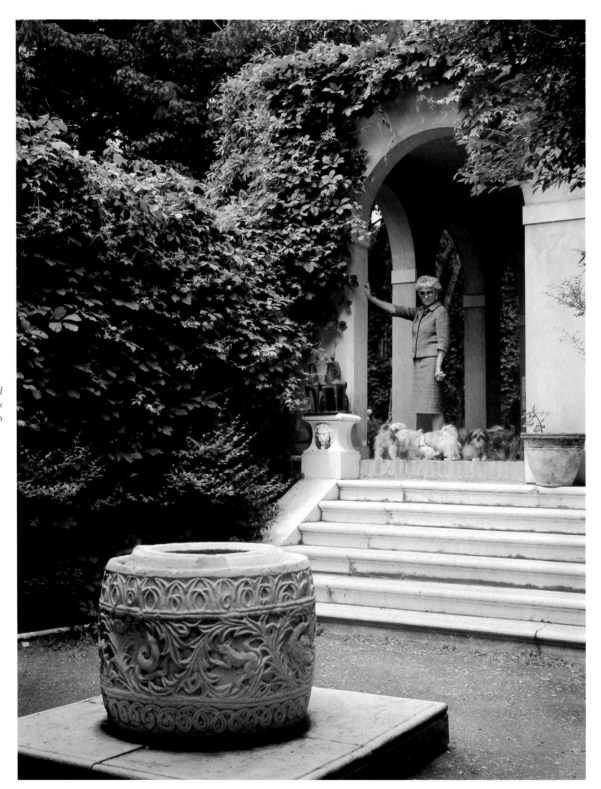

The last Dogaressa and her guardians on the steps of the palazzo

Peggy decided to build a pavilion in the garden. Her original idea was modeled after De Chirico's *Melancholy and Mystery of a Street,* but Vittorio Carrain warned her that such a series of arches would look too fascist. In the end, she took her friend Martyn Coleman's advice and copied a wing of a Palladian villa. When this *barchessa*—a sort of Venetian barn—was completed she exhibited a group of young painters and called the show "my Biennale." The pavilion eventually became her surrealist gallery.

Peggy's enthusiasm for contemporary art was waning; she thought that artists were simply imitating work that had been done with much more talent forty years earlier. However, in the early 1950s she supported Italian artists such as Bacci, Tancredi, and Vedova while making it clear that she preferred modern sculpture to painting. The collection was now open to the public three afternoons a week, and the hostess liked to mingle incognita with her guests to eavesdrop on their comments. She was amused by the Princess Pignatelli's remark, "If you would only throw all those awful pictures into the Grand Canal, you would have the most beautiful house in Venice."[2] While her grandchildren were pressed into service selling catalogues, her two Italian maids acted as guides. One evening after the museum had closed, they informed Peggy, in shocked tones, that a man had told a group of students that a cubist painting by Braque was a Picasso. When she asked them why they had not corrected him, they replied as one, "Oh no, we couldn't, because he was a professor." The house staff rapidly acquired an excellent art education and Peggy was happy to state: "Besides making my maids into curators, I also taught my two gondoliers to be expert picture hangers."[3]

Ralph and Pegeen at the Angelo

When André Malraux, the French Minister of Culture, visited Peggy in Venice, he proposed that she show her collection in Paris at the Museum of Modern Art, which he promised to renovate for the event. But Nellie Van Doesburg, who thought the museum space was not prestigious enough, advised against it. As she was escorting him around the *palazzo,* Peggy noted that he seemed to be fascinated by her daughter. Pegeen was amused by the abstruse and recondite theories of the famous writer, who took infinite pains to explain her own pictures to her. Pegeen created beautiful naïve paintings which the celebrated French writer, Raymond Queneau, described in his preface to the catalogue of her exhibition at the Galeria del Corso as "a world more real than the real world, because it is closer to the Earthly Paradise. No sense of guilt clouds her colors or oppresses her line." Quoting the poet Jacques Prévert, he added "it is a new age: a fertile land, a child moon, a welcoming sea, a smiling sun, on the water margin, the airy threads of time . . . " and Pegeen was one of these "adorable children."[4]

Meanwhile, Pegeen had separated from Jean Hélion, with whom she had three sons, Fabrice, David, and Nicolas. In 1957, Peggy took her daughter to England, hoping to break up her turbulent relationship with the painter Tancredi by marrying her to an English lord. Returning to Peggy's old haunts in Cork Street, they went into the Redfern Gallery where Ralph Rumney was having an exhibition. This young English artist was seen by certain critics as one of the more promising painters of his generation. He was the son of an Anglican vicar and was soon to become one of the founders of the

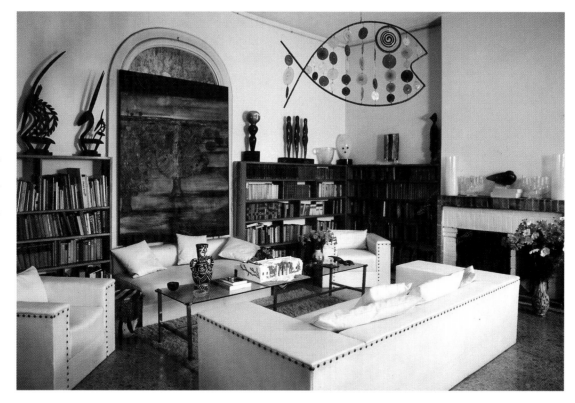

In Peggy's salon a Calder mobile of Murano glass poses as a chandelier among primitive fauna, sculpted in wood and gathered from the four corners of the earth; in the background, L'Automne à Courgeron by René Brô

With the faithful Nellie

Situationist International. His striking appearance and his unwavering hostility to received ideas made him a sort of incarnation of the archangel Lucifer—too gifted to follow the well-posted pathways of a facile career. "Polemic" was a word that might have been coined for him, but he claimed it was only "the wall that protects my territory."[5] Rumney suggested to Peggy that she go to the Francis Bacon opening which was taking place at the Hanover Gallery that evening. Peggy was exhausted and sent Pegeen to look the show over (She subsequently went herself and bought *Chimpanzee,* which was to hang in her bedroom). During the party which followed this opening, Ralph fell in love with Pegeen and gave her the largest picture in his own show, *The Change,* which is now in the permanent collection of the Tate Gallery. Peggy returned to the Redfern the following day and attempted to buy *The Change* privately from the artist without paying the gallery commission. She was accompanied by her daughter, whom Ralph had not yet associated with Peggy. When he told her that the picture belonged to Pegeen she was, to say the least, displeased.

The lovers flew to Paris, leaving Peggy, and her dreams of a prestigious marriage, in disarray. On one of her subsequent—and now frequent—trips to London, Pegeen was questioned by an immigration official, who found the number of visits recorded in her passport intriguing. Her explanation was simple: "I'm madly in love." Peggy could not accept that she no longer had exclusive rights over her daughter and became bitterly

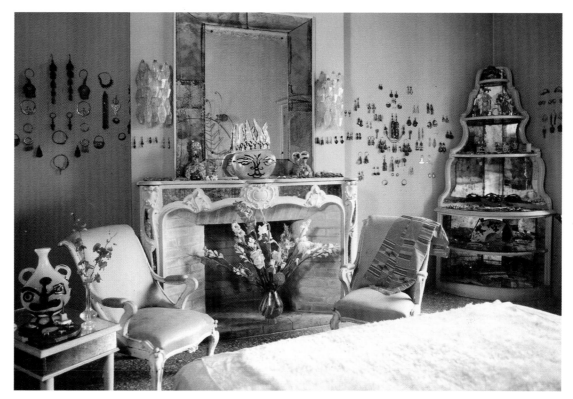

Murano glass and earrings affixed to the wall capture the shimmering light of the canal that floods into Peggy's bedroom

jealous. "By ostracizing your daughter," warned Cocteau in a letter to Peggy, "you are damaging yourself and hurting her, yet destiny weaves exactly the same threads as if you were seeing her. So? Let the stars manage things without interfering. When we meddle with our lifeline, we only achieve muddle and we distance ourselves from those who could help us to live."[6] On his way back from the Lido, Cocteau stopped off at the penthouse in Castello where Pegeen and Ralph were living and offered to become the godfather of their baby son, Sandro, who had been born in Venice and named after the great Renaissance artist, Botticelli.

With Jean Dubuffet

Ralph, Pegeen, Sandro, and his half-brother Nicolas (six years his senior) split their time between the Île Saint-Louis in Paris and the Giudecca island in Venice. In the morning they were greeted by the smell of turpentine and the vestiges of parties which Peggy herself would not have disavowed in earlier days. The couple frequented the dinners that Daniel Spoerri gave at the Galerie J and preserved as "snare-pictures" by glueing all the used plates, glasses, and cutlery to the table-tops. In divergent ways the New Realists and the Situationists were breaking the taboos of past generations. Raymond Hains lacerated posters in Paris, Mimmo Rotella ripped the film posters of Cinecitta, César crushed cars, and Yves Klein discovered the ultimate blue. Among the rebels of the Age of Aquarius, the Situationists, who were the harbingers of the May 1968 riots in Paris, made devastating criticisms of consumerism in books such as *Traité de savoir-vivre à l'usage des jeunes*

générations by Raoul Vaneigem and *La société du spectacle* in which Guy Debord asserted, "the world already possesses the dream of a time which it must now consciously possess if it is to live it in reality."[7]

In 1960 Macmillan published *Confessions of an Art Addict,* a watered-down version of *Out of This Century.* Peggy compared the two: "I seem to have written the first book as an uninhibited woman and the second one as a lady who was trying to establish her place in the history of modern art."[8] Djuna asked her why she had felt the need to rewrite but added: "Thank you for your own *personal* discretion in saying nothing."[9] She added, "if you are 'correcting' the reissue of your book, you might remove the remark that I was 'embarrassed' by being 'caught' wearing the handsome (mended) Italian silk undershirt— I was not annoyed at that, (or I should not have worn it). I was annoyed, and startled, that someone had come into my room, unannounced and without knocking."[10]

Peggy renewed her acquaintance with the composer John Cage, whom she had known in New York during the war, and she gave a party at her home to welcome him and his friends, the dancers Merce Cunningham and Carolyn Carlson along with the pianist, David Tudor. When he left for a concert tour in Japan, in the winter of 1962, Cage suggested Peggy come along. She was delighted and discovered Japanese cuisine and the centuries-old traditions of the Land of the Rising Sun. She frequently shared a room with Yoko Ono, who had yet to meet John Lennon. Yoko was the group's interpreter and took part in one of Cage's concerts. Peggy found her extremely kind and competent, and they became good friends.

When the Tate Gallery offered to show her collection in 1965, Peggy realized that true recognition had finally arrived. Three large galleries and one smaller room were put at her disposition. Nearly her entire collection was sent to London: one hundred and eighty-seven works, plus the primitive art. It was the first time that her life's work was recognized as a distinct entity, and the scholarly catalogue became a work of reference. The British and American press saw it as the art event of the year. *The New York Times* claimed that Peggy "has been a real influence in modern art. . . . She never had the intellectual status of Gertrude Stein but she has always had a quick unintellectual eye for interesting experiments."[11]

The red carpet was rolled out, in every sense of the term, to welcome the high priestess of modern art and hundreds of prestigious guests. Sindbad came over for the opening with Peggy Angela, his new wife, with whom he had two charming daughters, Karole and Julia. After Jacqueline Ventadour had left him and married Jean Hélion, he had retained custody of their two sons, Clovis and Marc. Hélion had kept Fabrice and David. In the early 1950s, in Paris, Sindbad had started *Points,* a little magazine devoted to young writers. He drove around distributing it himself and, like most such ventures, it soon went bankrupt.

In August of 1965 Peggy heard from Breton, whom she had not seen since their years in New York. He was hoping to put on a show in his gallery l'Oeil, on Rue Séguier, which was to be called *L'Ecart Absolu.* "In Charles Fourier's use of the term," he

Preparing chicken with chocolate sauce

With Henry Moore

added. Breton asked to borrow three pictures that he regarded as fundamental to his project: _The Birth of Liquid Desires_ by Dali, _Garden Airplane Trap_ by Ernst and _Very Rare Picture Upon Earth,_ an exceptional 1915 Picabia. He wrote that "what is at stake is Surrealism, and the absolute divergence is as much yours as mine or that of our friends." Regretting that he could not come to Venice himself, he recalled "New York and Marseille at that turning point in 1940, when I was able to escape in time thanks to you. I never think, without emotion, that we owe everything to your generous intervention."[12] Though she was touched by these memories of an heroic period, Peggy replied: "I never loan out my collection as 'spare parts.' It forms, as you well know, a comprehensive whole which I would be pleased to lend in its entirety to selected museums."[13] The following year, Peggy was invited to mount an exhibition at the Modern Museum of Stockholm by the curator, Pontus Hulten. Gustave Adolf, the king of Sweden, opened the exhibition and Peggy showed him through her collection. However, she found that his interests ran more to archeological sites and Oriental treasures than twentieth-century art. Accompanied by her daughter, Peggy traveled on to Denmark. The director of the Louisiana, a museum near Copenhagen, programmed an exhibition of the collection for the following year alongside a retrospective of Pegeen's work.

With Sandro, 1966

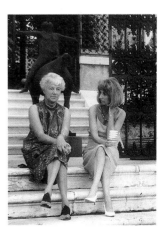

With Pegeen, 1966

In March 1967, while Peggy was in Mexico basking in the sun and visiting the Mayan temples with her friend Robert Brady, a bombshell arrived from Paris. Pegeen was dead. An overdose of barbiturates had put an end to her life. "Dearest Peggy," Djuna wrote on 14 April 1967. "The whole thing is dreadful . . . it truly kills the heart. . . . How can anyone, not present, know how it went; probably it's a fearful accident, a pointless disaster . . . it is like a grizzly early Italian Opera plot . . . senseless and quite horrible. Strange to think of the down-thrust chin, the floating golden hair, the stubborn and lost wandering walk . . . to know it is not there—but, once the grief is over, then . . . she can't be tormented anymore. But we can."[14] The death of her daughter was a terrible blow for Peggy. "My darling Pegeen, who was not only a daughter, but also a mother, a friend and a sister to me."[15] Laurence, who was already badly shaken by the death of his wife Jean, never got over the shock. After a trip to Africa, he went to the United States to see his daughters for the last time. And for the last time he dined with his old accomplice, Djuna, who found him: "So old, so ill, so shattered, yet holding together with incredible 'ferocity' . . . tho a wind lays him, like a leaf, in the gutter . . . "[16] Not long afterwards, in April 1968, the "King of Bohemia" rejoined his _blonde enfant._ Outside the windows of the palace, the day dawned on a sky of doom, and inside an old lady surrounded by her treasures tried to learn to live again. She consecrated a room to Pegeen's memory, filling it with a dozen oils and pastels, a glass panel by Constantini, a biography on parchment, a photograph, and a bronze plaque; "To me this was Pegeen's tomb," she wrote.[17] Kathe Vail-Kuhn, the second youngest of Laurence's daughters, brought up Sandro along with her own children Vesna, Kolia, Yannick, and Myrine. Sandro was spending the summer with his grandmother when she wrote to Kathe: "I am so happy to have had Sandro here. . . . I wish I had not given

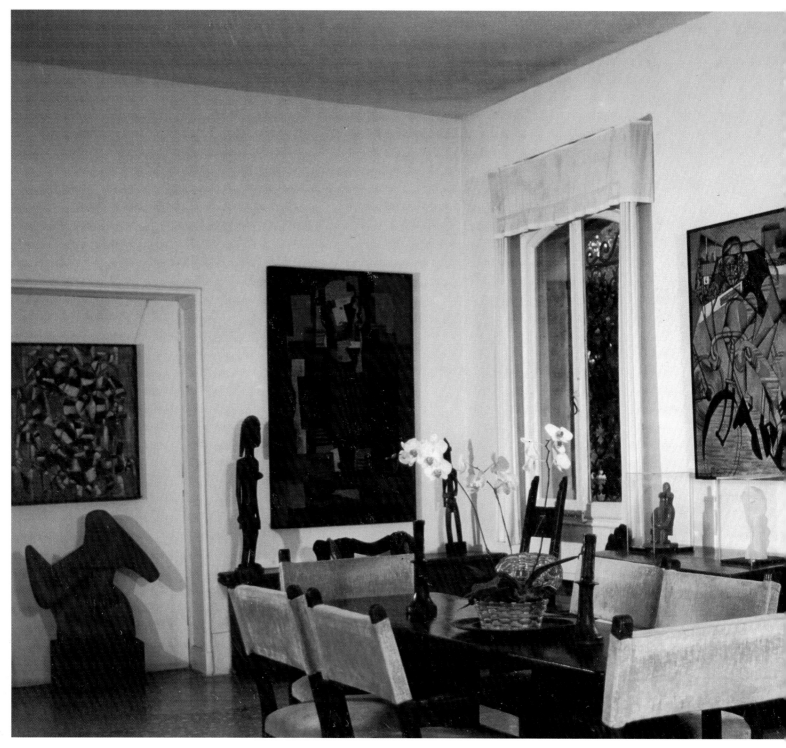

In the "cubist" dining room, from left to right: Contraste de formes by Léger, Boxers by Archipenko, L'Habitué (The regular) by Marcoussis, Au vélodrome (At the cycle-racetrack)

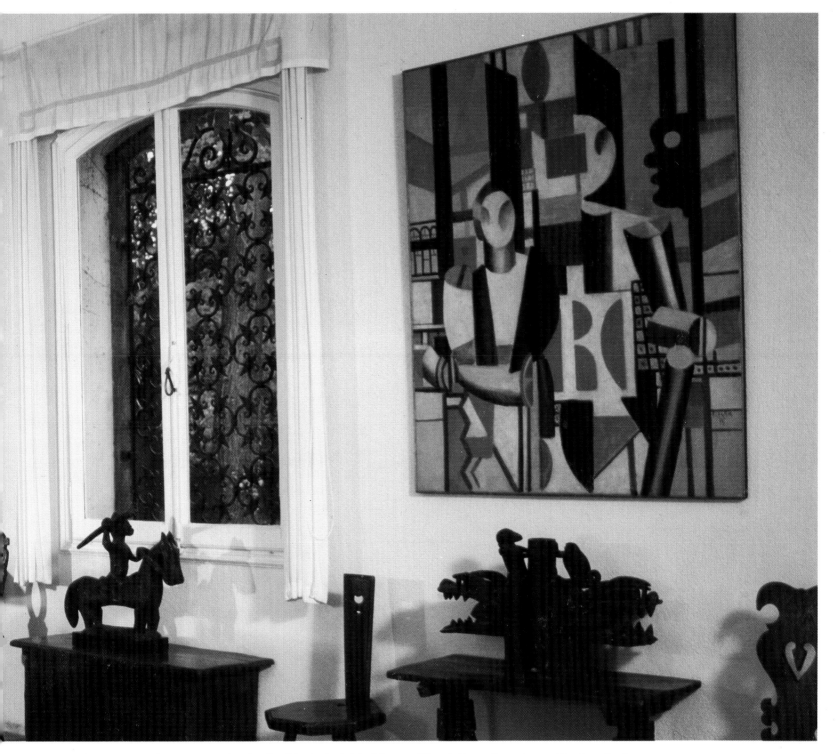

by Metzinger *and* Les Hommes dans la ville *(Men in the city) by* Léger, *set off by primitive works—a juxtaposition Peggy loved*

him to you except that I know he is much happier with you and all the children. He has changed my life completely. He is absolutely adorable. I don't know what I will do when he is gone." She added with emotion: "I don't think he was too upset coming here but certainly it reminded him terribly of Pegeen and he thinks a lot about her and the room I have made for her downstairs, which he loves, and has chosen 3 paintings of hers. I think it means a lot to him to be connected with me because of her."[18] This new type of relationship was a revelation to Peggy, and she continued, "It is wonderful for me in my old age to have grandchildren."[19] That summer, David, Nicolas, and Fabrice with his fiancée Catherine, came as usual to spend their vacations with their younger brother in their grandmother's *palazzo*.

As the years passed, a visit to Peggy Guggenheim became an obligatory stop on the itinerary of any celebrity passing through Venice. During one summer, after she had been named a Commander of the Italian Republic, Peggy had more than thirty-four house guests, to say nothing of friends who had been invited to keep them amused. Though she complained, secretly she was delighted. It was a house rule that guests should lock themselves in their rooms during museum opening hours, to avoid being surprised in a state of undress by visitors. In addition to close friends like Nellie Van Doesburg, Yvonne Hagen, Emily Coleman, or Herbert Read (a dog had been named Sir Herbert in his honor), were Giacometti, Miró, Matta, Calder, Tennessee Williams, Somerset Maugham, Yoko Ono, with John Lennon now, European royalty, André Malraux, Jean Cocteau, Igor Stravinsky, and Marlon Brando, to whom she said as he was leaving, "I loved your last book." She made a brief foray into the movies: Joseph Losey cast her in a cameo role in *Eve,* seated at a casino table with her huge eyeglasses. But as the winter mists closed in, her thoughts would return to Pegeen, to Benita, and to her father. When the film *A Night to Remember,* which told the story of the Titanic, came to Venice she went to see it three times. "The actor who played my father was not at all like him. I cried and cried," she recalled. "I've always thought that the Californian was near enough to come to the rescue."[20] In the winter of 1968, Peggy traveled to India again, this time with the photographer Roloff Beny. She was running away from the chill which was gripping not only the city but her life; two of her old friends, her guides, Marcel Duchamp and Herbert Read, had died that year. She got into the habit of leaving for sunnier climates with the waning of the season, but when she was back she surrounded herself with young people and laughter. In the home of an American neighbor she met an entertaining young painter, John Loring, who is now artistic director at Tiffany's in New York. One day she took him into a church where she said there was something interesting to see. John was intrigued to see Peggy sit down in front of a large Carpaccio and start sketching rapidly in a small notebook. He was amazed as he watched her copy the shoes of one of the figures: "They were incredible sandals turned up at the end like gondolas."[21] She ordered a dozen pairs in different colors from her startled shoemaker. They were to go with her extravagant eyeglass frames and her extraordinary Fortuny dresses. In Venice, Peggy explained, "one can

M*arini's* Angel of the Citadel
watching over the Grand Canal

In the enchanted
garden,
foreground:
Dans les rues
d'Athènes
(In the streets
of Athens)
by Max Ernst,
La Tauromachie
(Tauromachy)
by Germaine
Richier;
background
in the barchessa:
Le Baiser
by Max Ernst

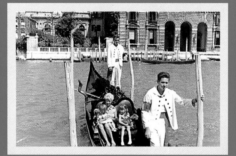

Karole and Julia in a gondola with Peggy

Laurence and Kathe making a collage

Peggy Angela and Sindbad

Beauty contest

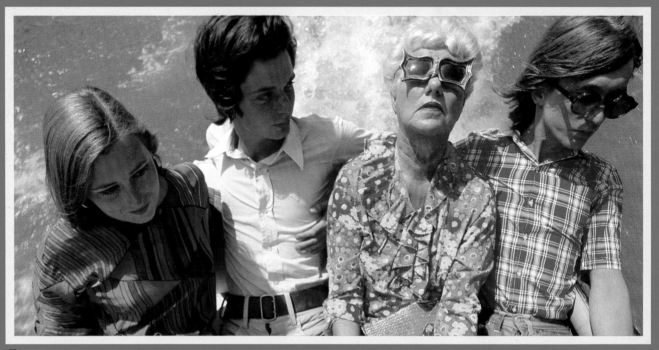

Catherine, Nicolas, Peggy, and Fabrice, summer 1970

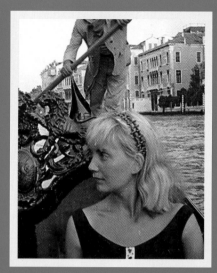

Kathe in Venice

John Loring throwing Sandro into the Grand Canal, 1972

Ralph Rumney in front of Cuberies *from 1959*

Sandro in David's lap, and Nicolas

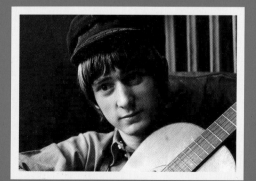

David the musician

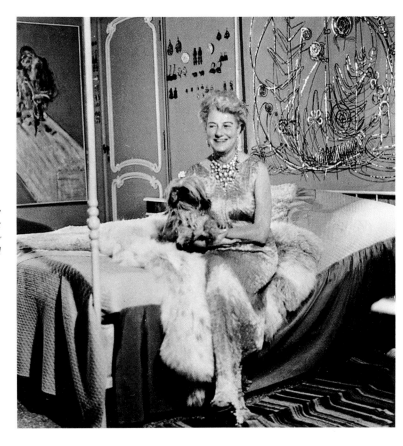

Radiant in a Fortuny lamé gown in front of her silver Calder bed head

wear almost anything and not appear ridiculous. On the contrary, the more exaggerated one's clothes, the more suitable they appear in that city, where carnival once reigned supreme."[22] Despite her white hair, she had not lost the sarcastic wit which Jimmy Ernst had remarked years before. When an indiscreet guest asked her how many husbands she had had, she retorted, "Mine or other people's?"

At the age of seventy Peggy began to be preoccupied by death. She worried about the way in which posterity would view her, and fretted about her responsibility towards her pictures. She confided to a friend: "I worry what will happen to my paintings after I am gone. I dedicated myself to my collection. A collection means hard work. It was what I wanted to do and I made it my life's work."[23] Her first plan was to leave the whole collection to the city of Venice, but the crushing financial burden of maintaining the art treasures for which Venice was already responsible obliged the city to decline the offer. The world's curators began to cast covetous glances at one of the most important historical collections still in private hands. Started with about forty thousand dollars in Paris during the German occupation, it was now estimated to be worth more than forty million dollars. Old Meyer Guggenheim would certainly have approved of the investment.

The Tate Gallery seemed to be the front runner. Its director, Norman Reid kept Peggy supplied with cuttings of rare and exotic roses, which to his surprise flourished in the damp and salty climate of the lagoon. The Berkeley Museum was another candidate until suddenly an outsider appeared. During an exhibition at the Solomon R. Guggenheim Museum, Peggy was feted like the prodigal niece who had returned to the fold. They spoiled her all the more, as she cannily remarked, because they too hoped to inherit her collection. She could not help thinking of the Baroness Rebay turning in her tomb and wrote: "I never dreamt, after all the rows I had with my uncle Solomon, that I would one day see my collection descending the ramp of the Guggenheim Museum like Marcel Duchamp's nude descending the stairs."[24] Thomas Messer, the museum's urbane curator, began making regular visits to Venice to get to know Peggy's collection. He did not conceal the fact that, as a museum director, an essential part of his job was to find new collections. "When I arrived at the Guggenheim in 1961, the question of where the Peggy Guggenheim collection would go was wide open. . . . I took the initiative, but also considered that I was riding on the Guggenheim horse."[25] Peggy, of course, was highly amused by this competition, and enjoyed dragging things out and keeping everyone in suspense. Messer's hope of uniting the two collections was satisfied at last in January 1969 when Peggy decided to give the collection to her uncle's museum. She coquettishly described her situation as "someone who was longing to be proposed to by someone who was longing to marry her."[26]

Peggy wrote to her cousin Harry, Solomon's son, setting out the conditions attached to the gift. She stipulated that the Peggy Guggenheim Collection should remain intact and complete in the Palazzo Venier dei Leoni, "without addition or deletion";[27] that certain works were never to be loaned, and that the rest of the collection could only leave the *palazzo* during the winter. Finally, she advised the donees to buy the building next door to exhibit works which were not part of the collection. Though he was very ill, Harry took the time to reply thanking Peggy for her generous offer, and stating that he understood her desire to keep the collection intact. He added that major exhibitions abroad could be envisaged without reducing the important role that the collection played in Venice. He further suggested that she should sign a formal agreement setting out her conditions in detail. The board of directors of Peggy's and Harry's foundations met respectively in Venice and New York to approve the *sine qua non* conditions of the donation. To further bind the destiny of one of the jewels of the lagoon, a presidential decree declared the collection to be part of Venice's national heritage.

One of Peggy's last great joys was the exhibition of her collection at the Orangerie in Paris from December 1974 through March of the following year. The exhibition's organizer Jean Leymarie, who was head curator of France's national museums, stated that, despite the absence of the works which were too fragile to travel, the historical survey embodied in the collection made up "an ensemble, unique in its radical and comprehensive scope."[28]

Sandro, 1966

Pegeen, 1966

In August 1978, Peggy's eightieth birthday was celebrated with appropriate honors. As she alighted from her gondola, carved with her personal device, she was greeted by a banner bearing her name and the phrase "To the Ultima Dogaressa." She was childishly enthralled by a sugar model of her *palazzo* lit from the interior. Sixteen months later, Peggy was rushed to the hospital in Padua. She had slipped as she was jumping out of her gondola and had broken her hip. She took *The Brothers Karamazov* with her as it was "a good long read." Shortly after the operation, she suffered a stroke and fell into a coma. Peggy had announced, "I'll be home for Christmas." She passed away on 23 December 1979. In observance of her wishes, her ashes were buried in the garden between her marble throne and the graves of her beloved dogs, Cappuccino, Pegeen, Sir Herbert, White Angel. The marble headstone, surrounded by daisies, her favorite flowers, is engraved with the modest inscription: "Here lies Peggy Guggenheim, 1898–1979." As an epitaph, one might have added a phrase of her *éminence grise*, Marcel Duchamp, "Art is a question of personality."[29]

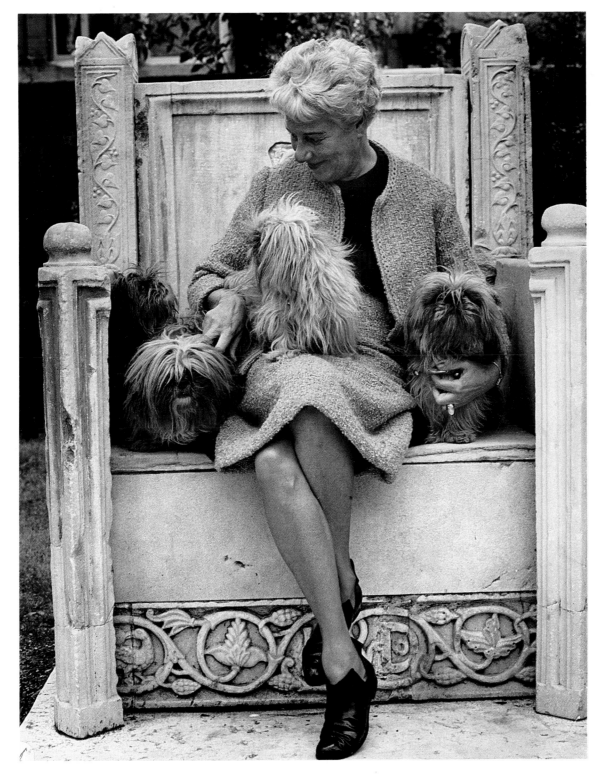

The last Dogaressa

NOTES

MILESTONES
1. Peggy Guggenheim, *Out of this Century: Confessions of an Art Addict* (New York: Universe Books, 1979), 218.
2. *Ibid.*, p. 276.
3. Clement Greenberg in *The Nation*, 31 May 1947, cited Angelica Zander Rudenstine, *Peggy Guggenheim Collection, Venice* (New York: Harry N. Abrams, Inc. and the Solomon R. Guggenheim Foundation, 1985), 798.
4. Katherine Kuh, cited in Guggenheim, *Out of this Century*, 322.
5. Letter from Djuna Barnes to Peggy Guggenheim, 14 April 1967.
6. Peggy Guggenheim, Introduction to *Invito a Venezia*, reprinted in *Out of this Century*, 381.

AN AMERICAN SAGA
1. Guggenheim, *Out of This Century*, 1.
2. Stephen Birmingham, *"Our Crowd": The Great Jewish Families of New York*, (New York: Harper & Row, 1967), 38.
3. Guggenheim, *Out of This Century*, 2.
4. John H. Davis, *The Guggenheims 1848–1988: An American Epic* (New York, Shapolsky Publishers, Inc., 1988), 57.

A GILDED CAGE
1. Guggenheim, *Out of This Century*, 10
2. *Ibid.*, 7.
3. *Ibid.*, 14.
4. *Ibid.*, 15.
5. *Ibid.*, 21.
6. *Ibid.*, 22.
7. *Ibid.*, 24.

VIE DE BOHÈME
1. Guggenheim, *Out of This Century*, 36.
2. *Ibid.*, 26.
3. Cited in Jacqueline Bograd Weld, *Peggy, the Wayward Guggenheim* (New York: Dutton, 1985), 56.
4. Guggenheim, *Out of This Century*, 27.
5. Eugene Laurence Vail, Retrospective Exhibition catalogue, (Paris: Galerie Jean Carpentier, 1937).
6. Guggenheim, *Out of This Century*, 30.
7. *Ibid.*, 40–41.
8. *Ibid.*, 40.
9. *Ibid.*, 41.
10. *Ibid.*, 50–51.
11. *Ibid.*, 57.
12 *Ibid.*, 73.
13 Robert McAlmon, *Being Geniuses Together* (London: Secker & Warburg, 1938), 262.
14 Guggenheim, *Out of This Century*, 73–75.

A COMEDY OF MANORS
1. Philip Herring, *Djuna: The Life and Work of Djuna Barnes* (New York: Viking, 1996), 196.
2. Guggenheim, *Out of this Century*, 89.
3. *Ibid.*, 80.

4. *Ibid.*, 107.
5. Edwin Muir, *The Story and the Fable,* cited in Guggenheim, *Out of This Century*, 100.
6. Guggenheim, *Out of This Century*, 113.
7. Susan Chitty, *Now to My Mother: A Very Personal Memoir of Antonia White* (London: Weidenfeld & Nicolson, 1985), 61.
8. Letter from Peggy Guggenheim to Emily Coleman, 27 April 1942.
9. Herring, *Djuna*, 197.
10. Guggenheim, *Out of This Century*, 116.
11. *Ibid.*, 118.
12. Letter from Peggy Guggenheim to Emily Coleman, cited in Herring, *Djuna*, 202.
13. Guggenheim, *Out of This Century*, 126.
14. *Ibid.*, 128.
15. *Ibid.*, 130.

GUGGENHEIM JEUNE
1. Guggenheim, *Out of This Century*, 162.
2. *Ibid.*, 165.
3. Rudenstine, *Peggy Guggenheim Collection*, 747.
4. Guggenheim, *Out of This Century*, 163.
5. Richard Ellman, *James Joyce* (New York: Oxford University Press, 1959), 661.
6. Guggenheim, *Out of This Century*, 175.
7. *Ibid.*, 171.
8. *Ibid.*, 174.
9. Rudenstine, *Peggy Guggenheim Collection*, 799.
10. Guggenheim, *Out of This Century*, 183
11. *Ibid.*, 184.
12. *Ibid.*, 188.

A PICTURE A DAY
1. Guggenheim, *Out of This Century*, 204.
2. *Ibid.*, 205.
3. *Ibid.*, 209.
4. *Ibid.*, 211.
5. *Ibid.*, 210.
6. *Ibid.*, 211.
7. *Ibid.*, 212.
8. *Ibid.*, 214.
9. Leonora Carrington, *La Dame Ovale*, 1939. Cited in Peggy Guggenheim, ed., *Art of This Century*, (New York: Art Aid Corporation, 1942), 132.
10. Guggenheim, *Out of This Century*, 218.
11. Fernand Léger, *Propos d'artistes*, 1925. Cited in Guggenheim, ed., *Art of This Century*, 68.
12. Guggenheim, *Out of This Century*, 221.
13. *Ibid.*, 231.
14. *Ibid.*, 241.

LIFE WITH MAX ERNST
1. Guggenheim, *Out of This Century*, 245.
2. Jimmy Ernst, *A Not-So-Still Life,* (New York: The Pushcart Press, 1984), 200.
3. *Ibid.*, 201.
4. Guggenheim, *Out of This Century*, 247.
5. *Ibid.*, 248.
6. Ernst, *A Not-So-Still Life,* 216.
7. Guggenheim, *Out of This Century*, 263–264.

8. *Ibid.*, 261.
9. *Ibid.*, 266–267.
10. Ernst, *A Not-So-Still Life, 227–228.*
11. Guggenheim, *Out of This Century*, 260.

ART OF THIS CENTURY
1. Guggenheim, *Out of This Century*, 171.
2. Frederick J. Kiesler, "Note on Designing the Gallery," 1942. Unpublished document from the Kiesler Archive, Collection Lillian Kiesler.
3. *Ibid.*
4. Guggenheim, ed., *Art of This Century*, 35.
5. *Ibid.*, 42.
6. *Ibid.*, 123.
7. *Ibid.*, 13.
8. Ernst, *A Not-So-Still Life,* 211.
9. Guggenheim, *Out of This Century*, 276.
10. Cited in Rudenstine, *Peggy Guggenheim Collection*, 771.
11. Edward A. Jewell, *The New York Times,* 21 October 1942.
12. Henry McBride, *The New York Sun,* 23 October 1942.
13. Guggenheim, *Out of This Century*, 277.
14. Unsigned article, *Art News*, vol. 41, 15–31 January 1943.
15. Guggenheim, *Out of This Century*, 282
16. Rudenstine, *Peggy Guggenheim Collection*, 799.
17. Robert Coates, *The New Yorker,* 29 March 1943.
18. Clement Greenberg, *The Nation,* 29 May 1943.
19. Rudenstine, *Peggy Guggenheim Collection*, 799.
20. Guggenheim, *Out of This Century*, 285.
21. *Ibid.*, 287–288.
22. *Ibid.*, 296.
23. Rudenstine, *Peggy Guggenheim Collection*, 776.
24. Guggenheim, *Out of This Century*, 315
25. Rudenstine, *Peggy Guggenheim Collection*, 799.
26. Guggenheim, *Out of This Century*, 322
27. *Ibid.*, 324.
28. Mary McCarthy, *The Cicerone*, in the anthology, *Cast a Cold Eye* (New York: Harcourt, Brace, and World, 1950), 353
29. Clement Greenberg, *The Nation,* 31 May 1947.

VENETIAN RENAISSANCE
1. Guggenheim, *Out of This Century*, 325.
2. Letter from Peggy Guggenheim to Clement Greenberg, 2 December 1947.
3. Virginia M. Dortch, *Peggy Guggenheim and her Friends*, (Milan: Berenice, 1994), 14.
4. Weld, *The Wayward Guggenheim*, 354.
5. Guggenheim, *Out of This Century*, 327.
6. *Ibid.*, 329.
7. *Ibid.*
8. Alan Levy, "Peggy Guggenheim: Venice's 'Last Duchess,'" *ARTnews,* vol. 74, no. 4 (April 1975), 60.

9. Guggenheim, *Out of This Century,* 334.
10. *Ibid.*
11. *Ibid.*, 336.
12. *Ibid.*, 348.
13. *Ibid.*, 350.
14. *Ibid.*, 363.
15. *Ibid.*, 343.

THE LAST DOGARESSA
1. Guggenheim, *Out of This Century*, 354.
2. *Ibid.*, 354.
3. *Ibid.*, 344.
4. Raymond Queneau, preface to the catalogue for Pegeen Hélion's exhibition at the Galeria del Corso.
5. Author interview with Ralph Rumney, December 1995.
6. Letter from Jean Cocteau to Peggy Guggenheim, June 1959.
7. Guy Debord, *La société du spectacle* (Paris: Buchet-Chastel, 1969).
8. Guggenheim, *Out of This Century*, 324.
9. Letter from Djuna Barnes to Peggy Guggenheim, 29 January 1967.
10. Letter from Djuna Barnes to Peggy Guggenheim, 15 April 1979.
11. *The New York Times,* 31 December 1964.
12. Letter from André Breton to Peggy Guggenheim, 13 August 1965.
13. Letter from Peggy Guggenheim to André Breton, 27 August 1965.
14. Letter from Djuna Barnes to Peggy Guggenheim, 14 April 1967.
15. Peggy Guggenheim, *Out of This Century*, 370.
16. Letter from Djuna Barnes to Peggy Guggenheim, 21 November 1967.
17. Peggy Guggenheim, *Out of This Century*, 371.
18. Letter from Peggy Guggenheim to Kathe Vail-Kuhn, June 1970.
19. *Ibid.*
20. Dortsch, *Peggy and Her Friends*, 14.
21. Author interview with John Loring, December 1995.
22. Guggenheim, *Out of This Century*, 381.
23. Dortsch, *Peggy and Her Friends*, 15.
24. Guggenheim, *Out of This Century*, 372.
25. Quoted in Weld, *Peggy, the Wayward Guggenheim*, 417.
26. Guggenheim, *Out of This Century*, 371.
27. Deed of ownership cited in Davis, *The Guggenheims: An American Epic*, 389.
28. Jean Leymarie, "Art du XXᵉ siècle, Fondation Peggy Guggenheim, Venise," *Le Petit Journal des grandes exposition*, Réunion des Musées Nationaux, no. 18, November–March 1974, i.
29. Yves Arman, *Marcel Duchamp joue et gage*, exhibition catalogue, Gallery Yves Armand, New York; Galerie Beaubourg, Paris; Galerie Bonnier Geneva (Geneva: Marval, 1984–1985), p. 98.

INDEX

Numbers in italics refer to captions

ACKNOWLEDGMENTS

The author wishes to express her sincere gratitude to the people who, during the course of this undertaking, volunteered their help, their advice, or access to their collections or personal archives. Special thanks go to Sandro Rumney, Kathe Vail, John Loring, the late Jacqueline Kennedy-Onassis, Suzanne Tise, Diana Groven, Sauveur Vaïsse and Christian Brémond,
as well as

David Hélion, Nicolas Hélion, Karole Vail, Julia Vail, Jacqueline Hélion, Catherine Gary, Ralph Rumney, Marie-Claire Coleman, Giselle Waldman, Aube Elléouët Breton, Vittorio Carrain, Mrs. Charles Gimpel, Lillian Kiesler, Jocelyn Kargère, Phillip Herring, Jurgen Pëch, Constantin and Christiane Tacou, The Peggy Guggenheim Foundation, Renata Rossani, Claudia Rech, Harry Shunk, Kheira Messadi and Sandro Castro
and finally,
for their extraordinary patience, her darling children Olivia, Sindbad, Santiago, and Lancelot and the inestimable Daniel Andres Seminario.

Picture Credits: All the photographs reproduced in this book are from the collection of Sandro Rumney and a private collection, except for those listed below.

P. 2: Magnum, Paris. Photo David Seymour; p. 5: Cameraphoto, Venice; p. 7: Mary Evans Picture Library, London. Photo Ida Kar; p. 13: Peggy Guggenheim Collection, Venice; p. 14c: Photo Robert Whitaker; p. 15: drawing by Stanislas Bouvier; p. 16: Solomon R. Guggenheim Museum; p. 17: Drawing by Steinberg copyright © 1954, *The New Yorker Magazine*, Inc.; p. 18 and 19l: University of Oklahoma Libraries, Bass Collection; p. 19r: Collection of Geoffrey T. Hellman; p. 20l: University of Oklahoma Libraries, Bass Collection; p. 20r Roger Viollet, Paris; p. 21: University of Oklahoma Libraries, Bass Collection; p. 22 both: University of Oklahoma Libraries, Bass Collection; p. 23tl: *New York Globe*; p. 23tr: University of Oklahoma Libraries, Bass Collection; p. 24t: University of Oklahoma Libraries, Bass Collection; p. 25r: University of Oklahoma Libraries, Bass Collection; p. 25b: Colorado State Historical Society Library; p. 26: Reproduced from *The Best of Art Young*, by Art Young, copyright © 1936, renewed 1964 by Vanguard Press, Inc. by permission of Vanguard Press, Inc.; p. 27t, p. 27b: Nassau County Museum, photo R.J. Wyatt; p. 27c: University of Oklahoma Libraries, Bass Collection; p. 32: background and p. 32b: Roger Viollet, Paris; p. 37t, p. 37b: Roger Viollet, Paris; p. 41; Collection Giselle Waldman; p. 44: Collection Kathe Vail; p. 45: Editions d'Art Yvon; p. 46: Copyright © Man Ray Trust–A.D.A.G.P., Paris 1996; p. 51t: Collection Kathe Vail; p. 51b: Roger Viollet, Paris; p. 52: Copyright © Man Ray Trust–A.D.A.G.P., Paris 1996. Photo Collection Kathe Vail; p. 53: Berenice Abbott/Commerce Graphics Ltd., Inc. Photo Collection Kathe Vail; pp. 54, 55, 56: Collection Kathe Vail; pp. 62-63: Collection Kathe Vail; p. 68b: Collection Marie-Claire Coleman; p. 73bc: Collection Marie-Claire Coleman; p. 78: Photo © Gisèle Freund; p. 80: Collection Giselle Waldman;

p. 87: Solomon R. Guggenheim

Museum; p. 88: Courtesy the Henry Moore Foundation; p. 90: *Untitled* by Yves Tanguy © Spadem, Paris 1996; p. 94: Roger Viollet, Paris; p. 95: Bibliothèque Nationale de France. Photo Rogi André; p. 96: Delphi, Paris;

p. 102: Collection Jacqueline Hélion; p. 103: Collection Aube Elléouët Breton;

p. 105r. Agence Rapho, Paris. Photo Ylla; p. 106: Berenice Abbott/Commerce Graphics Ltd., Inc.;

p. 109: Courtesy Vogue © 1942 (renewed 1970) by Condé Nast Publications, Inc. Photo Hermann; p. 114: Collection Jürgen Pech., Bonn. Photo Herman Landshoff; p. 115: Collection David Hélion; p. 119: Marcel Duchamp Archives. Courtesy the Philadelphia Museum of Art; pp. 120–121: Courtesy Lillian Kiesler, New York; p 123: Photo John Schiff; p. 124c: Courtesy Lillian Kiesler, New York; p. 125r: Berenice Abbot/Commerce Graphique Ltd., Inc.; p. 125b: Cour-

tesy Lillian Kiesler, New York; p. 126: Solomon R. Guggenhein Museum; p. 128: Photographic Archives, The Museum of Modern Art, New York. Photo W. Leftwich, Courtesy The Museum of Modern Art, New York; p. 130bl, 130br: Collection David Hélion; pp. 132, 133, 134l: Solomon R. Guggenheim Museum; p. 138r: Cameraphoto, Venice; 138c: Collection Vittorio Carrain; p. 140l, 140r: Cameraphoto, Venice; 140c: Courtesy ASAC, Biennale di Venezia; pp. 141–142: Cameraphoto, Venice; pp. 144–145: Cameraphoto, Venice; p. 146r: Collection Jacqueline Hélion; p. 147l: Photo André Morain; p. 152: Photo Yasuhino Yoshioka; p. 154c: Photo Charles Gimpel; p. 155: Cameraphoto, Venice; p. 156r: Courtesy ASAC, Biennale di Venezia; p. 156t: *Connaissance des Arts*/Edimédia. Photo P. Hinous; 156d: Collection Karole and Julia Vail p. 157: Peggy Guggenheim Collection, Venice. Photo Roloff. Roloff Beny Collection, Documentary Art and Photography Division, National Archives of Canada, 395 Wellington Street, Ottawa, Ontario K1A ON3; p. 159: Collection Vittorio Carrain; p. 160, p. 161t: *Architectural Digest*. Photo Peter Vitale; p.161r: Photo André Morain; p. 162l: Photo Charles Gimpel; p. 163 all: Photo Harry Shunk; pp. 164–165: *Architectural Digest*. Photo Peter Vitale; pp. 166–167: *Connaissance des Arts*/Edimédia. Photo P. Hinous; p. 168tr, 168b: Photo Robert Whitaker; p. 168tl: Collection Kathe Vail; p. 168tc, 168c: Collection Karole and Julia Vail; p. 169tl, Collection Kathe Vail; p. 169tr: Photo Robert Whitaker; p. 169bl: Collection David Hélion; p. 169c: Photo Harry Shunk; p. 170: Peggy Guggenheim Collection, Venice. Photo Roloff Beny. Roloff Beny Collection, Documentary Art and Photography Division, National Archives of Canada, 395 Wellington Street, Ottawa, Ontario K1A ON3; p. 172: Photo Harry Shunk; p. 173: Time-Life Publications. Photo Carlo Bavagnoli; p. 176: Photo Robert Whitaker.

The publishers would like to thank all those who have lent photographs for this book. Efforts have been made to trace copyright holders. Should there be any omissions, the publishers would be pleased to rectify them in the appropriate way.

Canine memorial